Armed to Surrender

Melissa,

Thank you for blessing us by sowing into the ministry. My prayer is that you remain armed to surrender.

Ptr Ashanti
♡AF

Armed to Surrender

LIFE DOESN'T HAVE TO
BE PERFECT TO BE AMAZING

DR. ASHANTI

purposely
created
PUBLISHING

Special discounts are available on bulk quantity purchases by book clubs, associations and special interest groups. For details email: sales@publishyourgift.com or call (888) 949-6228.

For information logon to: www.PublishYourGift.com

To my beautiful children

To every soul who thinks they can't make it

*To every woman who thinks she
isn't good enough*

*To every man who believes he won't
be able to lead his family*

*To my big sister, Joy, who simply said,
"You need to write that book!"*

TABLE OF CONTENTS

FOREWORD

Joy "Big Sis" Jackson

"We are afflicted in every way, but not crushed; perplexed, but not driven to despair; persecuted, but not forsaken; struck down, but not destroyed."

2 Corinthians 4:8-9, ESV

My name is Joy "Big Sis" Jackson. Big Sis is a name I earned from my colleague, Dr. Ashanti. When we met in 2002, she was a young, quiet, friendly, knowledgeable seventh and eighth grade Language Arts teacher and mother of one toddler, Quincy. Initially, our friendship did not exceed more than a casual greeting when passing in the hallways, but as a more veteran educator, I watched her from afar. I was amazed by her confident posture; shoulders back, chest up, smooth stride, and head held high, all at the tender age of 22. It was difficult to believe that she was a novice teacher because she ran so many clubs and activities seamlessly including yearbook, SGA, and Step Team, while teaching two grade levels! Ashanti stood out from the other teachers, and I knew she was destined for greatness. And it is true that she always sat on the front row at every staff meeting and was known as the "principal's pet," but that nickname was "all love" considering

we knew where to go to find all the answers. However, one day, I was surprised to learn that she left teaching to complete her master's degree. I will never forget our staff cruise in June of our first year together when she wore these form fitting peach pants, something only Ashanti would be bold enough to pull off with grace. Her long legs, brown skin, and giraffe-like stature was admired by all. Even childbirth offered her a more motherly figure; her confidence was evident. I told you she stood out and winning became her norm! Upon her return to our middle school after a year of studies, our friendship grew into a sisterhood throughout the next sixteen years. I gladly cheered for her when she fulfilled leadership positions in our school, spoke at local and national conferences, and spearheaded the implementation of AVID (Advancement Via Individual Determination) in our school, her pride and joy! I jokingly started calling her "Baby Doc" because her drive emulated that of our then principal, Dr. Marian Whitehood, and I constantly suggested that Ashanti write a book because her accomplishments were mind-blowing! She was unstoppable and learned through life's lessons who had her back. In 2006, our local grocery store started home deliveries just when her twins were born. Even though we only lived a mile apart, Route 214 separated the haves from the have nots. Her side of 214 didn't have the delivery option, but we both knew that this could be a deal breaker since she had to get a sitter just to do grocery shopping because twin infants, a two-year-old, and a six-year-old is already a handful as a single mother. I offered, and she happily accepted. My husband and

I started to accept her grocery deliveries at our home, and all she had to do was drive up to load them, and then figure out how to get them into her apartment with the children. And she did. I would call her Wonder Woman, but it wouldn't do her justice.

In her debut book, *Armed to Surrender*, Ashanti reveals that while her resume is stellar, her emotional and mental foundations were sometimes crushed, and her faith faltered. Why would God place simultaneous hardships on His daughter? How would she ever find her way back to balance and inner peace? You'd never know that Ashanti went through these overlapping experiences and potential setbacks because she always found a way to make lemonade. When she lost her baby, she coped by quoting scriptures and acknowledging that Johannah must have been too much for her to bear, so God took her to heaven. When writing this letter of love about her, she shared with me that "the peach pants don't fit anymore." Well, I told her it's time for her to get a new pair of peach pants because as she always says, "Life doesn't have to be perfect to be amazing."

It is my prayer that your heart respects her vulnerability, appreciates her grit, and is motivated by her daily grind to keep you pressing forward in spite of your situation because God will forever be with you.

We are resilient.

INTRODUCTION

2613 New Glen Avenue. The beginning of my memories takes place at this yellow and green house with a white picket fence and lots of white neighbors. Tae Marie and Doll Baby are the names I answer to, and for the most part, I am always dressed like the latter.

I have cool parents, and I know it. Real cool. Daddy plays baseball—no—softball for a team called Express, a community league in the county. Red and white are their colors, and they are my favorites too. My daddy is number five. I am so in love with him, and I know he loves his Tae Marie too. Dad-

dy takes me to all the games and makes sure I get ice cream before we go home.

Mommy and Daddy have friends over all the time, and I like to make everyone laugh. I dance and sing to make them smile, even as a four-year-old. I say Bible verses and pray to let them know how much I love Jesus. Three of my uncles came up from North Carolina directly after their high school graduation, much like my daddy and his bride who were high school sweethearts. I am the only child my parents have for five years. I spend a lot of time around grownups and have just a few friends. I try so hard to keep up with the grownup conversations Mommy has with other adults in my presence because she spells the words she doesn't want me to hear. That is when I started visualizing words, but I can't keep up. She is way too good at it. And her handwriting—it looks like a cursive typewriter, and I work hard to write neatly just like her. She loves words and uses fancy ones. I notice that and try to use "big" words often, so I can fit in with the grownups.

I have my daddy's height, his moles just like my paternal grandma, JB, and a perfect gap between my teeth. He doesn't hug me often, but who needs hugs anyway? He gives me all I need, so what's the big deal? Hugs are extra and overboard. Love is an action word, and I never have a want or need that my daddy cannot provide. He didn't just want anyone taking care of his daughter so when I was born, Daddy took up night shifts, so he could be home with me during the day while Mommy was at work. Now, I am sure I watched him sleep more than he watched me draw and sing. I am also sure

that he will never stop telling the story of how he had to go to work with polished fingernails because I hooked him up while he slumbered one day.

As far as I'm concerned, my parents knew I would teach long before I even knew what a teacher was. Bossy and grown are words I remember them calling me the most. As the only child, Mommy and Daddy serve as my students. Around four-years-old, I wrote shapes on my chalkboard and put happy faces on their completed coloring sheets if, and only if, they stayed between the lines. I am not hard to please—just give me a steno pad and some colored ink pens, and I am quiet when visiting my mother's office at her corporate job downtown.

Teaching and learning are my first and only professional loves. I make worksheets and flashcards all the time. Even as an elementary student, my baby brother and best friend, Danya, are my age-appropriate students. I continued to be successful all through grade school and had opportunities to travel internationally and spend summers away at STEM internships on the campus of North Carolina A&T State University during high school.

Even though my parents did not attend college, they sure are determined to raise us as if they had. I am not allowed to have a job as a teenager because I was told that my job is to get good grades and go to college. My friends have jobs, but I always seem to have the money. We spend a lot of time at each other's homes. Our parents know one another, and

we have similar goals, but I could never spend the night, especially if they had older brothers or friends of the family hanging around. My parents didn't play that! When I accepted the Honors scholarship to Morgan State University over the phone one day after school, I had no idea what the next four years would be like. My first time visiting the campus in Baltimore was actually my first day as a resident in the Honors dormitory. All I know is that my best friend and my boyfriend were going. She and I are going to be roommates, and he and I are going to be in the marching band together just like in high school. I dance and twirl the flag while he brings the melody with his trumpet.

My love for the band grows as a little girl sitting on my daddy's shoulders watching the Howard University marching band through a fence during their homecoming festivities. He takes me to D.C. each year to see the band. That is one of the special things he and my mom did together back home in that little town in North Carolina when they were in high school, my daddy on the snare drum and Mommy as a majorette. At least that's how I remember it being told. When we went to the Howard homecoming, I could tell that Daddy wanted to be in the college band, and he had the moves to do it. We dance, clap, and spend quality time together on our daddy and daughter dates.

It was not until joining the college band that I knew what it really meant to bring the crowd to their feet. Sure, I always dance and twirl, but nothing like this. This is the best feeling in the world, and I am hooked! So, when I am not in my

early morning classes, I am either studying, hanging with my first love, or with the band. I learn to be a committed leader through my band membership. Under the leadership of the band director and older sorority sisters gained through the music, I learn how to serve others through music and dance, how to move as a unit, the importance of doing my part, and how to be a leader that others want to follow. These lessons carry me throughout my dance to the rhythm of life.

MY EVERYTHING

I love him. Oh, how I love him! Since the tenth grade we have been a team, and it can only get better from here. I'm such a lucky girl. I got to bring my high school sweetheart with me to college to become my very own Morgan Bear. He reminds me of a teddy bear, too, the perfect cuddler. The phone rings, and he says he has something important to tell me. It's three weeks after I got his nickname tattooed on my lower back, a few days after his twenty-first birthday where I unveiled the surprise tattoo, and a month before Thanksgiving of my senior year in college. Is this it? Is it the moment I have dreamed of since 1995 when he first asked to be my boyfriend? Well, wait, did he ever ask me? I remember packing my things the night before I was to leave for an eight-week internship on the campus of North Carolina Agricultural & Technical University, preparing to say goodbye to our late-night conversations for a while.

The house phone rings, and I answer.

"Hey, do you have everything packed?"

I replied, "Yes, I think I have everything I need, but I can't put you in my suitcase."

"What are you going to tell the guys when they ask if you have a boyfriend?"

"Uh, I don't know. What do you think I should tell them?"

"You should tell them you have a boyfriend."

"Okay, I will."

And we've been going strong since June 15, 1995, and now, it's October 20, 1999. He has an off-campus apartment and has band, school, and work. He's amazing. I graduate with my Bachelor's in Elementary Ed in May, but he doesn't. That's okay with me. I can go home and teach while he finishes up his degree. Our wedding is going to be beautiful because we are the perfect couple. I won't have to change my initials, and our moms share the same name, first and middle. We already have date nights on the fifteenth of every month, but we don't spend any money, partly because we have none, and partly because money doesn't define our love. It's the real deal. Why else would we give ourselves to each other before marriage? Even though we aren't making the best decision by deciding to be intimate, we always keep it safe. We don't want to have any children before we get married and get our house. We have a plan.

June 15, 2012 is my wedding day goal. That way we are already out of school and have money saved for a house by the time we get married on the same day we started dating back in 1995. Seven years is a long time to know someone,

and I know everything about him. But I don't know what he needs to talk to me about.

"Hello, Ashanti." He never calls me Ashanti. He never needs to call my name because I am always there.

"Hey. Are you picking me up? What time do I need to be ready?"

"I don't exactly know how to say this, so I'm just going to say it."

"Say what?"

"I'm calling you to say that we need a break."

"What does that mean, Q? What are you saying to me? A break from what?" I sit in the middle of my dorm room floor in the dark wondering why two best friends are having this conversation over the phone in the first place. He sounds almost like he's choking up and can't quite get his words together. Even though I am in shock, I spoke again, "How long is this supposed to last, and why can't we be together? I thought you loved me!"

"I do love you, and that's why I am telling you beforehand. There are some things I want to do, and I don't want to disrespect you or hurt you by cheating on you, so I'm breaking up with you. I don't know what else to say. I'm sorry, and I do love you, and you know that."

He hangs up, and I'm still sitting with the phone to my ear. After a moment of silence, I'm smiling. My Morgan Bear plays way too much. He has to be playing because I was just

at his apartment, in his bed, with a newly etched permanent tattoo of his name on my lower back last week! This has got to be another prank, but this time he has gone way too far. I tell myself he's going to call back and say "GOTCHA," hoping that it's true. This just doesn't make sense! His best gal pals are my sorority sisters and roommates, and I know they would have told me about something like that, but they didn't. After two minutes pass with no SIKE phone call, my heart starts to beat at that familiar uncomfortable pace while my palms get sweaty. I do all I know to do; I call his roommate and best friend, Christian. He isn't answering, so after three rings I almost hang up then I hear his voice on the line.

"Hey, Ashanti."

"Christian, what is going on with Q? Is he serious?"

"I don't know what he's thinking about. I told him he needs to come and talk to you in person." He isn't laughing. I have actually never heard jokey, funny, all-smiles Christian be this serious.

"Why is he doing this? Did I do something wrong?"

"I don't know if the tatt freaked him out or not, but he just said he needs a break. You're a good girlfriend, Ashanti. Just relax. He loves you, and it will work out."

"Okay, Christian. I'll calm down, but I just don't understand why he's doing this to us."

"If I hear anything, I'll call you, okay?"

Christian's words help calm me down a bit, but I'm still on the floor because the wind has clearly been knocked out of my soul. I sit still for a good ten minutes before making my way up to my bed. I need some Mary right about now to ease my mind. She always knows exactly what I need and how much I need. I reach over and grab my wrap-around purse and pull her right out.

Yes, this is just what the doctor ordered! I reach for my light switch and close the door. Tonight, it's just me and my Mary J. I lean back on my orange, husband pillow and crack the window for just a bit more air circulation. It doesn't take long before I'm on the second hit, and for the moment, I'm thinking about dancing and the way Mary is making me feel. "Not Gon' Cry" plays, and Ms. Blige keeps reading my diary and making hits off of my life's happenings. I am falling in love with my mp3 player all over again. After a few songs into my jam session, including "Real Love," then "I Can Love You," and then "Reminisce," my cell phone rings. It's him. Did he change his mind already? Yes, I know he loves me. Christian must have talked some sense into him. He's a real friend.

I answer, "Hey."

"Hey babe. I miss you already."

"Um, I just wanted to say I'm sorry for telling you that over the phone. That was wrong."

"Okay. That's it? That's all you want to say?"

"Yeah, I guess. I just wanted to apologize for hurting you. I thought that I would avoid hurting you by telling you, but I feel like I have caused more pain for you anyway."

"Yes, I'm hurt, but do what you have to do and hopefully I'll still be waiting for you."

Okay, now I'm pissed off. Why do you keep calling and teasing me? Let's not play with my heart any longer. The next songs are "Missing You" and "I'm Going Down" and right back into misery I go. I get up and dance this one out because it's the only thing I know to do when life gets rough. I dance like my life depends on every pointed toe and every clean line, even in my little dorm room.

I am devastated. Marriage is what I want and thought was going to happen. I want him to marry me and be my first, my last, my everything. He needs to sow his royal oats and see what dating and real college life is, and I am in the way of that. I appreciate the apologies, but my heart's wound is so exposed. We are both in the band, so everyone knows. And if they didn't know now, they'd know just a few days later when his car is seen waiting for some other band girls in front of the women's dorm. Maybe he's just giving them a ride. I mean he just broke up with me. Why would he do that with someone I know? The truth of his most recent fraternization is given to me from the lips of a Virgo freshman who plays sax. He comes all the way across campus just to fill me in. He's charming but has no credits. Virgo says they were having a sleepover party at Q's place. Virgo says that my

Morgan Bear was intimate with another band member at his house. No way, not my Bear. This can't be why he left me. Not for her anyway.

In the band world, the word is out about the big breakup, and we pass one another on the marching band field just like we have never met, just a number in a drill, marching near each other just so we can get to our assigned spots on the yard lines. This is a bittersweet place to be, marching my last drill in my tenure as an undergraduate student. I have accomplished so much in the sorority leadership, both locally and regionally. I have aspirations of penetrating the field of education in a mighty way. And just like that, the party is over. My last twirl, my last crowd, and no Morgan Bear.

I remember the first day of band camp, unpacking my stuff in my room all by myself. I am already irritated by the XL mattress and trying to wrestle with these twin sheets that I tried to tell my mom I didn't need. Only the band people were moving in, and only the people in Honors stayed in my dorm, so I was shocked to hear another voice on the same floor as mine.

"Hi, I'm Mel. Are you in the band?"

The closeness of the voice exceeds the entrance of my door which is violation number one. I peek around the corner to make eye contact with this space invader and see a tall, thin, honey-blonde chick with almond milk skin and rosy lips.

"I'm from Newport News, and I play the clarinet. What do you play?"

"Nothing. I dance, so I'm on the flag line."

"Oh."

Okay, so one thing I certainly cannot do is be friends with people who can't get with personal space or who see dance as less important than playing an instrument. I've heard that "oh" before.

"I'm almost done. Do you want to walk over to the band room together?"

She's already overwhelming me and now you want to walk all the way across the campus to the band room together?

"No thanks. I have to go to the store with my parents first." I feel my mom's eyes pointing at my temple like a laser, and I don't even care. I have the only friend I need. I brought him from home with me, and he is my Morgan Bear.

Now, four years later, he's with them and not with me.

I wish this experience would last forever, yet I can't wait until I take it in for the last time, so I can get away from this cesspool of love that I chose to be a part of. I have outgrown the parties, late nights, sharing gossip, carryout ordering, and waiting for Q to love me back. I am tired of putting on a strong face when I'm broken into pieces inside. I want to be with my man, and I need him to want to be with me.

His fraternizing at the band party just a few days later showed me exactly what he feels about me. He buries his head in her lap like he is searching for some additional college credits and financial aid. I'm crystal clear now. I am

standing right there in front of him. Is he too intoxicated to know I'm there? Who is this guy, and what happened to my Morgan Bear? Thanksgiving can't come soon enough! Only three more weeks, then I can breathe. I cannot do this party. I don't even like house parties; I just really want to see him and for everyone to see that I'm strong. If they didn't know already, they know now that he is no longer just for me.

The next week, Virgo visits my dorm room, and this time he didn't bring his sidekick, saxophone playing band mate from his high school. He's here when the love of my life isn't. It all starts with a kiss, and at the end of the night, no, really ten minutes later, I don't feel better. But I do feel a little more even, and in a moment's time, my life changes forever.

Chapter 2

ONE NIGHT STAND

Finally, it's my last band show, and the sorority sisters are in my dorm apartment cooking for the annual spaghetti dinner while the fraternity brothers are taste testing. I'm not complaining about the brothers, though; someone has to put up the tables and carry the heavy pots of spaghetti sauce into the band room. Marching band season 1999 has ended and just in time because I don't like people right now. And my chest—oh, my breasts hurt so bad! It is the end of the semester, and student teaching begins in five weeks. But I can't stop crying enough to get myself together. This breakup thing is hitting me harder than I ever thought it would. Breakfast. Class. Room. Dinner. Repeat. Ms. Hill got it right this time. This *MisEducation of Lauyrn Hill* CD is saving me right now. Between "Doo Wop (That Thing)" and "When It Hurts So Bad," she and I are one.

I feel like he planned this all along, but why couldn't he simply wait until after the band season, so it isn't broadcasted to everyone? Oh, I get it. He has to be single when we go back home, and it has to be over before the holidays. These

twenty-one credits are too much for me to bear right now. I'm in class nonstop, then band, then sorority life, and I have to be fully engaged in all aspects. It's too much, and I am consumed by it all at once. Why do I always put myself in these situations? Just so I can graduate in four years? I've had enough of him for the moment, and the real question is what is wrong with my body? I feel like I am peeing every hour on the hour and can't stay awake.

Everyone is in the kitchen while I'm on my bed covering my mouth from the stench of food. My best friend, Angel, calls me from the kitchen.

"Ashanti!"

"What? I'm coming! I'll cook, but I can't do that ground beef smell. Did you check the date on it?"

"Okay, just go back to your room, and we'll call you." She pushes my back as I walk slowly back down the hallway.

I hurt my friend's feelings, and I know it. I have never yelled at her or even been upset. Angel is just that, the closest friend in my life right now.

When she comes to check on me minutes later, I know I need to apologize.

"I'm sorry, Angel. I'm just all over the place with school, Q, and I'm just tired."

"Girl, I'm not tripping. You're cool."

She leaves me alone, and I have time to do an internet search for my symptoms. I begin to put the pieces of this

cryptic puzzle together. Why won't this online calculator tell me what I want to read? Please tell me I was not ovulating that night! Please tell me he didn't do what I think he did. Q and I always keep it safe, so I never worry about this, but this time I'm shaking. I'm terrified by the ideas presented on website after website. I have no one to talk to about it, so I will just keep it to myself for now. What in the hell just happened?

After using the restroom again, I head out to the band room, and I'm hungry. But I don't want spaghetti after smelling it cooking for hours. While the rest of the sisters serve all one hundred and twenty-five band members, I find a quiet corner and fall asleep right in the middle of the dinner. The band room is always loud, with or without instruments, but it didn't matter. All I hear is a song about sleeping. I am awakened by my new friend, Virgo.

"Hey. You okay? You look tired."

"Thanks for the compliment. Yeah, I'll be fine. I'm just glad the season and semester are over. As soon as we finish cleaning up, I can really sleep."

"We clean up? Don't you mean them? You sat over there slobbering the whole night." Here goes nosey Chuck in my business again. The sisters and brothers laugh as they continue to clean and put away tables.

"Please, I know you aren't talking! I'm surprised we have any sauce left for the band as much as you ate!"

He pulls me closer. "Calm down, Ashanti. I was just joking."

"Get off of me, boy. I was just joking too. Now, hurry up, so I can go please."

He squeezed my breasts with that hug. What was once comfortable is now causing me pain.

The night is finally over, and the spaghetti dinner is a success. As band sorority president, I lock up the band room to head out. Everyone in the band is going out together to Denny's, like we didn't just eat, but that's the tradition so whatever. I elect to walk back to my dorm alone. I need to breathe this cold December air, and I need to think in peace. Back in my dorm, my other four roommates are packing up their things to move, so I join the party. Only a few shirt folds later and still fully clothed, I fall into my bed. I know we have to vacate by tomorrow, but I can't do one more thing. My "no street clothes on bedsheets" rule is broken tonight. I haven't been this tired since, well, the process. I guess every organization has a membership intake process, some leaving you with more energy than others, but even that was no comparison.

Not too far behind me enters my line sister, Angel, who is most in tune with my every emotion. Angel verbalizes what I have been thinking for the last few days in only the way Angel can—straight and to the point.

"Ashanti, dude, what is your problem? You are around here barking at everyone!"

"I don't know, but I am super stressed out, and this thing with Q is too much for me to handle."

"Well, that's all fine and good, but you need to go handle that. And please know that I know. You can't fool me."

I can't fool her because I am busy trying to fool myself.

Before I get in bed, I go back to the bathroom.

I cry myself to sleep, this time laying on my back because laying on my stomach looks like it's out of the question right now. I sing, *"I worship you, oh mighty God, there is none like you."*

The next morning, I wake up late. I never wake up late, and I don't have an alarm clock, but this morning Daddy took care of all that.

Bang! Bang! "Tae, you in there?"

I jump up and panic because nothing is packed, and everything must go. But I realize that jumping up in my condition is not the move. I almost fall on the way to the door, trying to get my balance.

I need a plan to stall him because I know he came up here straight from work, and he's tired.

I open the door and make my way back to the bed.

Sitting on the corner of the bed, my tummy rumbles, and I motion for him to hand me the trash can.

He does, and there goes the spaghetti dinner and garlic bread from last night.

"I wasn't drinking; I just don't feel well."

"Ain't nobody say nothing about no drinking. Why isn't your stuff packed? You know I go to work tonight, right?"

"Yes, Daddy. Can you go and get me an orange juice from McDonald's, please?"

"Orange juice?"

"Daddy, please. I'll be ready when you get back. I promise."

Luckily, I only have a few things. So, I just throw things in the large plastic tubs and push the orange and blue tubs out to the living room for Daddy. Sending him to McDonald's bought me some time because I knew they were out of orange juice and that he would have to go somewhere else to get some. He would never come back without whatever his baby girl requested. Within thirty minutes of his return from the Stop, Shop, and Save grocery store, we were all packed up. When I lock the door, he says something that makes me smile for the first time in about five days.

"Look here, girl, you better not leave that orange juice in that room. You know how many oranges I had to squeeze to get that for you?"

I grab the OJ, lock the door, turn in my key, and we are off!

Daddy and I get into the truck with all of my non-perishable food, mattress pads, sheets, microwaves, clothes, and other electronics, and I listen to talk radio on the way home. I'm still crying inside, but I can't let him see me upset. I really have to go pee as this orange juice seems to go right through me, but I am afraid to ask him to stop on an otherwise for-

ty-five minute trip home. I have never had to stop before, and I don't want him wondering. As soon as we pull up at the house, I go straight in and to the bathroom. I hear Mommy coming upstairs from the daycare calling my name.

Finally, in the comfort of my own queen-sized bed, I'm still crying. Now, I know what's wrong, and I am terrified. My mother comes into the room for the fiftieth time to offer me food, but I don't want it.

"Ashanti, I don't know what you're crying about. Why can't you tell me?"

"I don't know."

"Are you on drugs?"

"NO, Mommy!"

"Are you gay?"

"What? No, I'm not gay!"

"Well, are you pregnant?"

I look at her and proclaim, "I don't know." Then I bury my head in the oversized cheetah printed pillow.

"Well, take a test, so we can find out and move on!"

She leaves, and I feel instant relief. She knows, and now I can exhale.

I can imagine that she is in her closet crying and praying, asking God for strength and to comfort me. I'm having a baby, and I am in college. She doesn't need to know that Mor-

gan Bear isn't the father, not now anyway. One step at a time. She loves him and calls him her "son-in-law." That will hurt.

Days later, the pregnancy is confirmed, and Morgan Bear has been calling all week. I'm avoiding his calls because I don't know what to say. He's in love again, a month after breaking things off with me, but this may just be the last leg of Destination Destiny. He wants to come over on Christmas Eve in a few days and bring my present. I oblige because my mother says I need to talk to him. She asks me if he knows about the pregnancy, and I answer her question.

"No, he doesn't."

"Well, you need to tell him."

It's Christmas Eve already and anticipating his arrival is beyond unnerving.

If I wear this shirt, he will see. I don't want him to see. Who am I kidding? I'm not even showing yet, but if my nerves had a diary, it would be a bestseller for sure. Okay, he will be here at seven, so let me practice what I am going to say.

When we broke up—no—when you broke up with me, yes, that puts the blame on him.

When you broke up with me, I was hurt and made a mistake in judgement.

Hold up, my baby is not a mistake. I can't say it like that either.

When you broke up with me, I made a decision to hang out with other people like you did, and I'm pregnant.

Okay, that's it. We did the same thing except boys can't get pregnant. Yes, that's how I will say it.

If he would have just loved me, we would be together.

That's the doorbell.

He's here.

Chapter 3

CONFESSIONS

He greets me with a kiss and comes into the living room. I miss those kisses. We sit in silence, watching *Jeopardy* on the small television which sits on top of the floor model, broken television in our family room. I'm still mad from the party shenanigans, and I am sure that he heard I have been hanging with the young Virgo. At each commercial, I plan to say it, but I chicken out each and every time. I get up enough nerve and take a deep breath all for *Jeopardy* to come right back on. I feel time stand still when the category entitled "Having Babies" comes up on the last round. The clue is *a baby born before the 37th week of pregnancy*. I answer aloud, "What is premature?" Even in turmoil, I am always up for a challenge. I stand slowly, motion to the television, and turn it off. This silence was like none other. I hear every sway and creak of my house that night. I return to the couch and look straight ahead, away from Morgan Bear. Then I speak these words.

"I have something important to tell you."

"What is it?"

"I'm pregnant."

He sits there for fifteen minutes in silence. I am afraid to look over to see his reaction. If he's crying, I am going to lose it. If he's not crying, I am going to be afraid. I don't look at all. Suddenly he speaks.

"Whose is it?"

"It doesn't matter." My trembling right hand motions to his soft left hand as the distance between the two widens. I realize that touching him might not be the best decision.

"Oh, now, it doesn't matter. You are too embarrassed to tell me who? I need to know!"

I move closer to him and grab his hand as tears flow from my eyes and onto his hand. He pulls away, stands up, and walks out. I hear his car engine start, and he drives away. I hurt someone I love so deeply, and Christmas Eve will never be the same. My future husband just walked out of the door as I carry the evidence of another man's adventure in my womb. I go upstairs to continue my routine of crying my eyes out until sleep takes over.

As I lie face down in my pillows, I feel her presence. She sits down on the corner of my bed. She doesn't speak at first. As she moves closer to me, I smell her. It's my baby sister, Maria. She always makes me feel better with her funny faces and songs. Maria is an inquisitive five-year-old who holds on to the word "why" for dear life.

"Why are you crying, Ashanti?"

"My tummy hurts."

"You have to be a big girl. You need to use the bathroom?"

"No thanks."

"Why not?"

"Because I already went."

"Okay. You want some medicine?"

"No thank you."

"Why not?"

"Because I just need to lie down and rest."

"Okay. I will pray for you."

Maria moves her little hand over to my tummy as I turn over, so she can touch me.

"Dear God, please bless Ashanti's stomach, so it will feel better."

As she prays, she squeezes her little eyes so tight, and I feel her faith that her prayers will be answered. If she has that kind of faith at five years old, then I must get it together and have faith too at twenty-one years old.

"In your name we pray. You feel better now, right?" Her look of optimism and belief in immediate healing shines through those big brown eyes.

"Yes, I do. Thank you."

The thing is I actually do feel better in my heart. Everything happens for a reason, and life is about choices.

My mom comes in quickly to shoo her out of the room. She can tell that things didn't go too well with Q and me. This time she has no words for me. Just a pat on the bottom and a blanket to cover me. I sleep the rest of the night away with my charged cell phone near my pillow just in case he calls me, just in case he needs me. He doesn't call though. Christmas is one big blur. My mother gives me a stocking for the baby, and I realize that she is dealing with this is her own way. She's going to get a grandbaby for her birthday next year, a band camp baby at that. Ode to the rhythm of life.

The next morning is here before I know it. We have an appointment scheduled to confirm the pregnancy at Kaiser Permanente just two miles away, and I go to visit Mom in her office downstairs before we go. When we have nothing else to talk about or lots to avoid talking about, we talk about my daddy. She thinks I take up for him, and I think she picks on him too much. Either way, daddy dialogue always yields smiles and laughter. I love how we are both in love with the same man but have totally different perspectives regarding his actions.

I get up to leave to get ready for the appointment.

Walking away I hear mom yell to me, "I will give his mom a call a little later. He's just shocked, I guess. He's a good guy."

Oh, boy.

Now, I have to give part two. I was waiting because she is finally dealing with this baby thing, but I can't straight up lie to my mommy, not if she is getting ready to make it worse.

Too much to remember. Here goes nothing. I turn around in the dark hallway and unload for the second time in two weeks.

"Uh, well, I wouldn't call his mom because it's not his baby."

She won't look at me. She doesn't turn around. I know she heard me.

I walk away, leaving her in her office staring at the computer.

Well, that's done. Now, all I have to do is tell my dad, then I think that is it. My confessions will be made. I exhale again as I leave the hallway and walk through the daycare pass the cribs, wipes, and changing station, and it all has a brand-new meaning to me. I have been helping change babies' diapers since my sister was born in 1994, but now, it is going to be my baby.

On the drive to the hospital, she has no questions, so I have no answers. She turns up the radio, and we listen to contemporary gospel while tears run down my face. As we pull into the parking lot, she breaks her silence.

"Before we go in here, is there anything else I need to know, Ashanti?"

"No ma'am. That's all."

The baby is a blob, and the doctor says the heartbeat is normal. My due date is my mom's birthday which she is very excited about, and that really helps me cope with the pregnancy a bit better.

What's up with that sex toy looking thing as a sonogram? The only sonogram I know of was the one my mom had with Maria—on her abdomen. I wasn't ready for that. Thinking about that uncomfortable state of being, I fall asleep on the way home only to complete the nap at home. As long as I am asleep, I don't have to answer questions, read texts, take calls, or be responsible. I can just sleep.

Chapter 4

GIRL ON FIRE

Back at the university for the year of 2000, my morning sickness kicks in hard like Ray Lewis's performance at the Baltimore Ravens' Superbowl victory that year. I'm exhausted and taking mass transportation to student teaching is already rubbing me the wrong way. I don't take buses, taxis, or subway trains. I'm from the suburbs, and I need a personal vehicle. With no license and no car, my options are to take the bus or make nice with my student teacher colleagues. Since the band room is really my second residence, I don't really socialize with the other education majors. This is a problem. I hate the winter, I am sleepy, and I am hungry. I am tired of people acting like they don't know what I know they already know, and I want to be in my bed in my house with my parents. This pessimistic rant begins the first part of every day during my first week back.

One morning in January 2000, I decide that moving home is what I must do. It's too much walking, and the elementary kids are making me ill, so I call my mother to let her know my plans.

"Mommy, I can't do it. I'm coming home."

"Let me tell you something. You have four more months, and you're done. You will not come home. You will get up and get dressed to go to your school. Now, let's pray."

She prays. I cry. She hangs up, and I get dressed.

The first half of student teaching leaves me exhausted every day, and where is my lead teacher? Did she quit? Am I the primary educator every day? If so, I need a check. My body is growing, but it's too small for maternity clothes and too big for these dress pants, so I wear them unzipped with my shirt covering them. Who makes these maternity clothes anyway? All mothers aren't huge at five months. Well, I'm not.

On Valentine's Day, Q comes to pick me up, and I'm feeling tired but excited to see what he is up to. I know he's dealing with this pregnancy in his own way, and I thank God every day for his love for me even through this experience. After driving me around for an hour, of course, I have to use the bathroom really bad. He goes into a building, leaving me in the car, saying he'd be right back.

I really have to go pee though.

He says just be patient, and he will be right back.

After five minutes which felt like five hours, he returns and opens my car door. I get out and follow him up the stairs to the door. As he opens the door, I'm blinded by a sea of candles that light the way to the living room. The scenery is amazing. I can't believe he did this all for me, the one who

broke his heart. I realize his love is unconditional for me, and I begin to cry.

"Well, what do you think?"

"I think this is the most beautiful thing that you've ever done for me." I keep doing the pee pee dance. "Can I go to the bathroom now?"

We laugh, and I finally empty my aching bladder.

Sitting on the bed with an empty bladder, for the moment, gives me another view of the beauty in this room, the care, detail, and intent. I guess he's been planning this for days! I wonder when he got over my confession and decided to love me unconditionally.

Dinner, a bubble bath, and relaxing music makes this Valentine's Day his best one yet. He is a hopeless romantic, and there is no doubt that he loves me. It doesn't hurt that he works at Godiva in the mall and gets discounts on my favorite white chocolate covered strawberries. As I lay in the bed next to him, I think maybe this can be our reality. Maybe we can raise this baby as our own and be a family after all. I can't sleep all night staring at him and trying to figure out his source of strength because I am in desperate need of it right now. How can this man treat me so kindly and make me, the woman he fell in love with at sixteen, a priority all while someone else's baby grows in my womb? Why does he stay? How long before he is no longer by my side?

It's morning, and I get dressed for work in the same clothes I wore yesterday: black stretch pants, white button-down blouse, and black flats. No one will notice; they don't even check on me. I start to call in but quickly remember that I am the teacher. Someone has to show up for the children, and that someone is me. Plus, I figure I would need a reason why I can't come and lying has never been my strong suit. On top of that, I believe that death and life are in the power of the tongue, and I would never speak illness or death onto myself or my unborn child. Off we go; at least I get a ride to school this time. I hate public transportation. Q drops me off with a kiss and continues with his day. He waits for me to walk into the building before pulling off. Love.

Mustering up the strength to get through the last weeks of city student teaching, I get my signature from the principal approving my work, so I can move on to the next experience. I still don't know where my teacher supervisor went, nor will I ask. Thank God I don't have to go to the city anymore. I live in the city, but it's not the same. I live on the campus, the open, public campus, but it feels like an island. I say goodbye to the city life of navigating bus stop times, staying awake, watching the stops, smelling the odors, and listening to the loud inappropriate conversations of the people on mass transit. I need the suburbs in my life.

Before my next student teaching assignment, I get to go home and see the sonographer to check on the baby and hopefully find out the sex. I follow the directions and get excited about seeing my baby. Drinking a half gallon of water

without relieving is torture to a pregnant woman's bladder, but that's what the directions say—a full bladder—and I really want to see my baby. I already know it is a boy because God sends him to me in my dreams. He has a head full of curly hair, a cute little birthmark under his eye, and beautiful brown skin! I'm already in love with him. I write about him and to him all the time in my journal and look forward to reading them to him when he's old enough to appreciate it. Mommy and I go in and only fifteen minutes later, she gets the news about her grandson growing ahead of schedule and probably being born just a few days before her fiftieth birthday. We are relieved to have a healthy baby boy to welcome to the Bryant family in just a few more months. Just like that, I'm already five months in and feeling much better about eating and staying awake. I give his father a call since he claims he couldn't get a ride to the hospital at the last minute.

"Hey, it's Ashanti. I just wanted you to know that it's a boy."

"I knew it. That's great! I will let my mom know."

"Are you going to tell your dad too?"

"I don't know where he is, and I don't need him. Quincy won't need him either. And I don't want to talk about him ever again." He is furious. Talk about zero to one hundred.

"Well, I wasn't trying to make you emotional, and I apologize if I upset you. I didn't know that would cause a problem."

"It's not your fault. Sorry for yelling. Okay, talk to you later."

The second half of student teaching is in a totally different demographic, and the weather is changing for the better, as far as I am concerned. This school has one Black educator and three Black children in the entire school with a population of over six hundred elementary students! All my life, I have been around Black children as the majority with a few White children, so this is very different for me. Bake sales, car pools, and fancy lunch pails full of fresh fruit, homemade applesauce, and sweet notes from Mommy make this situation the exact opposite of the city of Baltimore where kindergarteners use mass transit to commute to school to get a free breakfast and lunch provided by the irritable cafeteria ladies who are clearly upset at their current situation. Mechanicsville is a beautiful town with green acres and huge houses all lined up like a parade. There is no litter nor signs not to do it. You can actually hear birds chirping all day. The fire station resembles a country club with a huge water fountain out front and an American flag that I could wrap both my baby boy and me in comfortably. But there is a slight problem with this assignment.

My colleagues usually eat lunch together. In January, during one of those conversations over lunch, I lie about having a license and say that I would help drive sometimes because the commute from Baltimore to Westminster is a whopping fifty-five miles one way. And in the snow, those hills and one-way streets aren't friendly. I pray that they take pity on the pregnant girl and never ask me to drive because I have no clue how. I mean ZERO clue. I don't even have my

learner's permit. I have a state issued identification card. If I just keep supplying the abundance of gas money without being asked, then maybe they won't ask me to drive. Hell, I'm pregnant, so the fake fall asleep method should do the trick regardless. I know I shouldn't have lied, and I never come clean, nor do they ever ask me to drive.

Thankfully, the second grade teacher who supervises me spends lots of time with planning a gradual release of authority instead of just leaving me to teach the entire class by myself like the last appointment. She waits a while allowing me to observe her teaching and learning practices. I feel bad for those pre-professional educators who don't have the experience of practicing teaching with a master educator like I do. I spend the eight weeks enjoying planning, analyzing data, having small reading groups, and even recess duty. The kids and families are so nice. To my surprise, I am given a baby shower during my last days at the school in the first week of May. The cake and food are amazing, and I have several outfits for my baby boy. One of the little second grade girls asks me about the baby's father.

"Ms. Bryant, is your husband going to help you pack your stuff?"

"No, I don't have a husband."

"But you have a baby in your tummy, right? So, if you have a baby, you have to have a husband, so what is his name?"

"If I had one, his name would be Q."

Her slight nod and classic second grade, no two front teeth smile, let me know that I have satisfied her question.

I didn't get these questions at my other school, but I am grateful that children are still being raised to respect the sanctity of marriage and building a strong family.

My heart is glad, and I am grateful for the monster commute that provides reflection time and a quick nap before getting home. I am finally ready to graduate.

My Morgan Bear takes some time to get his feelings together, but he loves me. He does me the honor of escorting me to my Senior Ball where we dance, take pictures together, and share great food in my sixth month of pregnancy. Many people who know me from my education world, outside of band, congratulate us on the pregnancy that night, and that makes me uneasy. I'm obviously expecting and glowing at this point. Secretly, I do want him to be the baby's father. Well, it is not that much of a secret because he's the one I love. The night after the Senior Ball, we return to my dorm room and go to sleep together. Towards dawn, I feel my baby boy kick right into the back of my first love and the baby's un-father. I know he feels the love tap because his head moves towards me. I just wrap my arms around my first love and hug him tight. What man stays around after his girlfriend gets pregnant by a teenager? Soon after the love tap from the baby, he sits up, gets dressed, and leaves my dorm room after kissing me goodbye on the forehead. I fake like I'm asleep because I

know he's hurt, and I don't have the words to say to make it better.

Two weeks go by and not a word from him. I know what's going on. I'm showing now, and each day he spends with me reminds him of a choice he made which influenced a choice that I made. He can love the mother but can't bond with the unborn child who won't continue his legacy. He honors me by ensuring I had a glamorous finish to the college days we started just four years ago. Four years ago, we were at our high school graduation dinner together with our purity, and now, we are here.

Graduation is this weekend, and it is time for me to pack up again. As my daddy and I take that last ride home with my refrigerator, microwave, and baby shower presents from my sorors and colleagues at work, I reflect on Fair Morgan. Grateful for the experience is an understatement. Beyond the good ol' college fun during my four years and long-lasting friendships that yielded godparents, maids of honor, and best friends, I know I am ready to be an amazing educator. As I walk across the stage on May 21, 2000 as the first to graduate college in my lineage, with high honor and twenty-six weeks of a one-night decision baking in my tummy, I walk away from the best four years of my life. I anticipate more greatness to come with motherhood, becoming a teacher, and someday a wife.

Chapter 5

A FAMILY AFFAIR

I have to admit this pregnancy thing feels great! I get to wear dresses all summer and enjoy my favorite fresh fruits. My hair, skin, and nails are amazing too. Who knew pregnant women attract so many men? Everyone holds the door, and I even get offered to go ahead of the line at the grocery store when I go. Daddy takes really good care of me, and since he goes to the grocery store every day, he just brings me what I need. I'm only twenty-seven pounds heavier than I was in November when this roller coaster ride all started, and I'm only two months away from meeting the love of my life. Are other women really that soft, or am I just made to do this? I'm still unsure, but as I approach the baby shower date, I feel like I just want him to stay in here. That way I'm not afraid to figure out what I have to do as a mother anymore because I'm currently terrified. How am I supposed to know what he needs when he starts crying? After reading eight baby books, I still don't know the real reason my baby needs to be circumcised this early in life.

It's Monday, and I keep asking young Virgo for the addresses from his side of the family for the baby shower, and I can't for the life of me figure out what the disconnect is. It is in a couple of weeks. Mom is tired of waiting on him, so she decides to call him herself. Maybe she can get the ball rolling a bit more. I really miss my sorority sisters and college friends, but I miss my Morgan Bear the most. I'm absolutely giving him space. He deserves it, and I can't be selfish enough to want him to love on me while I'm clearly bringing forth a life inside of me without him.

Before I can even ask her if she got the addresses, she addresses me.

"Did you know his mother doesn't know about the baby?"

"What? He told his mother about the baby in December, and he told her again in April when we found out it's a boy!"

"Well, I looked up her phone number and called her myself. We had a nice conversation, but she didn't know, so I invited her over to meet the family this Sunday."

"But he told me she was excited about being a grandma before she turned forty and all that."

"Ashanti, I am telling you that she didn't know."

Now, I am nervous and fuming mad at the same time until I hear my grandmother's reminder in my mind: *Whatever you are doing when you are pregnant, your baby will do. If you are an angry person, he will be angry. If you are crying all the*

time, he will be a cry baby. But if you decide to be happy for the blessing, he will be a grateful child. You decide.

I think she is right too. The cry baby kids I know had mothers who cried a lot during their pregnancies. But right now, I don't care about that because baby Virgo lied to me and has been continuing the lie for months. What is it with guys and lying?

After a heated discussion, I learn that he was afraid to tell her. I have no idea what he thought was going to happen when she didn't show up at the baby shower, but I'm glad Mom reached out. But I'm still nervous all the same. I'm the older woman who stole her son's opportunity to live his life as a carefree college student. I'm the one who is graduating and starting a career but having a freshman's baby. I know she thinks that I seduced and manipulated him. I know she thinks that I am some hot and bothered sorority girl who just had to have her way with her young son who just graduated high school this time last year. I have my guard up, but Mrs. Helen is there in case things get difficult. She keeps me grounded.

Before I know it, Sunday is here. I take a quick nap after returning from church and eating a snack for lunch. My birthday is this week, so there is nothing this lady can say that will steal my birthday week joy. Mom gently wakes me up from my nap, and I head downstairs. There in the living room sits baby Virgo and his mother, a short lady, shorter than most women, with a cute round face. His grandmother

is with her. She immediately stands to embrace me and touch my stomach. As I sit down, my mother asks everyone to stand and join hands for prayer. She believes prayer changes things and has taught me the same. Instantly, all I think I know about this woman disappears.

She says, "Before we begin, Ashanti, I just want to apologize to you for not being there, but I didn't know about the baby. Had I known, I would have made sure he (pointing to her only child who she had as a teenager) was at doctor appointments and helping you out."

Mom takes the conversation over with meet and greet chit-chat about living in the country and being excited to be grandparents, and the meeting commences. Next up is the baby shower, so we make sure she leaves with invites in hand. Even though the shower is soon, I thought it was the right thing to do. I sleep a little better that night, but the baby shower day is here before I know it.

The cake is here, the caterers bring the food, and guests start to arrive. Leave it to Mrs. Helen to find little plastic brown babies to hot glue onto each baby blue spoon for the baby shower. She's amazing. Because I'm feeling fabulous, I decide to look the part in a short, black, sleeveless dress with tulips around the hem of the flared dress. I put on my wrapped sandals that have a two-inch, block heel. I'm feeling very cute for someone who is about to be a twenty-two year old mommy in a few weeks. What I am not prepared for is the high schoolish baby shower guests and their non-gift giv-

ing presence. Not that I am extra pressed for gifts and such, but they are young, and my guests are a lot older. I need to get used to it. The food, love, and gifts are in abundance, and I'm completely overwhelmed. Who is going to put all of this stuff away? Virgo and I take several pics together with the gifts and the cake, but before I know it, it's time to clean up and get ready for fun at Six Flags of America tomorrow. And yes, I am wearing a bikini!

Six Flags is fun, but it is hot out, and Quincy is feeling the sun beam directly onto my belly. My fashion presence is not something I see pregnant women do too much these days, but I'm young and think bikinis are made for pregnant women anyway. I obviously have no problem with being naked. People stare and mostly smile at my confidence. They are in disbelief when I tell them that I'm due in three weeks. But I am. I look down at swollen feet when I get home from Six Flags and am reminded how close my delivery date is. In bed, with the fan blowing, I feel relaxed; I will finally get some rest. Baby Q is starting to really get comfortable in his space, however, and it is making it difficult to get comfortable on my side, even with the pillows behind my back and between my legs. Sleeping in the recliner is the solution for this situation.

I only have a few more weekly doctor appointments. August 1st is finally here! Mommy turns fifty this year, but the baby won't be born on her birthday anymore. We were moved up to August 22nd at the last ultrasound, so not much longer.

My baby sister enjoys talking to him and identifying his hands, arms, and little butt as they protrude in and out of my full-term belly. Can I mention how ridiculously hot it is? I'm still not ready to be a mommy, but I'm starting to get excited about not carrying this extra thirty pounds around.

MY SUNSHINE HAS COME

At my appointment on Tuesday, thirty-eight weeks in, the nurse checks my status and says that labor could happen at any time now because I am dilated two centimeters and 100 percent effaced. It may also be another week, so it's all about him. Before she removes her fingers, I feel something pull inside of me. The weird feeling made it difficult to walk when I got up from the table with orders to come back if anything else develops. Mommy and I go straight back home because it is almost time for the late morning shift to arrive at daycare. It is too hot upstairs, so I decide to lounge in the family room instead with no TV, no cellphone, no one else. Within minutes, Daddy comes in with my favorites from the grocery store food bar, fried chicken wings and fresh watermelon chunks.

I sit up to receive my goodies and feel another pull "down there" that I haven't felt before. That is not Braxton-Hicks because I have had those, and that's not it. I ignore it and chow down. I can't get through half of my meal before I begin to get really uncomfortable again like the stomach flu. Lord, I

need to have a bowel movement and quick. I get up and go to the bathroom, and nothing comes out but pee and a little bit of other stuff that I don't recognize. But sitting there makes the pain go away, so I stay for a bit before returning to the couch. I'm sleepy now, so I lay back down, and the pains return. This time Mommy comes in.

"Hey, you okay?"

"Yes, but I think I may be having real contractions."

"Well, she said any day now. Are you counting them?"

"I don't really remember how they taught us in Lamaze. I just know it's uncomfortable. It's probably not that though. They're pretty mild."

"Well, let me know if you need your dad to take you back to Kaiser. It's right up the street."

"Okay, I will."

I make a courtesy call to the doctor, and they ask me a thousand questions before determining that I need to return. Mommy leaves, and another pain hits me just before she starts downstairs to the home daycare.

"Mommy, can you tell Dad to come and take me to Kaiser? They said come in." It's now noon, and my daddy still hasn't had any rest from working the night shift from 10 p.m. to 7 a.m. Preparing myself for his grumbling, I just go and get in the truck while he sits there unaware.

This is starting to get really painful, so I do my breathing. I can actually feel the contraction approaching the base of

the mountain and the climb as it reaches the climax and sits on the peak for a few seconds before slowly descending from the throne. This is something else indeed. Daddy gets me to the doctor's office and drops me off at the door. I hate when he drops me off at the door because everyone is staring, but this time I have no time to fuss with him. I head upstairs, sign in, and have a seat. The receptionist takes one look at me and asks me to come to the back. In the room, my contractions are going crazy at this point. I have no doubt that the party is starting. It is the middle of the day, and Mom is still in daycare mode. I don't know where Virgo is, but he doesn't have a license or car anyway, so I guess Daddy is going to have to be mad for the day.

The same nurse who checked me just three hours earlier returns. She reaches inside me again and determines that I am six centimeters dilated and in transition labor. She says I should leave the facility now and go straight to the hospital. I sit up and wait while she makes a copy of my pre-authorization forms, and as soon as she closes the door, I feel something warm in my lap. Wait, that's not my lap. That's my water breaking! It's all over the bed and floor, and the only thing I know to do is get paper towels to clean it up. Reaching up for the paper towels is not a good idea, and the most painful contraction to date takes me into a paralyzed-like state. After the pain subsides enough, I run to the wall and press the help button while still trying to clean up my mess. I can't leave this room like this. She comes in eventually, which feels like eternity.

"What's wrong sweetheart?" she asks in her deep Jamaican patwah.

"My water broke."

"Okay, well, that's a part of the party, little lady. Here's a pad to help catch the water."

"Where's your ride? You aren't driving, are you?"

"No ma'am. My daddy is in the waiting room."

"Okay, now. Straight there, you hear?"

"Yes ma'am."

"Today's your day! Be strong. You're a mama now!"

I smile through the pain and head out.

I have to be calm and collected even though my dress is wet, and I'm leaking amniotic fluid.

As I approach the waiting area, Daddy is asleep with his hat over his face. He's exhausted. I need to tell him what the doctor said, and I already know how this is going to go.

"Hey, Daddy. I'm ready."

He sits up straight from his 'I work nights and got to carry this girl around all day' lean. "Huh, oh. What did they say?"

"They said I need to go home FIRST and get my bags, and then go to the hospital. My water broke, so I'll have the baby today."

"They said what?" He's now standing and looking at me perplexed.

"Come on, Daddy. Go ahead and get the truck. I'll meet you downstairs."

"Okay."

I can tell he is nervous. He's been waiting on me hand and foot for months. Now, his grandson is coming, and his baby girl is becoming a mother.

On the way down the elevator, I realize that the nurse said go straight to the hospital, but I spent too much time packing my bag and the baby's bag to just leave them at home. We are going to get my bags and my homemade labor ice. It's just two miles in the opposite direction of the hospital. What's the big deal anyway? At the Lamaze class, she taught us to keep a bottle of water in the freezer, and when it's time, we can put the frozen bottle of ice water in between our legs during contractions to balance the pain. I put it in the freezer weeks ago, and I desperately need it at this point. I call Mommy from the lobby payphone while waiting on Daddy.

"Hey, my water broke. So, we're having a baby today!"

"Praise the Lord!"

"Praise the Lord? You can't come if you're watching the kids! What am I supposed to do?"

"You'll be fine, and I'll make it there. I'll start calling parents now. You sure you have time to come home first?"

"I'm on my way. Dad just pulled up. See you soon!"

I can tell something is happening inside my body because my stomach looks like a sloping mound instead of the

big and round balloon it looked like before my water broke. So much is going on, then I remember I need to text Virgo. He says he'll meet me at the hospital.

Home is only five minutes away from the urgent care center, and when we arrive, Mommy runs out with my ice and bags. I need everything in my bag, and no one has a baby an hour after the water breaks anyway. It's a process. If I learned nothing else from Lamaze, that is it. Mommy takes thirty seconds to pray with me and sends me on my way. It's just me and Daddy in the big, red truck on the fifty-minute drive to Silver Springs. The ice works well. My daddy looks at me sideways as I shove the frozen water bottle between my legs, and I give him the death look right back. As he starts the engine and pulls away from the driveway, I realize that this is it and that my daddy might have to help me have this baby. At this point, I can care less about who sees what. Just make the pain stop.

Candle visualization with no talking is my chosen strategy to get through this pain. I always have a plan. So, I close my eyes for the ride. Sometimes I hate being such a visual person. I'm trying to concentrate on the image of my lavender, vanilla candle that is packed in my bag, but images of my dad holding my legs and telling me to push are unnerving. I need my mom's clients to hurry up and get their children.

Chapter 7

STRENGTH, COURAGE, AND WISDOM

Daddy just made a sharp unfamiliar turn in our very familiar community. I open my eyes and am in utter shock to see that we are at the gas station!

"The gas station? Really, Daddy? You have known for nine whole months about this baby, and you run out of gas TODAY?"

"Look, you want to get there, don't you?"

I just throw my head back, close my eyes, and position my ice bottle once again. This is ridiculous, but necessary. Remembering that I'm the only one who had the real doctor's orders to go immediately to the hospital shut me right up.

Another contraction hits hard, and we are back on the road. For whatever reason, there is noonday traffic on Interstate 95 North, and we are at a standstill. It is already one o'clock, and my contractions are two minutes apart and lasting really, really long. My thighs must be on fire because my

ice bottle melts fast and works less and less. This traffic is also not okay.

With my eyes closed and visualizing my single lit candle in the dark, I hear static, and then Daddy's voice interrupts the silence.

"Breaker, breaker! I'm in traffic and need to get through. I have an emergency."

"We're in the same traffic you are in, buddy."

"Anyone know a shortcut to Holy Cross Hospital?"

Static and mumbles from voices dissolve my inner peace, and I open my eyes and see the contraption that Daddy has pulled from under the seat.

"Daddy, what in the world is that?"

"It's my radio. I'm trying to communicate with these trucks and see if they can move, so I can get you to the hospital."

Bless his heart. My daddy means well, but sometimes I just want to scream!

In between swaying and wondering if my daddy really thinks these trucks are going to part the Red Sea for him, Daddy plays Angie Stone's "Sunshine" on the radio and starts to hum. It's oddly comforting to my soul. I know he doesn't know the words, and I already told him twice that I can't talk while I am visualizing. My sister is six years old, so it hasn't been that long since he's done this but not with his own child. I get it.

Finally, the traffic breaks, and we make it to the front of the hospital. Daddy pulls up and tells me to go ahead and get out. Again, I give him the death eyes, and he gets out to get a wheelchair. At this point, the ice bottle is regular cold water, and I need to go to the bathroom again. Virgo shows up just in time to sit with me in the waiting room on the maternity floor at now 1:50 p.m. Perhaps I am handling these contractions too well because the Latina woman who came in after me ooohing and aahhing was just taken to the back. Is that what I need to do to get some help around here? After the fourth contraction, Virgo revisits the desk. His hand is purple and blue from holding mine during contractions. He reminds the receptionist that we've been waiting and that my contractions are now ninety seconds apart. I answer one million more of the same questions, and everyone should know by now that my last meal was fried chicken wings and watermelon. Every time I answer this question, I just shake my head. I'm owning the stereotype today.

Finally, I'm on the triage bed, and my mother walks in just in time to help me get undressed.

I know there is a reason why we have to go through this much pain but my Lord!

Mommy gets me undressed in between contractions and amniotic fluid dripping all over the floor and running down my legs at 2:15 p.m.

At this point, there is no such thing as discretion. My goal is to stop the pain by any means necessary. I refuse to

lie down in the bed fearing that they will believe I am comfortable and leave me here, so I try to look as uncomfortable as I feel, sitting with my feet dangling off the side of the bed.

"Mommy, please let me go to the bathroom."

I scream, "I have to go to the bathroom, and I need some drugs!"

The nurse runs in as my mom is trying to calm me down.

"I swear I'm about to go on this table! I need some damn drugs!"

"Hey, watch your mouth!" Mommy goes from comforting me to scolding me in seconds.

I just wish she would be quiet though. Stop praying out loud! Can't God hear quiet prayers? I would be able to handle these better if she were quiet, so I can concentrate.

Meanwhile, Virgo is getting ready to get put out if he says one more thing about the contraction paper.

"Oh, this is going to be a big one," he exclaims, watching the monitors of our son's heartbeat and my contractions.

"What you're not going to do is watch this piece of paper like it's the Indy 500!"

I rip the monitor paper out of his hand and accidentally make the paper jam in the machine, which starts the alarms going crazy!

Three nurses run in to see what the problem is. This may turn out to be a good plan after all.

Finally, someone can stick her hand up in there and check me.

"Oh my! What happened to your paper here?"

He looks at me, and I look back at him with the same eyes Daddy got in the truck.

"I'm so sorry. I accidentally tripped over it." Virgo testifies.

"Oh, no problem at all. See, all fixed!"

She begins to leave the room, and I exclaim again, "Can I please go to the bathroom? Can you please check me, ma'am? I need some drugs really bad. I can't take this pain anymore. It's coming too fast." I use the sweetest voice I could muster as the contraction Virgo was watching comes full force.

She agrees, and in her sweet, calm nurse voice says, "Oh, no worries. That is just your urge to push. Your baby is ready. I'm going to get the doctor, so don't push, okay? We have to get you in a room. You are fully dilated and 100 percent effaced."

Sweet, little nurse runs out to get me some immediate assistance.

All of a sudden, I'm quiet. Mom is quiet. Virgo is quiet. Everyone is quiet. Nothing but the baby's monitor paper being released from the machine, his heartbeat, and my pulse are heard for the next full minute. At the next contraction, the silence is broken.

"Mommy."

"Yes, Doll Baby."

"Get ready to catch this baby."

"Ashanti, she said don't push."

"I can't stop it; it's doing it by itself."

"Ashanti, stop pushing."

"I'm trying not to, but it feels right. My body is doing it on its own. I can't tell my body no anymore!"

"Are you having a contraction right now?"

"No ma'am."

"So, just breathe through it. Come on. I can't believe you're having the baby this fast. We just got here!"

I know I just got here. I am the one actually feeling all of the pain, by the way.

I look at Virgo, "You okay?"

"Yeah, I'm good."

"Ashanti, I'm not playing with you. You better not be pushing!" Mommy interjects.

The nurse wheels my triage bed into the delivery room, and I am absolutely not resisting the natural urges to evict this baby and his placenta from my womb. They roll me right by the baby bed and warmer, and there are so many lights on. An actual baby will be in there shortly, and he will come out of my body and be deposited into my arms to nurture for the rest of his life.

I guess it's show time now. Let's do this!

The doctor gives me instructions to push when I feel the next contraction. Mom is on the left leg, and Virgo is on the right.

"Push like you're having the bowel movement you've been asking for."

I think about giving my doctor the eyes for saying that, but instead, I join her team.

Praying that I would not take a dump on that table, I push, and his head pops out. I don't think the doctor was ready for that on the first push.

"Okay, give me one more, but I need this one to be slow and easy, okay?"

I bear down gently as the doctor suggests, feel a little pinch, and out he comes.

All Baby Virgo says is, "Oh my God" over and over again, and Mom praises God, of course.

"Hallelujah! He's breathing, and he's perfect. Thank you, Jesus. Thank you, God. My grandson is here. He looks just like his daddy, Ashanti. He's beautiful."

At 2:33 p.m., just two hours after leaving my doctor's office and the gas station, on August 15, 2000, I am a mother of a six-pound newborn who will need everything from me to survive. God, I thank You.

They wipe him off and put him on my breast. He immediately grabs for my skin and rests his hand on my heart. This

is really my baby. He knows it's me. He does look just like his daddy too.

Then out of nowhere, this lady comes over and puts her hands on my nipples and on his mouth. Like magic, he begins to suckle. How did he know to do that? He's only a minute old. Babies are amazing, and God made them amazing. I'm sure I will process her violating my personal space later, but for right now, I'm a mommy.

I know he isn't getting any milk yet, but his eyes open for the first time, and I am forever in love.

As I stare at him, I see the very birthmark that I dreamed about under his right eye. God has a way of speaking to me, and He will help me raise this baby. All of the anxieties instantly go away as I marvel in his beauty. He is a gorgeous baby. All the babies I know are wrinkled and ET-looking for the first few days, but this one is so gorgeous and not because he's mine. He keeps his big, brown eyes focused on me as I look at his head full of curly hair. Yes, he knows my voice for sure. I don't want to put him down. I get no sleep, and I refuse to let the nurses give him pacifiers or manufactured milk. I just want to hold him forever.

Because I was so concerned with the birth, I forgot to read the chapters way in the back about the placenta delivery and the contractions that come in order for my uterus to go back where it belongs. These are just as painful as the previous ones, and I am experiencing heavy bleeding and clotting right now. I haven't read about the tears in my perineum and

the stitches the doctor had to put down there to close things back up, but I did read extensively on nursing. Wednesday evening, I go to sleep with regular breasts, and by Thursday morning, motherhood is in full effect with liquid gold, as they say, overflowing.

Leaving the hospital is even more of an adventure than getting there. Why does it take so long for us to get a sign off to go home? The nurse gives me meds. It is two hours later, and I will need them again by noon, so they have two hours to get me out of here. Daddy has options of what vehicle to drive up here to get Quincy and me, but he decides that I need to step up into the big, red pickup truck. Daddy is something else. During the entire ride home, I truly believe he attempts to hit every single pothole. I ride in the back, sitting next to my baby strapped in his rear-facing, green and tan car seat. The milk is here, and my breasts are so large that I have to express some out just so he can get a good latch on and nurse. I think I'm getting used to this mommy thing pretty well. However, the nurses aren't going to be there to take him while I get a shower. Now, the real work begins.

Chapter 8

SEPTEMBER

After another hot, summer night with no sleep, I awaken to another soaked bed. The inevitable happens again. My thirteen day old firstborn lays next to me soaked also yet seems to not have a worry in the world. He even smiles every now and then. All I know is that the sweet aroma of my homemade mommy juice has soaked into another set of bed sheets. My milk is more than enough for this beautiful baby with brown ears. This lets me know he will also have brown skin.

I slowly slide out of bed while trying to keep the mattress still, so I don't wake him and can attempt to shower before he wakes up. When he doesn't smell me, he gets annoyed. I turn on the television to hear my favorite morning anchors report the local news. Today, there is almost a song in their speech as they announce a day that I've celebrated since I was four years old. I know this feeling of fresh starts and new beginnings, and I've experienced it for as long as I can remember. But this time it's different. It's uncomfortable. It's unsettling. For once, it doesn't include me.

After drying off in the shower, I notice that I'm out of breast pads. Breast pads are the lifeline of a new breastfeeding mommy. This isn't something I can send my daddy to get on his own. Not yet anyway. I need to get my own. Plus, I need to get out of this house, but that's pretty tough without a driver's license. I guess I need one now that I am someone's mother. I may not have received lots of breastfeeding supplies at my shower, but I sure did receive a decent amount of gift cards, which come in handy when you have no job. I pick up a Target gift card and prepare to leave the house for the first time without my newborn.

I pump a little milk for Mom to give the baby and pray she doesn't touch him. I don't think anyone should touch the baby. No one but me. I mean, I'm the mom! After carrying him for nine months back and forth across campus, to football games, and during student teaching, I'm a little protective. And if you need to touch him, your hands need to be washed, and you need to put on one of the t-shirts I have pre-washed in Dreft detergent. Just thinking about someone's germs on my baby makes me want to stay home all day! But she's my mom, so I know she won't hurt him as long as she doesn't touch him.

Dad and I are off to the local Target, and I'm finally breathing the outside air again. Even though I'm thinking about mom waking him just to see his big, brown eyes, I'm spending most of the time in silent reflection. Who knew that the highlight of my day would include attempting to take a shower or enjoying a meal while my baby sleeps? I don't even

look like I had a baby, and my body is even more gorgeous. I love the little weight I've gained all in the right places. I accomplish my mission at Target.

Next stop is back to my baby before she gives him a pacifier. On the way home it happens.

I see a vision that changes my mood for the whole day. I immediately feel cold inside, but that one teardrop was as hot as lava erupting from Mount Saint Helens.

I think we are still cool, but it passes me by like we never had a connection.

The sight of me didn't warrant a pause for quality time, not this morning.

It is a yellow school bus.

And that school bus signifies the first day of school. The first first day of school that I am not involved in. I am no one's teacher. I'm on no one's roll and just don't know what to do with myself. I feel like a single woman sitting at the table with a group of wives while they talk about their wedding day, which I have never experienced—lost. As my daddy continues to drive, the one hot tear rolling down my right cheek becomes an outpouring of months and months of fear, uncertainty, and embarrassment of being judged because of my belly. Everything I worked so hard for during four years, and I can't even be all that I ever wanted to be. He looks at me with concern that only I could recognize. To everyone else it resembles a scowl, but this daddy's girl knows he's worried.

Looking at me, the recent college graduate and his oldest daughter, he says, "Now, what's wrong with you?" I keep my head in my lap and sob uncontrollably.

I sit up long enough to yell, "It's a school bus!" and put my head back down. Then he says one phrase in an attempt to take my mind off of the matter at hand because I now have to shift to being annoyed with his response.

"Girl, you crazy just like yo' mama."

I can never figure out why I always have to be crazy whenever I show emotion, especially tears, but if he says I'm like my mother, then I take it as a compliment every time.

When I get home, I find my newborn baby mixed in with the other daycare children and dressed like he is going to the prom. I leave for twenty minutes, and this is what happens. I am prepared for that because Mom does whatever she wants to do. I scoop up my prince, my Target bag of nursing pads, and a bottle of water and head upstairs to our room for some quiet time. Upstairs, I see that Mommy has also straightened up our room and changed the soaked sheets. I don't mind being like her if this is what moms do. I may have been crazy that day, but one thing I know is that I have to get back in school as soon as possible. I'm a teacher.

LOVIN' YOU

Being a single mother at twenty-two with no job is definitely not what I planned for my future. I am a college graduate, the first in my family, but the rest of my plan is to become an elementary school teacher, and then to marry my high school sweetheart, Morgan Bear. Well, I graduated magna cum laude with a Bachelor of Arts degree in teacher education; that's for sure. Baby Q is such a great baby. I can't complain about my pregnancy. I declare it was easy, and labor was one for the books. I think I was in active labor for three hours tops. Three slight pushes and my love was born. It is important to me that his dad was there. I now realize that I can handle a lot of pain. Labor is usually excruciating, but mine was a series of uncomfortable abdominal pains. Pain is meant to be temporary. Something you get through. No one should live a life of pain.

Getting used to motherhood is a challenge indeed. Two months in and I have to take Baby Q for his first shots. He is gaining weight nicely with my mommy milk alone, and that is a gold star for me. I keep wondering if he is getting enough

milk because he keeps falling asleep on me but then won't let go. I'm a pacifier, the same pacifier I don't want my mother to give him. It's time for his shots now. In the doctor's office, I get the baby dressed while mom holds all of the immunization "this is how you know you need to call the doctor" papers. The nurse returns to the room.

"Okay, come on, baby. He needs to get his shots and give blood."

"Give blood? How is this little teeny baby going to hold his arm out to give blood?"

"Oh, no. We take it out of his heel, so take his sock off for me please."

My heart is racing in a way that I am familiar. "Take his socks off?"

My lips tingle, and I grab my chest gently. *Come on now; this can't be happening. I'm his mother, and I have to be strong for him. No anxiety allowed. Panic attacks must be on pause.*

I start my breathing exercises, and mom takes the baby. Baby Q screams and cries, so I excuse myself to get my breathing and visualizing intact. I can hear him screaming from the waiting room, and my breasts are burning and filling with milk. I feel like I have failed him. I can't even imagine being present for his circumcision. The nurse calls me back in, and I move quickly. He is swaddled and clinging to my mother with his eyes closed. I know he smells me because I didn't say a word, but he's moving his face full of tears to-

wards me. I immediately begin to unswaddle and nurse him. His familiar comfort arrives, and he holds on for dear life. He usually palms my breast like a bottle, but this time he grabs fistfuls of my shirt and pulls himself close to me. I receive his communication clearly. He needs physical contact to know everything is okay.

Now that the baby has his shots, I feel a bit more comfortable with him being out in the elements of the world. Virgo is still in college, a sophomore with freshmen credits. He is not my high school and college sweetheart, but my choice to make him my partner for life is evident. I want Baby Q to know his dad, his voice, his face, and his love, so I accompany his mother back to campus to see his father. On the way we talk about my plans.

"So, when are you thinking about going to work?"

"I don't want to start in the middle of the school year, so I will probably sub for a while. But when I do, I will need help with daycare and supplies for the baby."

"Well, he is in college and doesn't have a job."

"I understand that, but Baby Q can't wait three more years for him to finish to be able to receive support."

"Well, I'm going to do what I can to help you while he's in school."

"I appreciate that."

"And if those grades don't get any better, he'll be coming home anyway."

We laugh.

That won't be Baby Q's story. He will be responsible for his actions and know how to take care of a baby.

His daddy doesn't know the first thing about changing a baby.

We arrive on campus around noon, and most students are in the class learning, in the Soper Library researching, in the student center socializing, or in the refectory eating lunch. I'm not doing any of those things. Instead, I am checking for a potential poop diaper, so the new daddy can change it. This is going to be hilarious. Virgo's dorm room is on the seventh floor of the tower for male students. Baby Q is laying on his father's dorm bed. I don't help just so I can see what he knows. The baby's privates have been exposed two seconds too long. I move back, so I don't get hosed. Just like clockwork, Baby Q starts to enjoy the air a little too much and pees right on his dad. I laugh so hard, but not too loud. The RA did us a favor by letting the baby and me upstairs before 4 p.m. on a weekday, and I don't want to get him in trouble. We laugh, and I step in to provide some support.

"First, you need to get all of the supplies out of the bag before you take his diaper off." He pulls items out of the bag.

"No, you can put the lotion back; we don't need that right now." He proceeds to change the baby.

"Wait a minute. You must always keep one hand or the side of your body on the baby. He can't walk, but he can sure-

ly roll off this bed. Don't you drop my baby, Lee. Now, make sure there is no poop up his back. Lift him up like this. You're about to step in the poopy diaper. Pick that up."

"Okay, got it."

"That's good, but the taped part usually goes on the bottom. Wait. Was his penis up?"

"Um, it's down I think."

"Look, it's up. You have to put it down, or he'll get his clothes wet next time he pees. Start buttoning him back up at the top, or it gets messed up at the crotch."

"Okay and what do I do with this? Holding up the soiled diaper."

"I wouldn't put that in your trash can if I were you. Get the plastic bag out and tie it up."

After his crash course in diaper changing, we put Baby Q in the green and beige plaid car seat/stroller combo and take a short stroll on the way to the car to meet his mother.

"You still want to be an astronaut, right? You know how you love the stars and astrology."

"I do, but right now, I'm trying to focus on getting these classes done."

"How does your major even fit into aerospace anyway?"

"It doesn't, but I know I need a degree to get ahead, so that's the plan."

"Okay, well, let me know how I can help with that plan, okay?"

We approach the car, and his mom is waiting with his favorite fast food meal and something for me too. He looks at Baby Q and waves goodbye. No kisses, no hugs, no I love you. Just goodbye. He doesn't know how a man shows love to his son. He is named after his grandfather and gets very upset when asked about his own father. It's has to be tough not to be close to the person with whom you share genetic makeup. I thank the Lord I don't know that feeling. Even if my daddy doesn't kiss me, hug me, or tell me he loves me, he loves me, and I know it.

Of course, the band would be practicing as we pull off. I really want to go pass the band room, but the truth is I'm a bit embarrassed. Miss magna cum laude doesn't even have a job, but she has a baby. Plus, my first love is still there, and I haven't seen him in months. Today is not the day for re-uniting either. As we drive up Coldspring Lane, I smell the half smokes from the food truck and see students donning the orange and blue collegiate gear while walking across and hanging out on the infamous welcome bridge, where you are welcome to stand and socialize if you want to, but need to realize that you have to go to class in order to graduate.

Oh, how I miss college life! And to think I was extra pressed to graduate, so much so that I took an extra class at the community college two summers ago at home just to make sure I had all of my credits prior to student teaching.

Silly me. The people that have to stay an extra year, the ones I once looked down on, are the real MVPs. So much for my perspective.

An hour later, Grandma drops Baby Q and me off at home and gives me some cash and a case of water from the trunk.

"I know you're nursing and everything, so I won't make you get dehydrated out here in this heat. And I know diapers are expensive, so I will drop some Pampers and wipes off tomorrow, okay? Okay Q, be good for Mommy."

Again, no kisses, no hugs, no I love you's. I tell her thank you and go inside with the baby.

I get to my room and remember the diaper left in his father's dorm room, so I text him.

Don't forget the diaper.

No response.

Chapter 10

TEACH ME

I know all about babies and diaper changes. Mom's daycare has been open since 1995, just a few months after she delivered my baby sister at forty-six years old. Forty-six and having babies! That means she and my dad still . . . I don't even want to think about it. As a sixteen-year-old, everyone's big question as we walked in the mall was "How old is your baby?" After her birth, Mommy said goodbye to the corporate world and hello to raising her own child. Raising one became raising the nephews, and then the nephews' friends, and before we knew it, we were a fully functioning home daycare of twelve to fifteen children from infants to preschoolers.

Now, everyone loves Mrs. Helen, and while I am not working outside of the home, I am contributing to the household by helping out in the daycare. It's pretty cool. I read, teach, change diapers, and sometimes prepare food, but what I love the least is the door service. Something about taking the children to the door and having to answer one million questions and having to remember twice as many reminders for moms gets on my nerves. But I am grateful for the oppor-

tunity to serve and get a few dollars in my pocket. I have one parent who lets me grade her papers for a fee, and I gladly take her up on that offer whenever it is presented.

What I really need to do is go and apply as a substitute at my little sister's school until I am ready to go back full-time. This is a Christian school, so I don't even know if they will let me work there now that I have a baby out of wedlock. It's obvious that I engaged in premarital sex, even though everyone sins. I just don't know how to feel about being denied employment because I gave birth. I make no apologies for my baby, and if they can't see beyond my circumstances, then it is surely their loss.

I talked myself into going over to apply and am welcomed with open arms. Now that I have my learner's permit, I am unstoppable.

"We were wondering if you were going to consider working with us this year!"

"Why thank you, Reverend Wakefield. I recently graduated, and I don't want to lose momentum."

"Yes, your mother told me all about it."

"My mother?"

"Yes, she shared that you were a teacher looking for a job."

"Okay, thanks for sharing that with me."

"I hope I didn't go too far."

"No, you're fine. That's my mom for you. Always looking out for others."

Within a week, I substitute for my first class, a kindergarten class. I remember very quickly why I don't want to teach kindergarten. My throat is sore from counting down a zillion times, and I'm in need of a shower to wash off all of the coughs, sneezes, and more importantly, hugs. Kindergarteners must have a "touch the teacher" daily quota to meet because they touch me all day, and everyone knows I don't like to be touched. I do, however, enjoy the mastery of Bible scriptures. Next, I substitute for a third grade teacher. The students are seated and writing in journals. No one is shouting out, and nasty noses are to a minimum. This is my speed! I have never heard of a sword drill, but apparently, it is just as impressive as the spelling bee. My job is to prepare the students for tomorrow's sword drill.

So, what is a sword drill exactly? I read my notes and speak two words that have the fifteen third graders looking like they are ready for battle.

Swords ready!

Every single hand is up in the air with a closed Bible in the other hand.

I read the verse, Exodus 4:10, and the movement of pages resemble the sound of Nancy Kerrigan in her championship routine at the skating rink. It's like magic. One male student stands, and a few of his classmates sigh in disbelief while others continue to search for the scripture.

Why is he standing? I need to read the rules again apparently. Okay, I see now. I am supposed to allow him to read the verse aloud while the other students find it. I think it would be so much more effective if they all had the same Bibles, but no one asked my opinion. I'm just the sub.

If I ever get to teach, I want to start with third grade. My Mechanicsville second graders were not quite the right fit, but this seems like the sweet spot. After allowing me to practice the rules, the students separate into teams of two and duke it out. One round is boys against girls, and another is fall and winter versus spring and summer birthdays. After a few more drills, math workbook, chapel, lunch, and recess, it is time to depart. No sore throat today, and I think they enjoyed spending time with me.

"Ms. Bryant, can you come back tomorrow?"

"Uh, I think your teacher will be back tomorrow. I'm just the substitute for today."

"But we want you to be our teacher. You make the learning fun!"

"I will leave a great note about you for your teacher so hopefully she can request me next time too." They wave goodbye.

That day was confirmation that I was born to teach the youth. My burgundy dress and I hop into my loaner, burgundy Nissan Maxima and head home for the day. After spending time with the third grade class, I block off two weeks in

my busy schedule to attend driver's education school for a certain amount of clock hours. Dad has already taught me how to drive, so now I just need the hours and the test. Then Daddy can rest while I run my own errands as part of being a grown up.

I finally get my driver's license, which is not as big of a deal as I thought it would be. Being in class with fifteen-year-olds is different but whatever it takes—even at twenty-two. This gives me another expense, car insurance. Good thing I am substitute teaching, so I can afford it. One hundred dollars a month isn't too bad at all, and I am driving mom's 1986 Nissan Maxima, so I don't have a car note. Life is good.

At the end of the school year, I reach out to the private Christian school again, but this time as a potential candidate for the intermediate teacher vacancy. I am excited about the opportunity to officially get my teaching career in gear with my own classroom.

It has been twelve months since I gave birth to Q, and he is still nursing like it is his first day in the hospital, but he is advancing in his communication. Now, instead of crying, he just comes over to me and pats my breast, talking about "my milk."

Your milk? Boy, you have a few more months to use me as a pacifier, and it's over!

He is using me big time. I know this because he will eat a full meal, drink a sippy cup of milk, and then come and find

me, so he can use my body as a human pacifier. No more of that little man!

My application and interview prove to be successful, and a week after Baby Q's first birthday bash, my first day of full-time work as a third grade teacher begins. Goodbye breast pump, hello gradebook.

I always thought that working close to home would be fantastic because the school is less than a mile away from us. That is, until I underestimate the timing of the one light that separates my housing development from the church school just across the highway. I arrive two minutes late for my first day of work. Apparently, they start promptly here, and I miss the opening prayer. The speaker is already presenting, and if that's not the worst, the only seat available is directly behind my brand-new boss, the brand-new boss who is the reason I have the position because some board members believe I should not teach at their school because I have a child outside of marriage. And it gets worse. He writes my name down on his legal notepad. I'm mortified. What does it mean? Am I getting a write up? I have no idea what the rest of the meeting is about, focusing on how I will be punished for being late on my first day. As we prepare to break for the morning session, my boss stands.

"Before we break, I want to thank you for your engagement and being on time because that is important. I also want to take this opportunity to welcome Ashanti Bryant to

our school. I didn't want to forget again, so I wrote her name down on my notepad."

He wrote my name down because I was late for sure. But he also is a leader and understands grace. Forty percent of the people in the room clap. It just so happens to be that those applauders are also Black, and the anti-single mother teachers are not. From this point on, I know how to govern myself.

After day two of the pre-service week, I report to jury duty. Here is one more thing to add to the "I wish someone would've told me" list. You can request that your date be moved because you are a teacher. I know you can state that you are away in college because I did that, but I have to report this time. As the multi-tasking mommy that I am, I pack my bulletin board letters, construction paper, and scissors because I am told that I may be waiting a while, and my classroom must be ready for my thrilling third graders.

Hours go by, and it seems that everyone's number is being called but mine. We are allowed to break for lunch, and I visit the ever-popular Al's Country Kitchen that's in walking distance of my holding place in the courthouse. After devouring a ham and cheese sandwich with a tall glass of water and soup du jour, I stop by the bathroom and release some milk because I am a little uncomfortable. I no longer pump because Q's needs have shifted, and I really would like for him to be done nursing by Christmas altogether. Finally, my number is called. I get in line, answer a few more yeses and no's and end up being chosen for a jury.

This is only a test.

I can either stress out about not being able to be in my classroom again tomorrow, or I can come up with a plan. I choose to stress. This is not fair. It's my first classroom all to myself, and I can't even set it up! The sun falls and rises again, and I am back at the courthouse, spending the next three days deciding someone's fate based on evidence presented in court. I leave after the verdict is given—a mistrial—and head straight to the school. I arrive to see teachers in my room cleaning off desks and bringing in supplies. Completely shocked, I just cover my face in disbelief. I know I'm new, but teachers really work together. One teacher is putting a bulletin board up, and it is purple. That isn't my color scheme, but I appreciate her willingness and leave it up. Days leading up to the big event, my first day of school as a teacher, my best friends from Baltimore, Mommy and Daddy, come by to lend support by cutting, laminating, emailing, writing, and hanging posters. I think I'm ready for my thrilling third graders. The question is are they ready for me?

HERO

Being an elementary educator is what the regular person pictures when you think about teachers. They have colorful rooms, lunch tickets, backpack cubbies, and learning centers with door holders, teacher helpers, and phone answerers. Teacher appreciation week is like an elementary school teacher's Christmas, with Christmas and Valentine's Day running a tie for second place. What they don't talk about is the twenty minutes that you have to use the restroom and make just one phone call while your children are at a specialty class or the three colds you get each year from students sneezing and from touching a germy telephone throughout the year. They don't mention the various lesson plans that you have to prepare for each week because you teach five different subjects. Yes, teaching elementary school is a beast. Fortunately, I am handling all of these tasks with grace. It helps to only have twenty students, and the fact that their families pay for their education offers another layer of accountability on the part of the parent.

On the morning of September 11, my students had their special time at 8:45 a.m. which worked well for me because I finished making some copies for the rest of the day. I walk into an oddly quiet faculty lounge and see people crowded around the television. Their faces look like a catastrophe has occurred, and Ms. Thompson has tears rolling down her face. Something has happened, but I don't know what. As I look at the screen, the most horrific event that I've ever seen happens on live television. A huge plane flies directly into the already burning World Trade Center in New York City. The reverend begins to pray aloud, and everyone else is in shock. I don't know what to do or how to move, so I resort to the family plan. I pick up my cell phone and call my mom. Busy signal. Okay, let me try on the other line because she's probably trying to call me. Busy. The messages about high call volumes are making me increasingly nervous, and it is almost time for my children to come back from art class. The Pentagon has been attacked, and the feeling that is supposed to be evoked by terrorists is in full effect. The news is on pretty much every channel. My students' parents work at the Pentagon. What am I supposed to say or do?

A warning goes out for everyone to stay off of the subway lines because there are rumors that the next strike will be right here in D.C. Well, that is a problem because Baby Q's dad, who decided not to return to school after break, is working downtown, and that is his mode of transportation along with thousands of other commuters each day. A little after nine, I begin to leave the room and prepare for my stu-

dents' return, and another tower is hit. Running for your life has become reality for not only those in the building but also everyone in that area on the street. Within thirty minutes, families are picking up their children and signing out other people's children too. I have no idea what is going on at the neighboring public schools, but these parents are coming to get their babies if they can.

We are instructed not to share information about the attacks due to the sensitivity of work relationships in the Pentagon and not knowing all of the details. Without taking the bathroom break that I really need, I ask God for strength to be the teacher and make my kids feel safe. By 10 a.m., I have four students left. No questions are asked or answered. Then in comes that one parent.

"Why is everyone leaving early?" one student says aloud.

"Well, honey, some really bad people flew an airplane into the Pentagon, and lots of people are hurt."

"My uncle works at the Pentagon. Ms. Bryant, can you call my mom?"

I can't call anyone because the phone lines are tied up, and her uncle usually picks her up.

Thanks a lot, helpful parent.

I have to make sure she is confident that everything will be as God would have it to be.

Finally, her mother arrives. Whew! I dodged that bullet for now.

By 10:20, I am home in front of the television with my mother and holding my baby real tight. Mommy's daycare children have been picked up also, all but one, but he's family, so it's cool. I finally get a text from Baby Q's dad that he is safe. News reporters aren't talking; no one is talking.

From the comfort of my couch, watching people jump out of buildings in hopes of saving their lives, emergency personnel running to save others' lives, and people on the street covered in debris, I know that America has been under attack not just today but for a while now. Pulling off an orchestrated act of this magnitude had to take months or even years of planning, practicing, and waiting. But waiting for what? What was so significant about today? Additional reports come in about a plane crashing in West Virginia, and they say it was headed to the White House. Those people made the decision to die today to save our government. I don't know who they are, but hopefully, the world will know. My gratefulness turns to disbelief as the North Tower falls on live television. Live like the Emmys. Live like CNN World News report. Everyone is running. If I didn't know any better, I would think this is a movie. The way people are jumping out of these buildings and running through the streets covered with dust, soot, and building materials is unforgettable. I can't watch anymore. This is what they want. The whole idea of terrorism is to create fear of the unexpected and unknown, but I cannot continue to cycle more fear by watching more channels. My heart is so heavy for all of those families, police officers, emergency personnel workers, doctors, and

firefighters. Today, I gained an entirely fresh appreciation for first responders. I am unsure of what else will happen today, but one thing I know for sure is that life in the United States will never be the same.

I am definitely not the average teacher. I receive my checks every other week and put them on top of the fridge until Mom nags me to sign them and put them in the bank. What's the rush anyway? I have everything I need. In November, I took advantage of the low rates, and now I own my first car. It's a brand-new, silver 2002 Mazda Protege ES, just enough for me and Baby Q. Paying ninety-nine cents per gallon of gas is great because I can fill up my tank and get a meal with a twenty dollar bill. Most of my sorors are mostly teachers, and we spend the weekends driving up and down the east coast visiting universities as far away as Atlanta and Tuskegee. There is just something to be said about southern hospitality.

Serving as a teacher requires so many skills beyond the ability to transmit knowledge to a student. You have to be flexible, nurturing, communicative, and professional at all times.

My first parent confrontation came in the form of an insecure mom who didn't want me talking to her husband, so she picked up her child late every day instead of letting the husband come when she knew he could be on time just like I was told he did the year prior.

Another lesson I learned was to never assume that children live with or know their parents, particularly their moms. Once when a male student was acting up in class, I instructed

him to get his mother on the phone. He said she didn't have a phone number. Oh, I wasn't taking that disrespect either, so I gave him an ultimatum: call your mom or go to the office for demerits. He left, and I kept teaching. He never returned, and that was okay with me. At the end of the day, the principal came to alert me that he couldn't call his mom because his mom is deceased. He didn't want to be disrespectful, so he left the room. His aunt serves as his guardian. Needless to say, I won't be doing that again. I will say, "Get your guardian on the phone" instead.

In the spring of 2002, I see a familiar face in the nearby department store. It is Dr. White from my middle school days. She shares that she is opening a brand-new middle school in our neighborhood and wants me to teach there. Sounds cool, but I'm not ready to leave. I just got started at my current school. I will say, though, if I decide to leave, it would definitely be left better than I found it.

The rest of the school year is full of various opportunities for me to lead outside of the classroom. With my mother as the Parent Teacher Association president supporting her first grade daughter, we host a community business bazaar, the school's first Honor Roll Banquet, and cater the annual sports banquet in June. Spending time designing the yearbook, so the students can stay connected for years to come is my favorite pastime. Year one is in the books, and after comparing salaries, benefits, and the enticing smell of being in a new building, I made the decision to join the public school system for the next school year.

Chapter 12

LESSONS LEARNED

The month of June always brings extreme joy to my soul. Being a summer baby definitely has its perks. There is never school on my birthday, and I get to wear short skirts and dresses. June is also the month that I used to celebrate beginning the love affair with my Morgan Bear. After a chilled night with my alumni band friends, I decide to stay in Baltimore for the night while Baby Q is with my parents. As I wake up on the morning of June 15, 2002, many emotions begin to evolve into a whirlwind of reality. I was supposed to be getting married to the love of my life today. Instead, I am waking up in a bed that's not my own, preparing for a weekend alone. Friends for the night, no funny business, it was just right.

I text Morgan Bear to see if he remembers.

(singing) Do you know what today is?

I know. Crazy, right?

Yeah. I miss us.

He offers no response to that.

So, what do you have planned today?

Hanging out with some friends in Philly; that's about it.

Okay, well, I guess I will talk to you later then.

My strictly platonic metrosexual friend has already left. and I am all alone in his apartment, feeling uncomfortable because everything is in its place, not a speck of dust anywhere. I'm totally out of my messy element, so I pack up and head back to my city to hold my toddler tight. It was good while it lasted.

In the blink of an eye, the summer is over, and I am finally finished being broke. Teachers don't get paid in the summer, but babies still eat, cars still need gas and oil changes, and insurance fees must be paid. You won't have to worry about me ever being without a check again.

For new employees to the district, the school year begins with orientations for human resources, benefits, and our content area trainings. Sitting in the reading language training, I just happen to sit by one of the other new teachers in my school. This is a unique opportunity because everything is new, including the school building. There's new technology, books, teachers, and students, and the word on the street is that everyone wants to attend the new middle school and not the middle school with the more seasoned building and the twenty temporary classrooms lined up in the back of the campus. From numbering books to assembling students' desks, this event was truly an all hands on deck type of day. I

also added four more minutes to my daily commute. This is truly heaven, and my mileage on this car is awesome.

Soon the first day of school is here. Children are everywhere, but I'm ready for my class load of twenty-nine students ready to explore the world of reading and writing with me. Coming from nineteen students in private school, twenty-nine is a lot more kids, and they are a lot bigger as well. I am excited for my energy to meet their pre-adolescent energy. I believe my calling is middle school although I hated middle school. From the acne problems on my forehead to being teased every day for having big lips, eyes, and feet, I was over it. Keeping up with my menstrual cycle continued to be a mystery, especially because I started almost a year after my friends. They carried cute little purses, so I did too. Nothing was in mine but tissue, but you hadn't really grown up if you didn't wear a bra and have a period. They had an entire year or three to get it right, but when did I start? It was the very month I started my middle school massacre. Excellent. I watched everyone else have their first kiss in between the buses for dismissal, yet I never made it there nor did anyone invite me. My outer façade of self-confidence wouldn't allow others to see me break, but I was emotionally fragile—an entire mess.

It was in middle school that I learned to always have two writing utensils. I can't say much social studies was learned in the eighth grade. Middle school in the early 1990's meant sitting in rows alphabetically by last name. Some teachers got real fancy and made their rows into pairs. And there was my

social studies class which naturally had me in the front with a B last name. But just as middle school goes, adolescent behaviors prove to be unpredictable and challenging. In April, this teacher decided to switch my fellow B colleague and pair me with a young man with an M last name who could use a little motivation to stay on track with his behavior. It was a last attempt to maintain order in the classroom. I had the pleasure of being the "someone he isn't going to talk to." And that was true. Maybe he couldn't read, so he needed to be class clown and interrupt the instructional flow and not get outed by the others. He was never prepared for class and only carried a one subject spiral notebook that he somehow was able to roll up like a paper towel and put in his pocket. He literally went from class to class every day with nothing in his hands. Never a book, never a pen or pencil. Nothing. That's where I came in. Shortly after being reorganized to sit beside me and in the front of the class, he became motivated to copy from my paper. Well hell, at least he was writing something, but the problem was that I not only became the supplier for answers but also his need for closeness. He spoke eerily and softly in my ear the entire time. He had to whisper, sitting in the front, so he wasn't detected by the teacher. But he's too close. He keeps putting his thigh near my thigh and accidentally knocking his knee on mine.

"You know you are beautiful, right?"

Silent adjustments in my seat meant nothing to him. Maybe if I smile, he will know I heard him, and then he'll stop. Within the week, he advanced from knee knocks to

gentle pats from the back of his hand on the side of my thigh. I never told him to stop. I never said a word.

"Where's my pen?" he asked while slowly touching my thigh, trying to slide his hand away from where my pen could possibly be. Three weeks in and I understood that this is my assignment.

In silence, I give him a pen.

Every day after that, he'd request his pen in his way, and I obliged.

In silence.

I thought I was being smart and got there early enough to have it on his desk when he came in, so he wouldn't have to "ask me for it." That Tuesday, he picked up the pen, looked at the side of my face as I attempted to focus on my work, and put it back on my desk.

"I want you to give it to me. Now, may I have my pen?"

Silence.

I wondered if the row behind me ever saw him grope me daily for four weeks. I wondered if the teacher wondered why he was so quiet and studious all of a sudden. One day, near the end of the summer, I messed up and only had one pen. My first pen ran out of ink in my French class, the period before social studies with my permanent seat partner, which left me with only one . I had to make a choice, take a zero or let him find the pen that he's been trying to find all semester.

In the front row. In middle school. In front of the teacher. In silence.

You'd think I'd never want to set foot in another middle school, but the relationships formed there are for a lifetime, and I connect with the adolescent era in a way that draws me in and allows me to coach other children to live it like I should have: bold, confident, and with a voice.

My voice was nonexistent when it mattered. And no one will ever sit in silence. Not under my watch.

Chapter 13

SMELLS LIKE TEEN SPIRIT

My first year teaching public school was eventful. Somehow, I ended up with forty-four students the entire year and taught social studies and reading instead of just reading. Oh, I forgot to mention that I was also teaching both seventh and eighth grades. Talk about mega planning! I was also known staff-wide as the principal's pet. It makes sense because I was always the teacher's pet as a student, so you can look at the principal as the teacher of the entire building. It doesn't help that my face tells the truth even if my mouth doesn't or worse, stays silent. If she sent an email, I unconsciously nodded in agreement that it was received, and she would always look at me and finish her thought by saying, "Ashanti Bryant is shaking her head yes, so you received it. Thank you, Ashanti."

As an avid front seater in meetings, workshops, and classes, my neck had the privilege of receiving evil stares, eye rolls, and even a few sighs. They hated me for the moment, but they know I had them covered. I was good for resending emails to my people to make sure they make the deadlines. Winning my colleagues over was the easy part. Convincing

the parents that I wasn't another student and that I am fully capable of teaching their seventh and eighth graders was another story. Yearbook, step team, Student Government Association, and Parent Teacher Student Association were all of the committees I sponsored. It seems like a lot, but it's just me and Baby Q, so I welcome the opportunity.

And I loved every single moment, every moment except two. And they both involved parents. In one scenario, a student claimed that she turned in a project when she had not. I graded all of my projects with rubrics and gave feedback. She lied to her mom and said she completed it and turned it in, which turned into a request to get her child moved to a more seasoned teacher's class. It hurt me so much to lose students for any reason. I love being a teacher and building relationships with my students and their parents was essential.

The other incident was when a young man asked to go to the bathroom. The rule was that the last ten minutes and the first ten minutes of class all hallways must be clear. The rationale was that missing the opening and closing of the lesson can cause a disconnect of instruction. He asked to use the restroom, and of course, I said no because it was within the last ten minutes of school. I went on teaching the lesson, and during the afternoon announcements, one of the other students motioned to me to look on the floor under the young man's desk. I knew I was smelling something, but my kids came directly from PE before finishing their day with me, so who knew what smells would emerge from day to day. I guess he couldn't wait and relieved himself right there where he

sat. I dismissed the students a few minutes early and called for a cleanup. He stayed seated until the class was dismissed. I asked him if he had a change of clothes, and he said no. Duh, of course, he doesn't have a change of clothes; he's not in kindergarten! So, I contact his parents. I got him to the office, and the floor got cleaned up. Why didn't he just say that it was an emergency? Rough day. I completed the day and headed home.

As soon as I get home, I see an email with paragraphs. I'm a twenty-two-year-old teaching thirteen-year-olds, and this parent is furious with me. The parent ripped me an email also sending a copy to my principal. We had a meeting, and the parents had an opportunity to hear and see that I love their child and would never do anything malicious. The word says, "Let every man be swift to hear, slow to speak, slow to wrath, for the wrath of man does not produce the righteousness of God." Activating James 1:19-20 helped me to deny my desire to be offensive and to listen. While I listened, I learned that he had some previous experiences that made him not want to speak up or go against authority, so he didn't want to get in trouble. I didn't know that information about him and knowing it would have helped me engage with him differently. We were able to repair the relationship and build a parent-teacher partnership, and the fellow students were supportive throughout the process with the help of a reminder about the consequences that awaited anyone who had anything to say about it. After that, I asked students if their requests to go to the restroom was an emergency. No more wet floors.

On the bright side, on parent-teacher conference day, I met back up with a familiar physique who now serves as one of my young ladies' father. It was really him. I've only been to one adult entertainment establishment, and I'm pretty sure it was him, but as a professional, I kept it cool and to myself. That didn't last long because soon after he left, two other teachers apparently noticed him and came to let me know who he was. I acted like I didn't know and gave them the "I'm too young to know about that" look. If they only knew.

Right before November's parent-teacher conference came Halloween, and I was fearful for an entirely different reason. For three weeks, Lee Boyd Malvo and his adult predator created mass fear all over our region. His name will forever be etched into the history book as the D.C. Sniper who literally terrorized schools, hospitals, and law enforcement, preventing people from performing simple tasks like getting gas and washing their cars.

After the thirteen year old young man was shot going inside his school in my school district early in the spree on October 7, nothing but the blood of Jesus kept me from calling out and staying home. But I had to be strong for the children, so we walked in zig-zag formations, kept our windows and blinds closed, cancelled all field trips, and had permanent indoor recess until the snipers were caught. Every white van in town became suspect, and I know I kept my eyes on each one I saw. It turned out that it was a blue sedan that was used all along. After seventeen people were dead and eleven were wounded, life as we knew it became new again.

BLOCKBUSTER

One thing is crystal clear to me. I need to seize the day and make moves like never before because my life is not promised. To be honest, I have too much time on my hands. My sorority girlfriends and I love Atlanta, and although we are all teaching, we'd get off from work and hit I-95 South in a heartbeat! My mom has been talking to me about going back to graduate school, and my brother has been talking to my parents about staying in off-campus housing.

Little Joe is what my family calls him. He's five years younger than I am and decided to make Morgan State University his college home after me. Now that he has pledged his fraternity, he thinks he's ready for off-campus housing and spending more quality time with his girlfriend, Nicole. The only way my parents are going for that is if I'm there. I think he has grown out of terrorizing my company and doing gross things like eating snot to get attention or faking an asthma attack. So, maybe they are onto something.

Their offer is for my brother and me to live together in an apartment for one year which is enough time for him to

graduate from college and for me to complete a master's degree program. At first, I think of the idea as insane until I spoke to my former band director at Morgan State University where my brother is in the band fraternity and active in the drum line. He offered a graduate assistant opportunity where I can go to school full-time and work in the band room. Hold it. You mean I can go back to my college life and actually lift my nose up from a book to live it this time? Sign me up! I consult with my principal, and without tenure, I am unable to take a leave of absence, so I resigned.

My first public school year ends with parties and cards from my wonderful eighth graders as they leave and go on to the brand-new high school up the street. Quincy is turning two years old, and I'm planning to essentially live out of two homes. I have been accepted to the Master of Education program, and all of my classes are on Tuesdays and Thursdays, so I can be home with Q from Thursday night to Monday morning, work in the band room from Monday through Thursday, and study on Wednesdays. The schedule is set. We finally find a spot that I can manage in White Marsh, Maryland, and I have to turn over my child support checks to my mom for Quincy. He stayed, and I left. My brother and I rent a three-bedroom, so Q has his own room with a bunk bed and clothes when I bring him up for the weekend. All is well. Godmothers, both honorary and official, come and watch Q for me while I am in class when he refuses to go back home. When they aren't available, he becomes the quiet graduate student in the back of the room equipped with a goldfish

snack and a Leapfrog game with headphones. All is well. I follow the calendar, and the calendar stays consistent; therefore, I am consistent.

As a great fall and first semester of graduate school comes to an end, the band is in recess, and I have some idle time. A former band mate hits me up on AOL instant messenger. I respond, but I don't hang with younger fraternity brothers, so I'm a bit confused as to why he is engaging me. Chit-chat turns into a plan for a movie night with some fettuccine alfredo microwave meals and ice cream. Sure, why not? I love to eat, so bring it on. He arrives and puts the movie in the DVD player, but it won't work. The only other one I have is in my bedroom, so instead of unhooking all of those cords, we head upstairs to my room. Everyone is clear that I'm a leopard print lover by taking one look at my room. I have leopard bedding, rug, lamp shade, footstool, and bathroom accessories. It's already late when he arrives, and I'm sleepy. But let's just get the movie in, and he can roll out. At least the DVD player works. The room is not huge at all—just enough room for a queen bed, the dresser, and one nightstand, so the theatre seating is just going to have to be the bed.

And concerning my bed, I have rules. No street clothes on bedsheets. Period. I offer a towel, but just like most guys, he has on basketball shorts under his pants anyway. Cool. Let's watch this movie. My dozing off was met by gentle kisses on my lips awakening me. When I tell you I know nothing about this guy, I'm so serious. As I lay here, I am contemplating asking his little, fresh behind to leave. Then he says, "If

you fall asleep, I'm going to kiss you to wake you up." I try with all my might to stay awake, but my lids are so heavy. I can't do it.

The next night I fly to Miami to hang with my college bestie, Mel. Yup, she went from the space violator in 1996 to my confidante and protector. That's what the college experience can be for you if you allow it. She works for the Dolphins, and that should be all I need to say. Miami plus Mel and Ash equals a good time.

Another holiday and I am just realizing that something is not right. I picked up another job at my first school, the Christian school right across the street from where my parents live. I was just doing some substitute work on Fridays, but the superintendent was impressed, I assume, and created a role called Guidance and Career Counselor. I accept the offer, but it means that I need to work on the days that I thought I would be off. Getting up at 4:30 a.m. is wearing on my body, and it's only three weeks in. I'm working back home with a fifty-mile commute, working in the band room in the evenings, and pulling a full load of classes while juggling motherhood; I thought this life would be easier. Thank goodness Thanksgiving is coming this week.

Chapter 15

CONFESSIONS PART TWO

My brother and I are heading to North Carolina from Baltimore early on the Wednesday before Thanksgiving 2013, and I'm showering to get ready, but this shower brings back an unnerving memory. As the water hits my breasts, I scream from the pain of nature's droplets onto my supple skin. That was weird, but I continue to shower and moisturize before ultimately drying off. Was that a leftover droplet, or did that liquid just come from my breast? I'm clearly seeing things. I'm just tired, but my brother can't drive my car. He already fell asleep at the wheel and crashed his. On the five-hour trip, I stop at least ten times to use the bathroom, and on a rest break, I visit the menstrual calculator just to bring myself some relief. Lord help me! My cycle is already a week late! How in the world did I miss this? There is no way that I am pregnant. Even though that dollar store test I took this morning said positive, but there is a such thing as false positives, you know. And to be under as much stress as I am under, I'm bound to get a false positive. We didn't even have sex all the way anyway.

Now, this is a story to tell indeed. But I'm not going to tell it anymore because no one will believe that I conceived this child without intercourse. Hell, I'm not even sure if I totally believe it. But it is true.

I made it through Thanksgiving without making a peep and releasing a lot of pee. We arrive back in Maryland at my parents' house, and I work up the nerve to tell him about his new role as future father.

"Hey."

"Hey, how are you? I saw you weren't feeling well on the 5th Quarter."

"Yes, I'm still under the weather a little. Hey, you remember when you came over earlier this month?"

"Yes, what's up? Did I leave something at your place?"

"Well, sort of. I'm pregnant."

"Huh? But we didn't even . . ."

"I know, but I'm definitely pregnant, and I've been abstaining since Quincy was born so . . ."

"Wow! That's crazy," he says.

"So anyway, I'm just calling to let you know that I don't believe in abortions."

"I understand, Ashanti, but I just don't know what to say."

"As far as I'm concerned if we were going to get pregnant, we should have gone ahead and done it."

"I know, right? When are you back in town?"

"Tomorrow."

Before we head back to Baltimore the next morning, I have to figure out how I am going to break this news to my mother face-to-face. She is raising my first child half-time, while fully supporting me financially fifty miles away, yet I find a way to abstain and get pregnant anyway with this random encounter. I feel like setting my living room DVD player on fire even after my brother fixed it. It's a little too late for that. I'm having some cramping and spotting—a little different than when I was pregnant with Quincy, so I get concerned. Mom is in the kitchen separating the large order of North Carolina barbecue, coleslaw, collard greens, and side of hush puppies. I have a seat at the breakfast bar and start what I pray will be a productive, swift conversation.

"Is this enough for you, Joe, and Nicole?"

"I think so. Mommy, you ever had a miscarriage?"

"No, I haven't. Why?"

"I feel like I may be having one now."

"Well, do you want to go to the doctor?"

"No, I will just call first."

I didn't call though. I hoped that things would just work themselves out. That God's will would be done. Whatever God desires to happen at this point is what I am rooting for. I'm on God's side. I know my mom is thinking what in the hell is her problem. She probably thinks I am at school hav-

ing sex parties, but it's quite the opposite. I actually made a commitment to God that I want to say that I am still upholding but then that sounds crazy because there is a baby inside me that God didn't miraculously put there. She has no follow-up questions; therefore, I have no answers. Joe and I head up to Baltimore on Sunday afternoon in time for work and school the next day.

Chapter 16

JUDGMENT

Thanks to a few people who I thought I could confide in the whole world knows about the baby including the girlfriend of the baby's dad, who of course, I was told didn't even exist. This is getting rather messy, and I really don't want to be in Baltimore anymore. Important people let me down, and I will never trust them with my life again. I want us to be able to share the information in our own way not simply tossed in the rumor mill. We aren't pop culture; we are having a baby together.

The one person I do get to tell all on my own is the superintendent of the school. This is not public school, and we sign a document that is crystal clear about what we say we will and will not do. Having Quincy already as a single mother was a big deal, yet they accepted me anyway. Now, I am pregnant again. This time I run the risk of getting dismissed altogether. I schedule a meeting in early February to have this conversation because it isn't taking as long for me to poke as I did with Quincy plus this flu shot actually gave me the flu, so I'm extremely sick. I share office space with the music teacher

and mom of six, and I know she knows. It's just a matter of time before she asks me.

"Thank you for meeting with me today."

"Yes, I appreciate all of the work you're doing around the accreditation. I don't really know where we'd be without your knowledge and organization."

"Right. I wanted to be upfront with you because I know bringing me on as a single mother was a big step when I was here a few years ago, but I am currently expecting."

"Oh, wow! Congratulations. When are you due?"

"Not until the summer, but I'm going to start showing soon so, again, I wanted you to hear it from me first."

"So, what are your plans?"

"Well, I'm going to have the baby and probably move back home to raise my two children after our lease is up."

"If you are pregnant, when can you get married?"

"Marry the child's father? Oh, no. That's not an option at this time."

"Well, we can plan towards your last day as it gets closer. What do you plan to tell the children if they ask?"

"How about the truth? Many of their parents are single mothers or fathers. I don't have a disease; I made a choice. It's interesting to me that if I were the male in the situation and chose not to share this with you, you'd possibly never know, but because I carry the load physically, I have to go. This has

nothing to do with my ability to do good work. You've been pleased with my work, so please let's just keep this between us for now while I try to figure out my next steps."

I wear sweaters and layers, and coats are my favorite wardrobe items for the next five months until we reach June, the end of the year. They knew all along but respected my space and left it to be talked about when I was ready. My college roommate just had her first baby, and I'm next. The weekend prior, I took maternity photos at the one-hour picture place and wore my class ring on my ring finger. I can wear my ring on whatever finger I want, and since the photographer didn't ask, I went along with a left profile where my ring is shown in the photos. Everyone should take maternity photos. I felt so beautiful, and the pictures, wow! I know my body felt good. I'm made to carry babies, but my heart is alone, and I can't come back to this school next year because I chose to carry my son. At least with Q's dad, he came to the shower and was there for the birth. I got word from the now reunited girlfriend, as if they ever broke up, that she is the girlfriend and that is not his ring. Well, ma'am, I knew that already. I'm not interested in marrying the love of her life. I want to marry the love of my life, and he's not it. Our role is parent and parent, once he decides that's what he is. I'm clear.

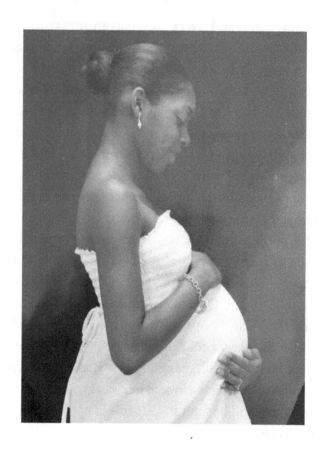

MY WAY

At our last faculty meeting in June, our superintendent gave me the floor with the intention of me apologizing for my sin and asking forgiveness from the all Christian staff of twenty which was comprised of no one under thirty-five and four out of twenty who look brown like me. With a well-defined belly and wearing a rainbow sweater over a blue, A-line dress, I take the floor graciously. Standing as only a true gazelle would, I hold my head up like I've been taught by my mother for the first time since finding out about the pregnancy.

"Thank you for giving me an opportunity to address the group. It has been an honor to work here with you all; however, I am moving on, and June 5th is my last day. I know great things will continue to happen here. I'm going to miss getting up at 4 a.m. to arrive here by 6 a.m. and working until noon then driving across the street to kiss my two-year-old. I look forward to hearing about you continuing to have the honor roll assemblies that I've instituted here. I hope that you keep letting the seniors have a dance and real senior trip like

I planned this year and that the college and career fair that I started will continue for the children.

"I also pray that you find the strength, courage, and wisdom to reunite with your wayward children, forgive yourselves for your past, and be honest with your children about their lineage when they do the math on your short wedding engagement that's eerily close to their birthday. It would also be wise to get on a path to healthier habits since we all know that prescription drug use beyond the illness is a problem. Since I have been here, more people at least nod and acknowledge my good morning greeting, and for that, I thank you because being ignored by your colleagues is a tough way to start the day. I pray that everyone has the opportunity to get to know someone beyond their circumstances and what you have been told to believe about them. I pray that your organization reaps the benefits of a renewed accreditation because I really worked hard on that too. I thank you for your support and look forward to seeing you all in the community. If I haven't said it already, thank you."

I take my seat without making eye contact with the superintendent. There are no claps only nods and red, sweaty faces also looking straight ahead. No eye contact. I thought I was going to cry. I didn't cry. He suggested I write a script, but I don't do scripts. I do words from the heart.

I will not apologize for being who I am, not being married, or keeping my baby. God has forgiven me, so I don't have to ask human beings who don't even like me to forgive

me. In that moment, God filled my heart with His love and His word that's in Psalm 130:4, "But with you there is forgiveness, so that we can, with reverence, serve you."

The fact that I was asked to do that shows that my work was done there, and it was time to move on anyway. I can only imagine what kind of grief the superintendent had to take on my behalf as I walked around with a silent belly that no one is talking about. I wonder how many times he's had to shut down conversations about me in the boardroom and from concerned parents or teachers.

Grateful for the experience, I pack up my car which takes only two trips. Then I am summoned back to the media center where the meeting was originally held. I'm in trouble now. I didn't apologize, and now I'm in big trouble. Well, here goes nothing. On the way in, my pregnancy nose kicks in and smells meatballs and potato salad way before I saw it. The announcement didn't stop my work sisters from throwing me a surprise baby shower in the library of the school on the same day. It was adorable.

The baby's name is Joshua, and in six more weeks, we get to meet face-to-face. It's amazing how the same room brought me so much angst is the same room where I was showered with love for the arrival of my second baby boy.

TO ZION

Several other baby showers later, it is time for me to see my prince. He is supposed to be another August baby, but he decides he wants to have his own month and represent the month of July all by himself! He is getting no complaints from me either. All pregnancy long, I have been boasting about how quickly I had Q, two pushes, and he was out—no drugs, just me. Determined to stay the course on this full moon weekend, I am sent home twice for false labor. I made a contract with myself that we aren't going back unless I feel like I need to push. They will not send me home again. That morning I sent Daddy to get orange juice and some castor oil to help things move along. I'm exhausted from just thinking about whether or not these very real contractions were going to amount to anything today.

Approaching the last day of the Cancer, moving right along into the land of the Leo, Wednesday, July 21, the moon is in full bloom, and I am ready to roll. Of course, Daddy has to take me this time too because Mommy has little people in her home daycare who don't drive. The problem is that by the

time we decide that we need to make the ride to Washington Hospital Center, Daddy is still not back from the store with my castor oil. When he walks in the door, I'm seated in the kitchen ready to go, bags and all. He walks into the kitchen and places the orange juice, castor oil, and the receipt on the table directly in front of me. Panting and blowing, I tell him it's time, and we should head to the hospital. You can tell when he's pissed about a store run because he puts the receipt beside it. In true night shift Daddy fashion, his response to my discomfort is, "So, you don't need this anymore, huh?"

This time the truck is gassed up, and by noon, we arrive at Washington Hospital Center to find out that yes, indeed, I am in active labor this time. However, so is the entire city it seems. There are no beds available in maternity or triage. This is something else. July 21, 2004 and it looks like my baby will be here in no time!

An hour later, we are transported to a makeshift area where they essentially put up partitions and rollaway beds into a hallway to make more spaces. This is insane, but I'm grateful for the opportunity to be able to finally lay my body down and get out of that wheelchair. By 4 p.m., my mother and father switch seats, and he heads back home with three year old Q and my baby sister, Maria, who is now nine years old. Based on Q's birth, I should be holding my baby by now, but all I have is increasing contractions with no relief in sight. I'm in a real room by dinner time, and Dr. Gillian, my doctor, comes in to check me every hour.

"I can give you something for the pain, you know. You are still at six centimeters. You have a ways to go still."

"I don't want any drugs."

"Okay then. I'll see you later."

I endure four more hours of sweat, pain, tears, and now hunger. Why won't he just come down and get ready. What is this? I have been in labor since Sunday, and now it's Wednesday and no baby. I want to just sleep it off, and I can with an epidural, but I'm scared. What if they hit the wrong spot, and I can never hold my baby again because I'm paralyzed? I'm not giving in. I owe it to myself to push through just like I pushed through with Q's birth. I can do this. I will do this. No drugs.

At the ten-hour mark, Dr. G and my mom help me understand that I won't be labeled a bad mom, and Jay won't hold it against me if I get some support with my pain for his delivery. But it's bigger than that. Throughout the entire pregnancy, I have been ridiculed and judged for having a baby with someone else's man and have had silent criticism daily as a Christian school educator. I owe it to myself to be able to endure this pain and see it through. But then I remember God promising me that He will never leave me nor forsake me, that He will never put more on me than I can bear, and that my faith must be in His promises and not what my eyes can see. He has forgiven me, yet I haven't forgiven myself. Yielding to the Holy Spirit and allowing logic to prevail, I call for an epidural at 10 p.m. The anesthesiologist is now my best

friend, and I'm laid back texting, laughing, and watching TV. Yes, now, I have allowed noise in the room. Angel and I are texting back and forth as band camp season approaches.

Did you call Jay's dad?

No, I didn't. I will call him when the baby is born.

Okay.

I don't need any added stress. My water is broken for me at 11 p.m. Even though I am comfortable, the labor is not progressing. Great, it's time to get the party started but not for another two hours. Well, I guess his birthday wasn't going to be July 21st after all because seven minutes after midnight and three good pushes that I couldn't even feel, he is here. And thank the Almighty God for that epidural and being numb from the waist down because he came out fighting with both fists on the side of his face. No wonder he took so long to get himself together! Fists by the face my body can handle, but elbows beside the torso altered my body in a manner that required three degrees of stitches.

But God is faithful. Since I labored in the hallway, obviously, there are no more mommy and baby rooms left. But God showed Himself mighty once again. Did you know that there is a secret wing for important people where all of the attendants wear white from head to toe? It's a place that is on the same floor as the regular rooms but nothing like I have ever seen before. My seven-pound, seven-ounce son was born seven minutes after midnight in the seventh month of

the year, and I was escorted to a luxury postpartum room that looked just like our apartment. A family could live in here easily. Even the light shines on you differently; it's not just on or off. It's shades of lighting. The television is huge, and the food . . .! Who knew about this place? I heard God say to me, "You will be honored for giving this child a life, and even if it's only you and Me, I am enough." He told me to let go of the guilt and shame. He said, "Give Me your sorrow, for this child you call Joshua will lead nations. I chose you to be his mother. You are fearfully and wonderfully made. I've already died for your sins. You are no longer on the hook."

I cried the entire night while holding my love child. He's the most beautiful, light-skinned, pink lipped little boy. I think he may stay with a lighter skin tone like his father based on the edges of his ears and creases of his nose, at least that's how I was taught to see it.

There are two more sunrises and sunsets and still no appearance from his father. He said he was coming on Saturday but no sign. His circumcision is done, and it is time to leave and be a family of three: Me, Q, and Jay. Before we leave, the nurse in the hospital guides me through a few documents.

"Make sure he signs this part, and you have to get it notarized because you're not married. If you don't, he won't be on the birth certificate. Some fathers refuse to sign you know."

"Why would he refuse to sign? It's his baby."

"I've seen a husband see the baby and refuse to sign when it was his baby too. I'm just telling you what may happen, honey."

"I appreciate that. Thank you. I don't anticipate that problem. He looks just like his dad."

Chapter 19

DNA

Why does the discharge process take so long? My baby and I have been ready to go home, and I had my last meds at 8 a.m. So, if I'm out of here by noon, then we are good once Daddy gets my prescription. Doc says I don't want to know the pain from my laceration down there. I still don't know what a "husband stitch" is, but she asked me if I wanted one, so I just said yes. If the doctor is offering it, then it must be recommended. I've never had perineal tears and wouldn't wish it on my worst enemy. Well, maybe just one. By 11 a.m., we finally get the paperwork to leave. Daddy comes back to get me in the famous big, red truck even though I asked him to drive my car, so I wouldn't have to do too much climbing up and down in the pickup truck. Sometimes, men just don't get it. The plan was that he would drop me off at home with the baby, and then go to the pharmacy to get my meds before the noon hour pain approaches.

He hits every bump during the commute back to the suburbs of Prince George's County, Maryland. The thirty-minute commute wasn't short enough. At home, Mommy takes

the baby in, and I crawl up the stairs to my room. Dad drives off as we closed the door behind us, and that is a good thing. He is working according to the plan for once! Quincy was already in bed taking a nap, so I laid quietly beside him with Jay. Daddy better hurry. About twenty minutes after laying down, Mom comes to the bedroom door.

"Ashanti, he's here."

"Okay. Tell him to bring the medicine up please. I'm in pain."

"No, I mean Jay's father."

"What? How does he know where I live, and did you call him? How does he know I'm home?"

"Get dressed and come down please. Do you want me to take the baby?"

"My baby? No. I carried him this long, I know how to carry my own son."

"Okay. Please be nice."

"He just shows up unannounced after not coming to the hospital, and you want me to be nice?"

Lord, please give me the strength to do this for Jay and take me and my hurt out of the equation.

He greets my mom and then turns to me.

"How are you feeling?"

"I have significant tearing, so I'm in pain, but other than that, I'm okay."

I sit on the back wall with Jay in my arms, while his new grandmother is to my left with her back to the sun. My mother is directly across the room from me probably so she can make eyes at me when I get out of pocket. And to my right sits his father in the oversized chair facing the sun.

Small talk about deliveries and how big Jay's dad was filled the first five minutes of the visit orchestrated by the mothers. Mom motions to take the baby from me and give him to his dad.

"You want to hold him, son?"

"Yes, I do. Thank you."

After ten more minutes of conversation, I'm getting quite annoyed, and the pain sets in even more with the repositioning of my body on the couch. I can't cuss, so I have to move to get my emotions in check. I want to say, where were you, why didn't you come, or who told you not to come? But at this point, who cares? You didn't come, and that will never change in anyone's story.

Mom gets the paternity papers out of my bag that's still sitting at the front door since our arrival less than an hour before.

"Here is the paper they need you to sign to say you are the father, so he can get his birth certificate and health benefits." Mom gives the papers to my guest of honor, while his mom motions to get the baby. If it was not for the mothers, this entire encounter would be going another way if it were up to me.

"Absolutely. Let me take the baby, so you can sign the papers, son."

"Oh, wow! This is you. Look at those lips! He's beautiful, Ashanti." She's in love. Her first grandson, and she sees her son as a baby in this child. It was nice for her to say that even though I think he has my lips. They are big and beautiful. Yup, those are mama's lips.

I don't know whether to say thank you or what. I'm in pain, and this third-degree tear is throbbing. While she is cooing with Jay who now has his eyes open, I also see that he is looking at the back of the page but isn't reading it. I'm a teacher; I know what fake reading looks like, and he's doing it as the sun and his son both stare him in the face.

"Go ahead and sign. What are you waiting for, son?" His mom asks him.

"Um, I want to get a test done first."

A test? Who invited him anyway? He couldn't even come to the hospital to see his own son! How can you let someone talk you into not coming to visit the woman who carried your baby and made you a father? Or is someone helping you think that you aren't a father at all?

I take the baby from his mother. Pain or no pain, the baby and I were back on the steps on the way back to my room to rest within five seconds.

"Goodnight all. My son and I need our rest."

"What about the Pampers and all the stuff?" he says.

"Give them to your child since this one isn't it. Take everything with you! We don't need it!"

Upstairs, I put Jay across my lap and begin searching for the nearest DNA place. I don't have time for foolishness. If he would have just left me alone that night in the first place and let me sleep, we wouldn't be in this position. My pain medicine is wearing off, and Daddy needs to hurry up and bring my medicine for the night. Mom comes into the room and sits on the side of the bed.

"Ashanti, what is he talking about?"

"Mom, I have no idea. Jay is his baby. He looks just like him, and even if he didn't, he is the father."

"Why did he take you out for Mother's Day and do all of that if he was concerned that he wasn't the father?"

"I can't explain his motives to you; I don't even know him like that, but I already made an appointment to take Jay in tomorrow to get tested."

"What? How are you going to get there?"

"I'm going to get in my car and drive my son and me to the doctor's office to get this test."

"Ashanti, you were just released from the hospital, and the tear you have down there needs rest in order to repair. You don't want to bust your stitches. Believe me!"

"Mom, I'm going, and I'm going alone. Please tell Daddy to give me my medicine. I'm in pain, and it's 1 p.m. already."

She goes and comes back with a bottle of water and a bottle of over-the-counter Motrin.

"What is this?"

"Don't get mad, but your dad dropped off the prescription and came back home because they said it wasn't ready. He's going back to get it now."

Tears are all I have at this point. Thank God Q is still asleep. There is no way, but if I could, I'd drive to get it myself. I need practice for my drive in the morning anyway.

On the morning after our first night home, I leave home around 9 a.m. to arrive at the agency by 10 a.m. My six day old baby goes down in history as the youngest baby ever swabbed at that facility. He can't even fully open his mouth, but we did it. After our pictures were taken and paperwork signed, the attendant has us back on our way. I cried all the way home, tears of anger, tears of faith, and tears from the pain of the perineal tear from labor just a few days prior. Mom meets us outside and grabs the baby. Daddy helps me in the house, and I can't even make it up the stairs without stopping at every step. The constant, radiating pain progresses until I nurse Jay, and I fall asleep. I know I shouldn't have taken them, but I needed three pills at that point. Twenty-four hundred milligrams could kill me, but at the time, I was willing to take the risk.

Three weeks later, after returning from the store for more nursing pads and diapers, I meet the mailman outside of the house. As he hands me the stack of envelopes, I spot a letter

from DNA Diagnostics. This is the letter he has been waiting for, and my copy has arrived. On the way to my bedroom, I stop by mom's room.

"Here you go."

"What's that?"

"It's the DNA test."

"Well, aren't you going to open it?"

"For what? I already know the answer, and I already told you who the father is, but you can open it if you need to."

I leave mom's room with the envelope still in her hand.

Nursing Jay is always an adventure. He can never handle the let down and chokes on the strong flow of milk every single time! This feeding was no different. As I clean off his face which had just been sprayed with liquid gold, Mom enters the room with the envelope.

"Did you get your answer?"

"I wanted to tell you that I believe you, and I don't need to open it. I apologize if you felt like I was questioning what you already told us. I just couldn't figure out why he would come all the way over here to hold him, and then deny him."

"I accept your apology. Can you get the light? We're getting ready for a nap."

"Okay, but where do you want me to put this envelope?"

"Right there on the dresser. I will put it in the fireproof box just in case there are any more questions."

"Okay. Enjoy your nap, and I love you." She kisses me on the forehead. She knows I'm not in the mood.

I awaken to a text message on my phone from the father asking when he can come over to see his son. Not please forgive me for purposely not coming to the hospital to see my son after he was born. Not please forgive me for coming to your house unannounced. And it clearly is not an apology for doubting me in the first place. I guess he received his letter also. August 15th, he became the official father of a three-week-old.

Chapter 20

WELCOME TO THE JUNGLE

My plan to enjoy my time with Jay while helping mom out in the daycare comes to a screeching halt when Doc, my middle school principal, called and let me know that a position was available which is cool because my initial plan to stay home for a year with the baby is not working out. I need to get my own place. With two boys, we need space in this room, and Mom and Dad support it, which means the most. The problem is that I can't live just anywhere; I have to live in luxury and be close enough to my mom and daddy. But Jay's so little. How do people leave babies this young with people they don't really know? I praise God that I will never know that life. As long as Mrs. Helen is alive, she will raise her grandbabies.

Uncertainty and guilt are running through my veins. I have two major concerns: how am I going to pump all of this milk for the baby, and what in the world am I walking into? I'm truly sad to leave my baby, almost in pain to separate from his closeness, but I know that going back to work will help us maintain the level of income that we need. Mommy and Daddy are extremely supportive, but sometimes I don't

like being told what to do and how to spend my money. It is time for me to be a mother of two in my own home.

By October, I'm back to work, and it's both exciting and weird. My first day is not their first day, and I've never had to take my pump outside of the house, but hey, here goes something. The first person I meet is my assistant principal, Shin.

"Hey, Shin. Where's Doc?"

"Oh, she didn't tell you?"

"Tell me what?"

"She's retired."

"What do you mean she's retired? She never said that. She didn't say she was here, but she . . . Okay, so who's the principal then, and can you show me my room?"

"Here you are!" It's upstairs and doesn't have a window; this is becoming a thing I see. I need sunlight, but no one wants to assign me a room with a window.

"Here is the class list and let me know if you need anything."

"I know I'm going to need to pump because the baby is only three months old."

"We don't have a mother's room, but you can always lock your door and put something over it."

"Okay, I will do that. Who do I see to get the key?"

"I will have it to you by lunchtime."

The children are different than the ones I left. Two years ago, I didn't hear cursing in the halls, running in the halls, and kids out of class. Is this what school is about now? I heard they've had several subs that they worked hard to run out of here. But they don't know me. I was born for this.

After two classes, it is lunchtime, and although the rest of the kids are all over the place, I attempt to get mine in line to go to lunch. No one told me that the kids walk themselves, and when I left, we were walking them to and from lunch, so in line they go, all twenty-eight of them. One or two said they had lunch detention with a team teacher and had to report back upstairs with their lunch.

I really don't care what these kids do, and I'm not keeping anyone back from lunch. This is my time to unwind. With fifteen minutes left, I only have time to make liquid gold. I still have no key, but the kids are at lunch, and it's quiet up here with no windows at all. If I position myself behind my desktop computer on my teacher table, no one will see what I am doing or that I'm even in here, especially with the lights off. The comforting sound of the suction almost puts me to sleep five minutes in. I haven't gone this long without pumping, and I can't do it anymore or my milk supply will decrease, and we can't have that. Jay's dad does help out financially but not enough to pay for something that my body naturally makes. Thank You, Jesus, for getting me this far. It's almost done with five minutes left to go when I feel something tickling my legs. Lord, if this is a mouse, I can't work here anymore. I don't do worms, birds, or mice. I know they are an important part of

the life cycle, but no thanks. No mouse is that far up my leg though. I look under the desk, and it's one of the students who said they had lunch detention. Now, I'm mad because one of the very full six-ounce bottles spilled into the trash can! I scold him and call the front office for support. Five minutes after picking up the kids from lunch and getting settled, he's back in class. Really? Did anyone even talk to him? I'm mortified, and he knows it. I love all kids, but I'm going to need some time to get through this day. On my way home, I head out with the buses. Wrong move. It's a pretty warm October, and my windows are down just enough to catch a full soda can to the face and an unsharpened pencil to the side of my eye.

That night I had to do some serious soul searching about whether or not this was really the career for me. A good shower helps me relax, so I hopped in the warmest shower possible and washed the day off. I rock Quincy and nurse Jay at the same time, and as I relax, the goals become clear. I will not be defeated. This is not a war against the children but a war against the spirit, and God and I will win. He promised.

We find a place we like just a mile from Mommy and Daddy with a gated entry and other important security measures that Mom likes. The boys will have their own room, and I will also. It's a beautiful place—third floor and enough for the three of us. After a year or so here, we should be ready to purchase something of our own. For now, it is the silver Mazda, my two boys, and me.

Life is good right now. I'm the mom who does what it takes to give her children what they need. A relationship between a father and his son is like no other and can never be replaced. Jay's dad is stationed in Dover, and he really wants to see his son, so it's off to Delaware for the weekend for the two of us. Visiting with him helps me prepare for his visits away from home without me. I know that it has to happen and that he deserves his time, but that's my precious baby. I carried him, and I nurse him. I know the meaning of every cry and how to make it all better. I guess he can learn.

Jay has regular visitation with his dad, and he is supporting him financially. Everything is starting to smooth out for us a little more by November. His mother volunteers to host his baby blessing reception at their house, which I obliged. Everyone is at the baby blessing at my church, but somehow when it's time to go to the reception, the list drops down to Jay and me. They are really sending me to these strange people's house by myself. Jay and I are there for about two hours that evening before it starts to snow. I'm not trying to get stuck here, so we get in the car to combat the worst storm, and my cell phone power is failing. It takes me two hours to get home, praying that I am in the correct lanes and trying to keep my windshield clear. No one called that night to check on us. Not Jay's dad. No one. But as they say, "as long as I got King Jesus, I don't need nobody else."

Both Jay's dad and Quincy's dad visit their boys on a schedule which gives me a little more time to complete graduate classwork and lesson plans for my middle school

students. We are comfortable in our own space, and the finances are working in my favor. And the students! Well, my sixteen year old eighth grader actually participated in class. My favorite unit to teach is poetry, and my students were really into it. Now, the haikus were a bit inappropriate, but the rules are that they had to follow the seven-five-seven syllabic sequence and write about nature. I never said they had to be appropriate, and they remind me of that. I didn't think I had to say that, but I should have. When my sixteen-year-old raises his hand to share, I'm shocked. He even wants to come up to the front of the room. Pleasantly surprised, I move to the side, but he asks me to stay.

"And what is the title of your poem?"

"The name of my poem is Coconuts."

"Okay, great. Go ahead and begin."

"Big round coconuts are sweet,

They make me so weak,

To rub the furry brown coconuts."

The students clap, and we confirm the syllables when he reads it again.

It is not a coincidence that I am wearing a coconut brown chenille sweater that day.

I simply thank him for sharing because the audience does not get the correlation.

He received a passing grade that day. The glass was half-full that day.

Two months back to work and it's finally our very first Christmas in our own home. Jay and Quincy are enjoying all of their gifts that they received from the grandparents, including train sets and a walker for Jay. There's more stuff to fill up my two-bedroom apartment. As I'm logging on to one of my very favorite websites, The5thquarter.com, I see that Jay's dad is getting married, and I'm instantly excited for him. Inside, though, I feel envious of their love and want it with my Morgan Bear. I should've been married, and the fact that he's a great dad to Jay makes me glad he will be in our lives. I send the bride-to-be a congratulatory email, but she doesn't respond, nor did I need her to.

WE CAN'T BE FRIENDS

I decide to end my year at church like I've done in the previous years. The boys and I go to New Year's Eve service, have a great time, and go home. Days after the New Year's service, my church always has a revival. This time, I'm going to revival with my Morgan Bear. He and I have a standing appointment, and I will not disappoint him going into 2005. Worshipping with my best friend after all we've been through is the best, especially because we are spending a considerable amount of time trying to figure out what the T.D. in T.D. Jakes's name stands for.

"Thomas Davis."

"Nah, he looks like a Theodore Deontae."

"They didn't have the name Deontae back then."

"Okay, okay. What about Deuteronomy? That's in the Bible."

"You are a mess. You know that?"

"Yup, I do."

After revival, on the way home, we talk about going to the Honda Battle of the Bands together. This would be an awesome opportunity for me to get out of the house and to spend more time reconnecting with him. We make the plans, set the date, and in a few weeks, we'll be on our way to Atlanta to celebrate with marching band communities from all over the country.

I'm so excited to be able to spend this time with him, and my desire is for us to be together once again. What we weren't ready for was the ice storm that hit the city like a brick. Not only were we not able to go to the Honda Battle of the Bands because it was postponed until the next day, but we were also stuck in our hotel. The time we spend together is precious, but I know that the time will have to end eventually, so I do not allow myself to get too emotionally invested, but physically, absolutely.

After sliding up and down the hill from the Residence Inn Marriott hotel to the Hard Rock Cafe, we decide that it's time to go home. Danielle, Rob, Morgan Bear, and I make our way to the airport to get back to life now that I'm fully invested into finishing my master's degree at Bowie State University. I'm also starting to fall back in love with my Morgan Bear, like I ever left it, but this time, I don't feel the connection back from him. I keep calling him asking him when he's coming over for dinner. He keeps saying that he has class, he has a study group, or he's not able to make it, for over a week. My woman's intuition is telling me that there's somebody else in his life, but he definitely told me that he loves me when we

were in Atlanta, and I believe him. This time what I'm not going to do is what we've done in the past and not talk about it. So, tonight I'm going to talk about it. It's too close to Valentine's Day to get overemotional and caught up.

"Hey. I'm glad you finally picked up. It's been two weeks since we've been back, and I haven't seen you yet!"

"Yeah, I was pretty busy, but what's up?"

As I sit on my kitchen floor cleaning up some noodles I spilled earlier in the day, I start to talk to him just as if he's in front of me.

"I don't know. I just feel like you're kind of distant and not really wanting to spend time with me. What's going on?"

"I mean I don't really know what you mean. I work, and then I go to school full-time, so I'm just busy."

"Okay. I want to know one thing, and it's either yes or no, okay?"

"Okay."

"Are you seeing someone else?"

The long pause lasted about five seconds. This type of pause is extremely familiar to us unfortunately. He finally spoke.

"Yes, I'm seeing someone."

"Exclusively?"

"I don't know what you call exclusive."

"Would she be upset about Atlanta kind of exclusive?"

"Then, yes."

"Well, if you had a girlfriend why did we do all the things that we did in Atlanta? Why did you even want to go with me in the first place?"

"I wanted to go with you because I love you, Ashanti, and I wanted us to spend time together. I just didn't know what to do or what to say, so I did what I know best and that was to love you back."

"Okay. But you know what type of situation I'm in, and you know that I have recommitted myself and my body to God. Why would you put me in a situation like that knowing that ultimately you won't even be able to be with me because you have a girlfriend? I'm the one with two kids. I'm the one who is vulnerable, and I'm the one who was saving myself for my husband thinking, yet again, that we could be together, and now I'm messed up. Again."

Again, there's a few seconds of silence.

"So, you don't have anything to say about that?"

I know he isn't crying again. It's old now and hanging up in his face is feeling really good right now.

"I don't know why I just keep hurting you over and over again, but I'm sorry this time."

But sorry wasn't good enough for me. I said my goodbye forever, and I hung up the phone.

I got in my bed and cried and cried, and at that moment, I decided I will never allow another man to deter me from my

commitment that I made to God because God is the One who is holding my hand. God is the One who is helping me and my children, so God is the One who I need to be faithful to.

Morgan Bear calls several times during the course of the night, but I decide not to answer because I already have the answer. He has a girlfriend, and that's the end of the story. We don't need to talk anymore. Anything that he has of mine can be dropped off at my parents. I no longer want to talk anymore. We have been going back and forth and in and out of each other's lives for over five years now. If it were meant to be, it would be. And it isn't, so I am breaking the cycle. I love him enough to leave him alone and not allow my memories to control my future love life. Or I am just mad enough to think I can anyway.

Chapter 22

NO MORE DRAMA

No man no longer has permission to violate, lie to, finesse, or caress me. I am no longer available to disrespect my God who has been so good to me by disobeying His word. I'm so done until God sends me a husband. Anything else is just passing time. My boys are watching me, and to date, every man who has entered my life and between my legs has failed me. Done.

I have too much going on anyway with the boys and school. I only have eight more classes before I finish at Bowie State University. Thank God they accepted my credits from Morgan State, so nothing is going to stop me this time.

The only thing I have time to do is work and check out the 5thQuarter.com. Now that I've graduated college and left campus for real this time, I get my marching band fix and social needs met by hanging out virtually with my friends all over the band world. In 2004 when I went to Honda with my sorority baby sister, Dani, I was pregnant with Jay. The 5thQuarter founders, Christy and Mike Lee, threw a cool event where bandheads, as we are affectionately called, ate great cake and spoke loudly about whose band was the best.

Once a band fan always a band fan. My screenname is Teacher Mommy. No hidden meanings there—I'm a teacher and certainly a mommy. Everybody who is anybody in the band world is on the The5th, and it's live from 6 a.m. to 6 a.m., 24 and 7.

It's April, three months after seeing everyone face-to-face in Atlanta for the Honda BOTB. Right now, I'm knee deep in my master's degree studies and about to win the semester with a 4.0 while also taking classes at church to work on my spiritual growth as a woman of God. One night I get a message from Christy telling me that one of the guys on the site likes me. Now, this can only go one way, so I direct message her back.

Christy, I'm not interested in men anymore, specifically band brothers.

Girl, what?

No, not like that—I'm not that mad at them! lol

Well, he wanted me to let you know he is interested.

Doesn't he have a mouth?

I'm just being a good friend. Don't you remember? I introduced you to him at the Great Cake event last January.

Christy, I was pregnant with Jay at the time, and I don't remember that introduction anyway.

Well, the message has been sent.

Yes, it has.

Hours later towards the evening, he sends me his first direct message. I'm not going to ever meet anyone worth marrying on the internet. That's creepy, and he's weird for doing that. What if I was crazy? What if he is a murderer? I have children. What if he can hack into my computer and see everything I'm doing? The message sits there for another seven days until I finally respond. While he waited, every time I made a comment on a post about anything, he's not too far behind also posting after me and saying how he agrees with me. Sir, I see you.

I finally answered back and gave him my number, but he didn't call me for another week, which was a bit attractive, but I'm still not interested. He doesn't mind waiting I see. The night he called we talked for eight hours straight. He has a voice like a radio announcer which makes sense because he is Norfolk State's marching band announcer and photographer. He's smooth, and he comes from good stock. His daddy is a preacher and so is his stepmom who helped raise him since he was twelve. He's the baby of the family, number six. I always wanted a big family. Everyone already knows I have two children with two different fathers, so what does he want with me? Could this be that this is my first male friend who isn't trying to "get to know me better." I doubt it. He's too fine not to be trying to holler at me physically. He's too far away to be considered anyway, so I'll just play along. Why not? Classes are almost over, and I need something to do to occupy my time.

Chapter 23

NOBODY'S SUPPOSED TO BE HERE

During the first week of May, I receive an email asking, "What do I have to do to become your Teacher Daddy?" Oh, that's real cute. Let's play.

Well, first you should probably apply for the position—it is available.

Well, may I have an application?

Oh, no. I didn't think that far! *Sure, I will have it for you tonight.*

Because I am who I am, I do a search for a boyfriend application and found one that a dad created for anyone who wants to date his daughter. It is detailed: salary, credit history, health history, last relationship—all that. After a few tweaks, the Teacher Daddy application is live.

Not only does he fill it out, but it is neatly typed. Seriously, he completes it so thoroughly that I think I'm starting to

take him seriously. He speaks of my boys by name. Consider my heart strings pulled.

For the rest of the spring, notecards of admiration for Queen Ashanti show up in my mailbox at home as well as my inbox online. He is the only man other than my daddy to get me a Mother's Day gift, and he's never even seen me in person.

The school year ends with my last class, Reading Language Arts, as a class with a mixed ability group: some labeled special education, some just low achieving, and some high achieving with poor behavior. School leaders make the mistake of gifting good teachers with classrooms that are built to fail. Why would you put the students with the greatest academic needs and the students with the most social needs in one classroom and expect miracles to happen? It was stressful, but I made it. The students made gains as well. Some of them didn't do work or carry a notebook until the end of the day when it was time to go to reading class with Ms. Bryant. Yes, they terrorized me and tried to make me quit. They didn't know that I wasn't just another substitute teacher to run away, but they figured it out quickly. I loved them even though they planned to stage five fights in the classroom when I had no additional support that day. And my sixteen year old eighth grader tried to date me a few times before I was told that he was with us and had some court appointments for a similar offense. I loved them even though there were times that I felt like I was managing the behavior of all twenty-five students and the additional adult

support, who acted like one of the children sometimes, when he was there. I loved them and was so glad to say goodbye on the last day of school that June.

By the time Cancer season rolls around, Gig and I begin to make plans to spend time together for the first time face-to-face. Question of the day (QOTD) emails are how we get to know each other better while we patiently wait for July 3, 2005.

Now that summer is here, I get to relax a little more after my stellar semesters back in school. I still got it! In anticipation of Gig's visit, I strategically choose a pay week because I knew the boys would be away. I don't know him like that to have him around my children. They have daddies for what it's worth.

Gig and I talk for hours and hours, and this evening is no different as we plan our first time together.

What's the first thing you will do when you see me?

Give you a kiss.

With those big, beautiful lips?

Yup.

And don't put on a whole lot of gloss and lipstick either.

Don't worry. I only wear gloss. My lips are too big for too much color.

There's traffic. I guess it's from the beach weekend and being close to the fourth of July and all. He's late, but it's cool; I just can't wait to see him.

My house phone rings, and it can only be my security gate notifying me to let him in. Who really uses the house phone anymore? It's him. He's here! The knock on the door is not greeted by a check through the peep hole because that's cheating. We have to see each other for the first time at the same time.

Two seconds after the door opens, we are in full embrace, and then he kisses me. It feels way better than I ever dreamed. Not too much French, just enough to get his point across. I have arrived.

Bananas foster is the dessert at the steakhouse. I think he researched that. Stuff doesn't happen like that by chance, or was it a sign that maybe, just maybe, he's who God has been preparing for me?

Back at my apartment, we go from movie watching on the couch to kisses whenever we press pause. That is our symbol of intimacy *II*; the pause sign; a virtual kiss since we are so far away most of the time. Things get a little heavy for the first time together, so we agree to gather ourselves and head to fellow bandhead Kerry's house for our first debut as "hanging buddies." He's wearing green and gold, and of course, I come through with my orange and blue representing Morgan State. Fellow bandheads are watching band tapes. Yes, we enjoy watching past footage of marching band drum lines, gorgeous dancers, and screaming trumpets. Everyone has a thing, and the twenty other people in that cramped apartment living room would agree that there is no better place to

be. After that summer, Gig comes back and forth to visit his queen and shows me how much he loves me. I never thought that a man would have me calling out from work, so I could spend more special time with him, but it happened.

By August, it's understood that we are an item, but his relocation package proves to be problematic for the every other weekend love affair; he's leaving Norfolk, Virginia for Atlanta in September, and I can't go. Before he leaves, I let him meet Q and Jay, and one year old Jay kicked him. Not a good sign.

I'm back in grad school and grinding for the 2005-06 school year. Only one more year after this, and I'm done with the master's degree. Q is finally starting to get real homework as a kindergartener, while Jay is fourteen months and still not potty trained, but who cares? They are the sweetest pair I could ever have. He will pee in the potty when he is ready. Until then, he's comfortable sitting in his own poo. Boys are so gross.

Chapter 24

WELCOME TO ATLANTA

Gig settles into his new place for a month before I finally get to see it, his face, and be in his space. I've been to Atlanta many times with my sorority sisters, but this time is different. Following my friend Angel's advice, waiting until Tuesday and Thursday to purchase flights paid off big time, and I'm all set. I can't wait to tell him the great news.

"I just got my ticket, and I should be there by eight, and then we can go straight to breakfast."

"That's sound like a plan." He coughs between every word.

"When are you going to go to the doctor about that cough? It's been almost three weeks."

"It's fine. I just need some cough medicine really. It just sounds worse over the phone. I can't wait to see you. I'll be right at the gate with a cheesy sign, so you won't miss me."

"If you have a cheesy sign, I'm getting back on the plane!"

"Okay, okay. No sign, just me."

"Yes, just how I'd like it."

Mom and Dad support the excursion by making sure the boys are okay. If I travel during pay week, that means the boys are away with their fathers, and I am technically free to live like so many of my same age colleagues—kid free! I had to get them on a schedule for my sanity's sake.

Going to Atlanta to visit my baby is in the plans for late September. I'm missing it, I mean him, like crazy, but I'm not excited about meeting that nasty cough he has been holding onto for over a month now. I don't do germs, especially other people's! The time is finally here, and the boys have been picked up, so bright and early Saturday morning, I head to the airport, trusting AirTran to get me safely to Atlanta on this early morning flight.

Less than two hours later, I'm in his arms at baggage claim. As I point out my bags, he grabs his chest and coughs horribly. The very first place we are going is to the hospital.

"Can you walk to the truck, or do you need a wheelchair?"

"I'm really okay. I just need to sit down for a minute."

"Do you think you're having a heart attack? What's wrong?"

After he is settled in the passenger's side, I strap on my seatbelt to head to the hospital. Lights, check. Engine on, check. Mirrors, check. Let's ride.

"What's wrong with the gear shift?"

"Ah, it's not automatic. Do you know how to drive a stick shift?"

"That would be a no!"

God drives us to the hospital with Gig's hands and feet, but I know it was only the Lord.

We arrive at Emory, and he tells me that his sister-in-law works there. Great. This is exactly how I wanted to meet the family. I don't know if my babe is dying or what! He can't speak to me without coughing, and he keeps holding his chest. X-rays, bloodwork, and urine samples later, we find that his condition has now blossomed into pneumonia in both lungs. I told Mr. Stubborn to go to the doctor but no, he just needed cough medicine and tea. His mom and dad, and then all of his sisters and brothers call and check on him. I have the phone, so this is how we get our first dose of family.

"I know you care deeply for my son because you're there, and Ralf told me that they had to convince you to leave his side and get something to eat. That's special, and I thank you for that." Reverend Foster prayed, and soon after, we are discharged after being there for a good ten hours. We get his prescriptions and some good food.

Back at his apartment, his brother, sister-in-law, and I get him settled before they depart. This is certainly not all I came down here for, and I have to leave first thing in the morning. As he lay sweating profusely through the sheets, I'm seriously considering how my needs will be met on this short trip.

"So, how are you feeling, Gig?"

I put my hand to his head, and then meet his shoulders. Soon he utters while lying flat on his tired back, "Ashanti, are you serious? I can't even breathe."

"I didn't ask you to breathe. Just relax."

He is grateful. He just doesn't know it at the time.

The next morning, Ralf picks me up from the apartment and drives me to the airport to head back home before my sons get back from daddy weekend. I won't be seeing him in two weeks. More like two months.

Chapter 25

DROPPED THE BOMB ON ME

Having health insurance surely has its perks. When I was eight years old, I was playing in our kitchen with my young Uncle P. Mommy told us to stop playing, but I didn't and danced an eight count routine in the small confines of the kitchen but didn't realize that to touch my toes from that position would mean that I would inevitably introduce my two front teeth to the side of the bar. I was so shocked that I started laughing, but it wasn't funny anymore when I got to the mirror and realized that I wasn't just suffering from another busted lip. I actually chipped one of my two front teeth. It never got fixed, so I just perfected the smile that shows only a little teeth, and that was fine for me.

Now that I have great dental insurance, I take my co-worker's referral and go to the dentist. I can't seem to open my mouth fully, and when I can, there is a clicking sound near my ear. The pain is now overwhelming. I wait three days for a primary care appointment and spend three more hours in the waiting room for a four-minute visit that ended in, "You probably have TMJ with all the stress you're under. I

suggest you see your dentist as soon as possible." The dental office offers to see me on the very next day although they have a same-day appointment that they can work me into. I am liking this already. And that is important because before today, I had no plans of going to any dentist ever again. Each time I think of a dental office I get flashbacks of the dentist standing over me while sawing my wisdom teeth out as I am hitting his forearm and grabbing his hand because I can feel everything. He didn't believe me. The first wisdom tooth procedure was flawless back in 1997. He numbed, I prayed, and minutes later the two on the right were out and the gauze was in. Ten days later, I return more confident than ever—I have done this before, so I am a pro. Well, after a successful anesthesia, my dentist is called away for an emergency procedure for a little boy.

"I will be right back, okay?"

I shake my head yes. Without a clock, I have no idea how many minutes passed, but I do know that the numbness is starting to subside.

"So sorry I took so long. Are you okay?"

I shook my head yes and pointed to my left jaw.

"Now remember, let me know if you feel anything."

Eternity passed, tears fell, and if I could have screamed, I would have done so.

As I received the appointment card for the stitches removal and follow up, I silently vowed to never see another

dentist again. And I haven't, until tomorrow, almost ten years later.

Raising two children, going to graduate school full-time, and teaching full-time is a lot going on, but I am handling it pretty well. Or so I think until I wake up to my jaws closed as tight as a pickle jar. This is not okay. Trying to fall asleep the night before I meet my new terminator, I mean dentist, is nerve-wracking, but I figure out a way to slumber in peace.

The next morning the routine is the same. I get Quincy dressed for school and the baby not-so-dressed for daycare at the grandparents. Next up is the dental office conveniently located two miles away from my work, home, and childcare. It gets no better than this. I drive around for thirty extra minutes trying to find the building before I decide to call.

"I am in a community, and I don't see any buildings. Am I in the right place?"

"Yes, Ms. Bryant. We're right on the corner. The corner house is our office."

"Okay. This is different."

"Turn right and you'll see our parking lot area."

"Got it. I'll be right in."

My heart is racing, but I get out of the car and head in.

Oh God. That familiar smell of dentist juices is making me even more nervous, and I'm handed about thirteen forms to complete. Please don't make me relive my past!

After filling out as much as I can, the receptionist calls me to the back within five minutes of my arrival. It isn't what I expected at all. The dental hygienist and dentist are calm and understanding. After the x-rays and interview, I am officially diagnosed with TMJ, and grinding my teeth at night is causing the locking up and major discomfort. While the doctor gets a mold of my teeth for a night guard, he notices something that has been off of my radar for years.

"I see you have a chip in your tooth there."

"Yes, that happened when I was a child."

"And you just never got it fixed?"

"No, after the last trauma…"

"Okay. I totally understand." He places his hand on my shoulder.

He really does understand and didn't make me go through the story again.

"Well, since I'm in here, I can take a mold of your front tooth and fix that for you pretty quickly if you want."

I immediately get excited.

I didn't come in here thinking I can get my chipped tooth repaired too. This is great!

Two weeks later, my night guard is ready and so is the mold for the chipped tooth.

This time I am eager to visit the dental house because I get to be brand new.

Sitting in his chair is comfy, and I never thought a dental appointment could be quite like this.

The night guard fits like a glove. Next is my chipped tooth. That didn't take long either and with a little filing to make the grooves on the bottom of the tooth match the two front teeth, I was handed the mirror. As I prepare to give the first confident full out smile that I have given since pre-adolescence, the chip tooth repair was nothing compared to the other catastrophe in my mouth.

"What happened to my gap? What did you do?"

Tears are flowing, and the dentist has a confused look on his face.

"I'm so sorry. I just thought that since I was in there I would close that up for you."

"Oh my God! What has happened to my mouth?'"

"Ashanti, I'm really sorry. I have never had anyone want to keep a gap between the teeth, but I can try to file it some to give you a little space back if that's okay."

"That's my daddy's gap, and I am the only child that has it. I need my gap back now, please."

He files, but it looks nothing like the gap I came into that office with. How dare he question my heritage and fix me? I didn't need to be fixed. I didn't want braces. I wanted my chipped tooth repaired, not part of me taken away. I cried all night long but not to my mother. She just said get over it. I had to cry to Daddy. Only he would understand me this time.

Chapter 26

SANTA BABY

The week after Thanksgiving, I get to see Gig again for a longer period of time. This time I'm going for two nights and three days. He's healthy, and that's important because we are supposed to meet another brother and sister-in-law, but they're on baby watch so who knows. I arrive Friday morning this time, and I'm in his apartment all day while he goes to work. I have work to do as well, four graduate school papers and editing for the middle school yearbook. We reunite and find out that the newest Baby Foster has arrived. Plans to visit the hospital tomorrow are set. He's holding me extra tight, and I'm not letting go. This is not going to be the norm, but tonight, we can act married in bed. What's the worst that can happen?

The next morning, we set out to his brother's home to see the beautiful children. The plan is to get a Cracker Barrel breakfast, White Castle lunch, and then off to the hospital. At Cracker Barrel, we reminisce about the past evening's activities.

"So, I hope you don't think that's going to happening every time."

"What? You told me to do it."

"Boy, are you crazy? Why would I tell you that? You asked me if you could."

"And then you told me to do it. What if you're pregnant?"

"I thought you said the doctor said you couldn't have kids because of the stuff they gave you in the military."

"Well, they said I may not be able to."

"Now, you tell me."

"What if you have twins, a boy and a girl?"

"Um, then what are you going to do? I already have two children, and I'm not moving them away from their dads."

"I guess we would have to figure it out then."

"I have to pee before we go."

"You already went twice since we've been here."

"I always go a lot when I drink lemonade and tea. I don't get it either. I'll be back."

I used the bathroom four more times before getting to the hospital that evening.

The children were so beautiful, and the house—I want a house like that when I get married.

Arriving at the hospital to visit his brother, Spence, sister-in-law, Gloria, and brand-new nephew, I remember what it was like to make this ride with my dad and not the person

who helped me make my babies. It's okay because it won't ever happen again.

"Hey, Ashanti. It's so nice to finally meet you. Gig talks about you all the time." Gloria makes me feel welcome.

"Oh goodness. What is he saying?"

"All good stuff, baby!" says Gig.

"Ashanti, you want to hold the baby?"

"Oh no. I have held my share, but I would like to step out and use the restroom."

"No, girl, you don't have to leave. Just use mine." I used it three more times before we left the hospital for Atlanta during that hour visit. After the second time, Gloria gives me a look, and I know what she's thinking. That ain't it though; we just had married sex last night. Even if I was, it wouldn't be happening this fast. One more night and then Sunday I'll be back home. Three more weeks until my well-deserved Christmas break. If I can just sit down somewhere and rest, I could accept that as my Christmas gift any day.

Christmas Eve exhaustion has set in something serious! Yearbook club photos, end of semester papers due for my master's program, and Jay's first real Christmas are all on the agenda. I can't sleep, so I park outside of the grocery store awaiting the 5 a.m. opening, while my brother stays at my apartment with my children. I'm making a yummy fruit salad for Christmas dinner, and somehow, we need more candy canes for the tree again. Before I leave the grocery store, I

stroll down the baby aisle, inhaling all of the good smells of diapers, lavender, baby powder, and the like only to get to the end of the aisle and exhale deeply while placing a three pack of pregnancy tests in my basket. Well, it's the holiday season, so I might as well play my part. Christmas 1999 with Q, Thanksgiving 2003 with Jay, and the potential of a 2005 Christmas pregnancy looms over my head.

At home everyone is sleeping soundly, so I go into the bathroom with my bag of fortune tellers. I sit quietly, Indian style, with my back on the door, two home pregnancy tests in my trembling hands. How in the hell could I have put myself in this situation again? And how am I going to tell my parents about this for the third time in five years? I know my mom is embarrassed. She has to be. I have to make this right. I have to stop this crazy cycle of lonely, empty infatuation that looks like love and the desire to belong when at the end of the day, all I have is another baby and another family to coordinate the rest of my life with. Lord, help me. Three babies, three fathers. I am the girl they talk about who's on welfare on Maury and at school parent conferences. I know because I've done it. I'm that chick with multiple baby daddies collecting checks. Or am I? No, but I am intellectually sound, Christ-breathed, and come from a two-parent home, so what is my problem? I have to figure this out before this gets out of hand. My baby sister is eight years old, and she's watching me. I need her do what I say and do but not like this, so I have to figure out my why. Right now, I feel extremely pregnant. It must be a girl because everything is on overdrive already,

and I haven't even officially missed my cycle yet. Welp, let the holiday tradition of fertility continue with the gut check 4 a.m. Christmas morning phone call.

"Hey, Angel. What are you doing?"

"What's up? You pregnant?"

"Dang, Angel, how did you know?"

"I just know stuff, and I know you. You tell him yet?"

"No, not yet. But this is what we get for playing around at Cracker Barrel."

"Where are the boys?"

"They are in their rooms. Joe is here too."

"Okay. Let me know if you need me to come down there."

"Okay. I will. I love you."

Here we go with another family holiday of uncertainty, confessions, and consequence. This time it feels different though. It's January, and yes, we've only been dating since July in a long-distance relationship, and I really don't know what or who he's doing when he isn't with me. Am I stupid enough to believe that I am enough every month or so? Yes, and he better not be cheating on me.

This pregnancy is kicking my butt. The caliber of tired that I am now is literally lifeless. I am missing work because I can't get out of bed, and when I do, I'm throwing up everything, including water. On top of that, I have a sinus infection. One winter I am going to be sinus infection free; I

declare it. For now, though, I'm no good to anyone. Crazy me made an appointment with my obstetrician for a sinus infection. Since I was there and had already paid my co-pay, she checks my vitals and gives me other options since these anal suppositories aren't working either. As she's listening to the heartbeat, she makes a strange face.

"Is everything okay?"

"Oh yeah. I was getting your heartbeat, and the baby's at the same time. No worries."

"Whew. I thought something was wrong. You sure that was my heartbeat?"

"Yes, you're good."

Back at home, after picking up another Zithromax pack, I'm still exhausted but trying to stay awake to care for Jay and Q. Well surprise, surprise. I'm not the only one having a baby. So is Jay's dad and his fiancé. That's pretty cool that we are due around the same time. Actually, she's still in Atlanta where my guy is, and Jay's dad is between the Air Force Base and Maryland. He calls to check in on us when he is in town, and this weekend happens to be one of those times.

"Hey, Shanti. I should be home this weekend. You mind if I come by to see Jay?"

"Okay, cool. Come on by. I'm not feeling so well, so that's perfect if you want to come."

"Oh man. You need me to bring you something"

"No thanks. Well, maybe some orange juice."

"Okay. Nothing to eat?"

"No, I'm not hungry."

"You will be after I fix my grilled cheese."

"Your what?"

"You'll see? You got cheese, bread, and butter?"

"Yes, I do."

"Okay. I'll see you guys tomorrow."

Jay's dad arrives, plays with Jay, and starts cooking in the kitchen. Thank you, Lord, for sending him to take care of me tonight. I have never had a grilled cheese that tasted so good. I guess he knew what he was talking about after all. Gently tucked in bed, I finally get some rest while Jay and his dad play. I have my first baby girl dream that night. We have three, which was a bit weird. The birth order was Ashanti, Helaynah, and Savannah. Helaynah had longer hair than the others. Ashanti and Savannah were identical twins. I just remember taking Jay and one baby seat from the truck. I had Quincy to stay with the other girls. Then I came back and got the other two seats. Quincy carried the bag. The Lord showed me how to manage the babies and all. See, I told you we will be fine. I can do this.

Chapter 27

ROLLIN' WITH KID AND PLAY

I take suppositories for a few more weeks since I can't even keep water down. I'm miserable. Thank God it's President's Day weekend, and Gig is visiting. I get an extra day off to recuperate from this crazy feeling. I am convinced that this is a girl. I have never had a pregnancy this rough before, and I never want another one like it. Somehow, I get to the emergency room at Washington Hospital Center in D.C. with my children in the backseat. My brother meets me and takes the kids home to my mom while Gig is still on the way. First, he was sick when I visited him in Atlanta, so now it's my turn, I guess. In the triage room, my vitals are taken, and my temperature is a whopping 103 degrees. Something is surely wrong. I don't even have enough urine for a sample, but they say I can try again later. I just want to be better and know that my baby is okay. The nurse measures my nonexistent baby bump.

"When was your last cycle? And you say you're eleven weeks pregnant?"

She has a quizzical look on her face, the same face that Dr. G had at my last appointment actually. What's up with them and these faces without saying something to me?

"Yes, I just went to the doctor the other day for this sinus infection and extreme fatigue."

"Okay. Well, let's take a looksie."

She leaves the room for two minutes and comes back with an antiquated, huge, brown machine.

"What's that?"

"I can do your sonogram on this, so we can see your little bean."

I'm excited to get my first look at my baby boy or girl, but my face doesn't know it yet.

The machine is so big that both of us can't see the screen at the same time in that tiny room.

While she's greasing up my tummy, Gig calls and says he's in the hospital parking lot and heading up once he finds his way. Thank God I will finally have support in here.

"You want me to wait for him?"

"No, you already got the stuff on me. What's up?"

"Ooookay. I see what you have here. Oh, girl, take a look!"

She shows me the screen, and I'm so out of it that I'm sure I see a body with a disconnected head.

"Oh my God! What's wrong with my baby's head?"

And in the most southern dialect ever heard, my life changed again forever.

"Girl, you're having twins!"

It's two babies that I see and not a disconnected baby. Twenty forming fingers and twenty more toes, two more car seats, two more mouths to feed, along with the toddler and four-year-old I already have to feed. I can't fit two more car seats in my paid for Mazda Protégé. I have to get a new car, a minivan or something. I'm so glad I'm laying down already. Now, my head hurts worse.

"Is it possible that you can dim the lights in here?"

"You must not know where you are. It's either on or off."

"I do know where I am. When I had my last baby, they had a… Never mind, you can just leave them on."

I turn over in the bed with the blanket over my face and do only what I know to do. I pray.

God, please help me get better, so I can raise these babies you gave me. You said in your word that you would never leave me or forsake me. Wrap your loving arms around me. In my weakness, be my strength. I can do this because you said so. You promised.

I give Mommy a call after confirming things with my Lord and Savior, hoping she's in a good mood.

"Hey mom. I'm in the hospital with a high temperature. Is Joseph there with the boys yet?"

"Yes, he is."

"Okay. Well, she did a sonogram, and I'm having twins which is probably why I can't keep anything down."

"Congratulations."

"Thanks. I'll call you when I know anything else. I'm not in an actual room yet."

That was the driest congratulations I have ever received. Knowing that she is disappointed in me is the worst feeling in the world, and there is nothing I can do about it, not one thing but get healthy, raise these babies, and get myself together with or without a man.

The doctor actually decides to admit me for a few days for the infection and to keep an eye on the pregnancy. I already see that carrying these two to term will be a challenge. Gig is finally face-to-face with my parents since the announcement.

"Your mom and I had a long talk in the garage."

"About what?"

"She was just talking about how I knew what position you were in with the boys and all and that she expected me, as the older person, to make the right decisions."

"Oh. So, it was a good conversation?"

"Just rest, babe. You need your rest. I won't be able to stay long. I love you. You hear?"

"Okay, I love you too."

He never did answer my question, but I was too out of it to go back and forth.

Good thing I've got God's number. We will not lose. He promised.

JOY AND PAIN

After many baby showers and gatherings to celebrate my baking babies, I experienced the loss of their paternal grandfather in April, the same month that we found out the sex of the babies. Baby A is a girl, and so is Baby B. Twin girls. Now, death and I don't quite get along. It happens, but I am not sure how to process it in the moment, so I flee from the ceremonies and all that. No visiting the house, and when I drop off food, I don't go in. I'm damn sure not going to the open casket wake and the funeral. Nope! I stayed home with my grandma when my uncle, her knee baby, was buried when I was a sophomore in high school. She couldn't do it, and I supported her.

Graduate school plus a toddler, kindergartener, one hundred student essays to grade, and trying to find enough energy to bake these two princesses didn't always pan out. Gig's dad's funeral was the same day as an exam at school, and I just can't do funerals. I want to be there for him, but the four-hour drive from D.C. to Norfolk is a lot by myself at night. I

reunite with him the next morning at a hotel near his parent's home.

During this time, we attempt to figure out our long-term plans as we get ready to be parents of two babies, living over 600 miles apart on the wake of losing Gig's biggest fan. In the hotel, we talk about life.

"Babe, I'm sorry I wasn't there for the funeral. I had to take that test and then try to drive down alone at night."

"I understand. Daddy knew you were fulfilling his desire for you to become Dr. Foster, so you had to take the test. He would've insisted on it."

"I'm going to be Doctor Foster just like he said. Speaking of the Foster part, when are we getting married anyway?"

"I don't know. I don't have a job yet, and you were clear about not leaving the boys' fathers."

"Correct. I'm not leaving Maryland. I always wanted to get married when there's a weekend or holiday already attached, so people can make a vacation out of it."

"You mean like Christmas?"

"No, I want to get married when it's hot like in June or July."

"Oh, like Fourth of July. What day is that?"

"That's a Wednesday, but the closest Saturday is on the seventh."

"Ooh Gig! that's so tight: zero seven, zero seven, zero seven—the day of perfection. Isn't that the symbolism for seven, complete or perfect or something like that?"

"Ashanti, the dirt is still fresh on my daddy's grave. Can we talk about it later?"

"I'm so sorry, baby. Yes."

Blocking out certain parts of life to shield me from the pain doesn't work when empathy for others is also blocked out. How dare I talk about moving on with life when he just lost his best friend? The rest of the night I hold him in my arms. He is fatherless and becoming a father of two in a matter of months. This has to be weighing on him.

I become overwhelmed with the fact that July is in three months, which only leaves me a year to plan, and the babies aren't even here yet. I reach out to my left hand and right hand, Dannie and Tiff, for advice on how in the world I will be able to afford this wedding. Gig wants his mom to officiate, but he says she's only able to officiate in Virginia. Dannie sends her suggestions, and Tiff agrees via her email response:

I believe that a wedding in Maryland might work with your budget; the new church edifice will be complete, and I'm sure they wouldn't charge a longstanding member such as yourself an arm and a leg to rent the space for a few hours. Will the new church have a reception hall? (just an idea) It could still be officiated by Gig's mom. Decrease the invited folk to fifty or a little bit more (just close family and friends). No cost for hotel, buses, and additional expenses for the week before the wedding

for you and the children. Flowers still done at Michael's, and favors can still be done by friends.

Reception could take place at one of the beautiful reception halls nearby, some of which I could drive you to. If you keep the invites to a minimum, you can have your reception at a restaurant that does large parties and will allow you to decorate, or you can select a restaurant that is so small that they're willing to close their sitting area for your reception, still giving you the option to decorate.

Just throwing it all out there.

Dannie

Chapter 29

BIRTHDAY BEHAVIOR

Everything Dannie said makes so much sense. But Gig convinces me to have the wedding in Norfolk. So, I agree.

Bedrest calls my name three times, and the third time is a charm with a little help from daddy-to-be and his birthday present. The first Monday of August, just one day after Gig already left to go back to Norfolk, I went into labor, and it wasn't going to be stopped. Acting like superwoman, I woke up Quincy to get the diaper bag, and I put sleeping, naked Jay in an umbrella stroller to get him safely to the brand-new minivan I just purchased for my growing family. We call her Majesty as she is a midnight blue Nissan Quest. By 6:45 a.m., we are in the truck after a call to my mom. Of course, her daycare children have already started arriving, and it's too early for Dad to get home from work. She tells me to wait for my dad to get me. When have I ever done what I've been told when in labor? Q, Jay, and I get to the corner store, about six hundred feet from my apartment complex, when I have to pull over because of the strength of the contractions. Am I having contractions for two as well? My eyes are burn-

ing, and I think I lose sight when the contractions peak. Mrs. Helen knows her headstrong daughter, though, and within minutes, she arrives on site.

"I knew you wouldn't listen, so I just came to get you."

"I'm fine; I can make it. Just let me breathe."

"You're not fine. Move over. I'll drive the rest of the way."

At mommy's house, I call and text Gig, and he is not answering right away. As usual, Daddy takes me, and Mommy meets me. Between the shift change of my parents, it is determined that both girls are presenting breach and at thirty-four weeks are premature. The goal is to ensure a safe delivery for me and the girls. C-section it is. And there is already an OR line. I'm not in any danger just pain, so I work through four hours of true labor. First, we receive a 10 a.m. time, then emergencies keep showing up. Gig is catching every construction traffic tie up and even some one-on-one time with a police officer as he tries to make the birth, but it is evident that he is going to miss it. Ain't this some bull! The daddy who could've been here chose not to, and the daddy who is fighting to get here can't. By 1 p.m., it is time to suit up. The nurse preps me, and Mommy puts on the outfit. In true form, this full moon week yielded lots of babies and emergencies in labor and delivery. It's finally my turn, and at 1:30 p.m., the wheels on my bed are unlocked, and it's time to roll. As the door opens, my love, Gig, walks through, and we all breathe a sigh of relief. My hero is here to experience the birth of the

children he was told he'd never have. There are tears of joy from the attendants all around. He made it!

Inside the operating room, my girls are delivered just one minute apart. They both weigh in at a healthy five pounds, and we go home in four days. They are smaller than we anticipated, and they are also early, so most of the baby shower gifts are still in bags. But who cares? My doll babies have arrived. I try my hand at nursing them both at the same time and am successful. I got this. Gig stays for ten days, the longest we've ever spent together, and he has some ways that I don't like, but oh well. I'm stuck with him now.

With mom's help and by God's grace, I got this.

One part of single motherhood that people don't really think about is the fact that you are coordinating lives with three other families besides your own. It's a constant calendaring session when done correctly. Trying to ensure everyone can go to everything and also getting my special time in is eventful, but it gets done with communication and keeping the boys first.

But I can't do it all.

WIPE ME DOWN

Mom helped me get my first house. As of September, I'm a homeowner. The boys have their own rooms, and now, so do the little ladies. The master bedroom has its own bathroom just like my apartment but has no tub in it. And I have a huge kitchen and a basement. It's gorgeous, and I'm grateful for space. The girls aren't even six weeks old when they spend their first night in the new house which is conveniently located less than a mile from my parents' house. I'm no fool. I know where my help comes from, from the Lord and through Helen and Joe!

With four kids, I can't take them all to grad class like I did with Quincy, and I have two sessions left on a Saturday in April. Mom takes responsibility for one, and Gig takes the other. Graduation is in view. Just a few more assignments to go.

Gig has never really taken care of a baby before, so I give him a quick rundown, and he swears that he got it. Checklists are all over the place, and things are labeled with steps. That's all I can do before I leave the house for class.

"Call me if you have any questions. Remember if they're out of the crib, they're in your arms. Wash your hands and use the clean shirts to pick them up in. Don't kiss them in the mouth. I told you that's nasty. And whatever you do, do not microwave the breast milk."

"Ashanti, I got it."

And he did.

The six month old girls looked like they were okay when I returned.

"Where did you put the wipes?"

"Oh, I used them all."

"The entire tub? Okay, babe, thank you."

The next morning, I get up to take a shower and turn the hot water on in the master bathroom. Noticing that I forgot the towel, I head to the hallway to get one from the linen closet. In the hallway, I hear a sound that mimics a shower, but I don't have a shower downstairs. Walking down the steps, the sound gets louder and more defined. That is a shower sound for sure. I turn the corner to meet water streaming down my walls in both the basement and guest bathroom. But wait. It's not only water, but it's urine, it's bowels, it's disgusting. What the hell is happening and why?

Soon Daddy and the emergency plumber arrives to determine that an abundance of wipes have been flushed down the toilet upstairs, and it has clogged everything up. Six hundred dollars later, we were still trying to get the fecal matter

together because the first plumber only cleared it from the house. The second one, on Cinco de Mayo, made us late for a whimsical wedding at a winery for Mr. and Mrs. Love. I couldn't make it up if I tried. The cool part is that we taught together at the first middle school. She's an African American woman who speaks fluent Spanish. A beautiful thing. We left my daddy to ensure that they snake the clog all the way to the street this time and pay another ridiculous amount.

The last class day arrives, and I am not taking any chances. Mrs. Helen is on duty while Gig is unavailable that week. I got so busy working the night before that I forgot to pump enough milk, and everything else is frozen.

"Mommy, I forgot to pump their milk. Can you just come to class with me? We're only doing presentations anyway, so I don't think it will be long."

The long pause was followed by the time she'd be ready.

My ride or die got my back all the time.

And in just three hours and one feeding, we were one step closer to graduation.

There's just one more thing I need to clear up.

It's three weeks from graduation, but I don't understand why I have this incomplete in Dr. Lester's class, so I'm sending him an email ASAP. I need to know what's going on. I've run out of money, and there is no way that I can take this class again. Sigh.

He responds:

Ms. Bryant: This note comes to acknowledge receipt of your email. You need to make an appointment to go over papers and/or assignments that were submitted for the class. I will be in the office on Tuesday, April 25, and also April 27. Please call for an appointment.

Upon meeting with Doc, I learn that someone who I trusted to print and turn my paper in for me when I was unable to get to class physically, simply changed my name on my paper to hers and turned in both papers. I was mortified. Seated beside me, she tried to explain that the paper she turned in as hers was a mistake. She had her own but didn't realize she backspaced my name to then type hers. Yeah right. She's still being dishonest. She was dismissed from the office. I can't even breathe at this point.

He said he knew I wouldn't do anything like that. We've had three classes together, and he wanted me to resubmit the paper through my email. I learned another lesson. Don't ever send your raw work to anyone but the instructor. That way you get a time stamp and have proof you turned it in. The other lesson was that when you do good work with consistency, your character is built. The incomplete grade was changed to an A, and my application to graduate was finally approved.

Chapter 31

HELLO, FEAR

Graduation day was beautiful. May is a tricky month. Will it rain? Will it be chilly? Today is nice and comfortable. All the graduates are nice and neat on the football field, and the party that is awaiting will be just as epic. But something isn't right with Gig. Why is he so unusually quiet during the whole graduation party? Is he jealous of my male friends? That can't be because I love these guys like my brothers. Gig is usually in everyone's face grinning and cheesing. He is leaving to go back to Norfolk tonight. I'm not sure what it is, but I am in the party mood and will only graduate with my first master's degree once, so let the black and gold party continue!

I'm so grateful for my work family. I ordered party favors that are actually water bottles that say Superwoman instead of Superman. Gold and black are the theme colors representing good ol' Bowie State University. My tiny waist, side bun, and gorgeous jewelry from my Philippino friends make the day even greater. Q and Jay have playmates in all of my coworkers' kids, and the lovely ladies are practicing their upright movements in the walkers. Everyone already knows

I don't pass my babies around to people. Just let the babies play. Mid party, Gig comes over to me while I'm talking to Sean and Clyde.

"Hey, I'm heading out, but I want to talk to you on my ride back."

"Okay. I didn't think you'd leave this soon, love. Be safe."

I know he is not jealous of Clyde and Sean. Those are my work brothers. It better not be about that. Seriously. Clyde and Sean stick around to put away the heavy tables that Gig helped take out, and the celebratory night ends. Once I'm in bed after nursing my daughter, Gig finally calls me.

"Ashanti, I don't think I am ready to get married."

Gently easing the sheet from the side of my current sleep partner, trying not to wake her, my awakened body sits erect in the middle of my queen bed.

"What's wrong now, Gig?"

"I've been applying for jobs, and I haven't gotten any calls. And I just don't think I'm ready."

"I understand."

Okay, Ashanti, do not show emotion but be clear about intentions. Be strong, not weak. No tears allowed. Hold your own.

"And why isn't this a conversation that you could've had with me when you were here a few hours ago?"

"I didn't want to mess up your graduation day."

"Well, if we aren't getting married, we'll need some time apart, so you can work on you."

"I will not have any other man around my children, Ashanti, so not being together is not an option."

"Well, it won't be both ways, Gig. I'm twenty-eight, and I have lots of life to live. I don't have anyone in mind, but if I'd like to go out and enjoy myself, I don't want to feel restricted."

"I'm not asking for it to be both ways, Ashanti. I just want to be sure I'm ready."

"What I'm saying to you is that it's obvious that you can't get ready with me, or you'd be ready, so if we aren't getting married, I accept that. Just know that we won't be in an exclusive relationship while you work on you, and prayerfully, we'll be together once you're finished getting ready. That has nothing to do with you spending time with your girls because you'll always be their dad, but it does mean that it's not unfair for me to sit around and wait not knowing when or how to help."

"Well that's not going to work, Ashanti. And what does that mean about not being in an exclusive relationship?"

"It means I love you enough to let you go, so you can get together whatever it is that you need to get together. Just let me know, so I can let my girls know about these dresses and all the other stuff I have secured please."

"But Ashanti, I don't have a job!"

"When you move here, we'll be a family and whatever you need will be what I need. You may not have a job now, but we can pray on it, and I believe if it is His will, you will find something."

"So, if I put in my notice down here in Norfolk and move up there with no job, you will be fine with that?"

"As long as you love me and support me, we will work it out. I don't want to seem like I'm pressuring you one way or the other because if you aren't ready, then you aren't ready. I would have liked to have known that before I started giving out non-refundable deposits to people, but it's better to know now than after the wedding, right?"

The pillow of tears engulfs my face, and the baby is now latched onto my breast. I can't hold the tears any longer.

"Are you crying?"

I speak to my inner self in a gentle but firm tone. *I told you no crying. He has to make a decision that's not based on your emotions. Get it together. Speak strong.*

"Yes, but I'm fine. It's been a long, emotional day, so I will talk to you later, Mr. Foster."

"We're using workplace names now? I don't want you to cry."

"Yes, I'll talk to you later. Goodnight and be safe."

How is it that this wonderful day with my closest friends and family that I worked so hard for turned out so devastatingly horrible?

Because it's me that's how!

And God always finds a way to present multiple paths in my life journey. This isn't a pass on a concert or a pass on a trip to Miami. This is a pass on a lifetime of living and loving each other. I'm going back to sleep before the night owl twin wakes up for her next feeding. Wait until I talk to the girls tomorrow. Cell phone is on silent mode. In my quiet place, I can hear Him clearly. "I said all things work together for good, I never said every moment would feel good, but I'm here so it's all good."

Did someone just sleep through the night? Pillows soaked with tears have now been saturated by an oversupply of liquid gold. I am so irritated that I could scream, but that's not what I do. I'm the one with the calm and cool outer shell while I am going out of my mind on the inside. No one else would know that though. First, Gig is acting stupid, and now I've overslept and spilled milk all over the bed. Not today. I have to find a way to get out of this funk. I'm not trying to take it out on the children. It's not their fault their dad can't commit.

Well, if he isn't marrying me, then the wedding is off, and if the wedding is off, then I need to let my girls know immediately.

Subject: DRESSES ARE IN!

Date: Sun, 20 May 2007 12:19:49 -0400

The dresses have arrived but never mind because he doesn't want to get married, so I will try to figure out how you can get your money back because I know you will never wear this platinum strapless dress with a train anywhere else. I will return any monies you have given me and attempt to sell your $140 ($180) dresses unless you want to keep them (which you probably don't). I only ask that you give me some time to make extra money to be able to give the money back and still maintain my regular bills. If you know of someone who is looking for something like the ones I chose for you guys in silver, which you probably don't, PLEASE let me know. I need to be made whole financially. Thank you for your love, commitment, and support during this time in my life. I love you all very much. I would appreciate time to get through this difficult situation quietly, so please do not forward or share the details of this personal email with others who are not listed above. I trust that you have my best interest at heart.

I want to be compassionate, but I am livid. I have to be strong; that's my role, the strong one, but I feel so vulnerable. And even worse, the replies I seek are invisible. Why is everyone so quiet? Say something! I told you so, I wanted to tell you so, the hell with him, something!

I get nothing back from my friends.

This is going to be a long Sunday to say the least. My Sunday routine of washing clothes, tidying up the house, and grading papers consumes the rest of the day, and then it is finally over.

Monday evening's email check includes a message in my inbox from my now third baby daddy. What does he want now, and why am I being blind copied?

May 22, 2007

As per our conversation earlier today, I regretfully advise that due to unavoidable family obligations, I must resign my position as Sales Supervisor. I am open to establishing a mutually agreed upon date, contingent on the hiring and training of my replacement. I appreciate both being a part of the organization and the opportunities that have been provided to me during the last 4 years. I also ask that you help communicate with Human Resources to determine if I am responsible for any bonuses or relocation assistance that I received in connection with this position.

Thank you.

He did it! He chose me! He chose us! Okay, first tell mom, and then tell the girls. No, first tell the girls! I hope they haven't cancelled plans and already decided to do something else with their Fourth of July! Here goes another email a week later:

Subject: COME AND PICK UP YOUR DRESSES! THE WEDDING IS ON!

Well, guys, through much prayer and stern counseling, Gig and I are on one accord and are excited to call each other husband and wife in just 47 days. Thank you so much for respecting my silence in my time of reflection and prayer. Gig has resigned his position and will be joining us as a family soon! Look at God! Our last pre-marital session is hopefully tomorrow, and he'll tell my parents in the morning. I can't fake it and say I don't feel overwhelmed again just completing my master's degree, BUT I'm confident that you guys will pitch in and help me out with favors, programs, seating, etc. We expect invitations to go out on Saturday. Yes, I already ordered them two months ago. And YES, all of our vendors are still available on the most popular wedding date of the century!

Dannie or Tiff will contact you with specifics as far as what they need done.

In the interim, PLEASE COME AND PICK UP YOUR DRESSES! Did I tell you guys that I love you?

Mom is rejoicing. Dad just says okay. Dad always says okay, but this okay was different. *Nope, don't overanalyze, Ashanti, just go with it.*

I'm getting married soon. I'm also finishing the school year soon, and my babies will be one year old. Everything is changing, and yet another major change looms.

While walking by my principal's office she says, "Hey Ashanti, we're getting this new program called AVID, and it's about getting kids ready for college. We applied for Middle Years International Baccalaureate, but they gave us this. It seems like you. Are you interested? I'll email you the website."

"Thanks, Doc, I'll check it out."

I get to my computer and click on the link that changes my professional goals forever. Am I really reading this? It would be my job to motivate and encourage students who may be first year or minorities to go to college and be more successful? Is this serious? And I get to go to San Diego to learn all about it in August. But first, I have to get married! I said yes to AVID and yes to the dress.

Now about the ring. My matron of honor had a ring from a previous relationship that she wanted to bless me with as my wedding gift, and I tell Gig all about it, but he is slow to agree.

"Gig, she is trying to be nice not show off. I don't have to wear her ring. Just take the money!"

"Why do they have to go to the jewelry store with us then, Ashanti?"

"Because it has to be appraised, and we have to agree and sign off on it."

"Well, after that, can it just be our business?"

"I'm sure that's her intent. Tiff loves me, babe. And she is already married. She doesn't need the ring. Why not accept the blessing?"

"Okay, we will take it."

At the jewelry store, we do just what we said, and then Gig and I are there to finish business. I show him the two I like and leave it up to him.

I sit on the stoop outside while he handles his manly obligation, and then he motions for me to come inside.

"Did you pick the one you wanted?"

"I sure did, and I know you are going to love it."

"Now, you have to spend three times as much to use this ring, so how will you all be taking care of this?" The jeweler smiles and is probably already picking out what cruise she's going on based on this one commission sale.

I step over to the right so that he can prepare his finances without me all in his face. I mean everything about this wedding has been off script including the lack of a proposal, so I can at least let him do this part in silence.

"Uh, I don't know what you are scooching over for. I don't have $10,000."

"Oh, that's not a problem, sir. You can just finance. Here, I can get you started."

Did he just ask me to pay for my own ring? Why are we even here if he couldn't afford it? It's June 1st for God's sakes!

You can't get any closer to the wedding. Are we expected to make rings out of paper like seven-year-olds?

"Well, I already know my credit isn't going to go through, so we can't get them right now."

"I will do it. My social is . . ."

"No, Ashanti, this is my responsibility. At least let me make payments on it."

"Okay, that's fine. Can I have this one for him? You like this one?"

"Naw, that's too gaudy! I don't want anything shiny or with stones. Just a plain band."

"And I need you and everyone to remember that you are married. What about this one?"

"Yes, Mrs. Foster." He pulls me close and kisses me in the crease of my neck.

The deal is done, and we head back home. I need to shower at my house, while he goes to have a conversation with my parents. We're putting the cart before the horse yet again, but hey, at this point, I just go along with it.

As I step out of the shower, he's in my bedroom on one knee.

"Boy, are you crazy? You scared the mess out of me! I thought you were going to my parents!"

"I did, and I would like to know if you will be my wife." He holds up the invisible ring while the real one is being resized.

We embrace, and he puts on the invisible ring after my yes.

With all of the back and forth with not getting married and then getting married, my maid of honor dropped out. One of my best girlfriends, Angel, steps right up and makes it happen. I really wanted to choose her anyway because we are so close, but I went with longevity of relationship since I had known Danie since the sandbox. But it's fixed now, and Angel linked up with Tiff who is due with her first child very soon, so soon she had to pick her own dress. But that leaves one dress. The only person I can think of who may be able to wear it and that makes sense to the entire experience is Gig's sister. They are only a few years apart—he's the baby. Maybe she'd like to help out by keeping my bridal party balanced. If not, Gig and I already joked about which guy has to go. I can't have lopsided pictures for my bridal party and my family portrait. She agrees, and Gig gets her the dress and my very specific instructions about jewelry, shoes, hair, and makeup.

There's three more weeks until the first festivities, and school is almost done for the summer.

All hands have been on deck for the last few weeks, trying to get ready for the wedding. The RSVPs are lopsided, and many of my family and friends aren't coming. Even though I am hurt by it, I am happy to be the reason why the family can gather together. The last gathering was to celebrate the life of the Reverend, so it's okay, I guess. Bridesmaids, Mel and Keisha, and Gig and I are sitting around making favors one weekend at my house. Mel and her boxed wine start

the question game which is always a riot when she's around. After about five rounds, everyone is a little tired of folding, spraying, gluing, and stamping, so I order pizza for the crew. From the kitchen, I hear Keisha pose the question about the dumbest thing you've ever done. I answer.

"Oh, that's easy. I purchased a house without a garage."

Then Mel and her boxed wine chimes in, "Um, no, that is not the dumbest thing you've ever done, Ashanti."

"Then what is it since you know everything?"

"Getting your first love's name tattooed on your lower back was the dumbest thing you've ever done."

I really hate her and her mouth sometimes. Before I get to formulate a response, Gig steps in.

"Soooo, I thought that Q was for Quincy."

"What?" Mel falls out of her chair being silly. "If you thought that a mother would put her child's name in a tramp stamp, then the next question needs to be what's the dumbest thing you've ever thought."

"No, it's actually his nickname."

"So, you just weren't going to say anything about that?"

"Well, you clearly saw it and didn't ask me any questions, and honestly I forgot it was there."

"Thanks Mel."

After pizza, the vibe is awkward, so we shut it down for the next day of festivities at the bridal shower.

By July 1st, it is clear that this is not my wedding but my future husband's family reunion. It's in his hometown, and the only people I invited who are coming just happen to be in my wedding party. It's okay though. I know having his mom officiate is important to him, and he already made it clear that his mom can't officiate outside of Virginia. So be it. There's always 07.07.17, and we can renew our vows in my hometown back in Maryland. The ladies give me a beautiful bridal shower in my home just six days before the wedding, and it's starting to make more sense.

A few days later, we pack up the bouquets of red roses, platinum personalized program fans that Joe and I made from the bridal website, the custom runner that we painted, and the cute candle favors. I'm so glad we won't be bringing all of this stuff back home. It has taken over my house!

When we arrive in Virginia Beach, the first person I meet up with is Mel the morning before rehearsal. She treats me to a manicure and my first Brazilian wax. Apparently, she's been doing them for years and loves it. At the salon, I head to the back and get undressed from the bottom down. After one strip, I'm up putting my clothes back on. Mel is almost on the floor, face full of tears. The esthetician tries to convince me that it gets better and that I should be able to handle it if I have four kids already. I told her to keep the money, and I leave to meet Mel at the car. She tries to convince me to let her "fix me up," but I am not having that. She doesn't need to touch me again and add to the pain. In the car, I notice an itch in that same spot. Great! Now, I'm going to break out over this mess.

I head back to the hotel for a final walkthrough at the venue and the rehearsal.

Rehearsal is done, and everyone is in tears from the comedy that took place. My bridal party is all in place except Gig's sister, but my girls are here, and it's all good. As I look out over the rehearsal dinner, I'm glad about the decision I made. Everyone is getting along nicely.

The twins and Jay have short rib sauce all over their cute little faces. Everything is finally going smoothly. Q is just being Q, calm and cool. My last and substitute bridesmaid, Gig's sister has yet to arrive, but we can just walk her through before the ceremony. As long as she has everything I told her to bring, I'm fine without her being here. She looks at me funny every time anyway. I want her to like me, but I don't bow down to anyone to make it happen. I guess we will come along at some point. I know she's still trying to figure out if I'm what he needs, and I am trying to figure out when she's going to mind her business. It's a few hours before becoming Mr. and Mrs. Foster, and Gig has that face again like he needs to go to the bathroom. He leans in and whispers in my ear.

"Uh, you think we can put this on your card?"

"Gig, the people are literally eating right now!"

"I know, Ashanti."

"Where is the money your mom gave you for the dinner?"

"I spent it on a nice car for you. I really wanted you to have a nice car. You deserve it."

"I told you that I would arrive in the van I already pay for. No one is going to see me in it anyway, and my credit card is over the limit, so I don't have another four hundred dollars. So, what are you going to do?"

"Can you ask your dad?"

"No, YOU can ask my dad."

Moments later, the two of them walk out and get in the car.

After forty more minutes of enjoying the guests, I start to get worried. I know everything has to be okay, but I text just in case.

Hey, where are you guys? We've finished eating.

Your dad had to go back to the hotel 20 minutes away to get the cash. We're pulling up now.

In the pit of my stomach, I feel truth swaying side-to-side, and I'm nauseous. This is the writing on the wall. He's not ready. I'm not ready for his not ready. We're not ready.

Before bed, I chat with Angel to help calm my nerves.

"I'm nervous."

"Everybody says they get nervous the night before."

"I know, but this is different. I feel like I need to say something or do something."

"Just pray. God will tell you what to say."

Chapter 32

SWEET LOVE

The morning of the day of perfection, 07.07.07, a woman who I don't know is doing my hair and makeup on a country road. Lord, please don't let her get heavy handed with the makeup. While under the hair dryer, one of the groomsmen, cousin Chris, enters and kneels in front of me. I can't hear him over the sound of the hairdryer, but I gather through his hand motions that he is there for the rings. After a quick threat, I hand him the watch I picked out especially for my groom, and he leaves. Now, I can have these last few moments to write my vows. Why did I say yes to writing our own vows anyway? I need to learn to say no, seriously. What's so wrong with the ones in the book? He just had to have written ones. It's the day of the wedding, and I'm still trying to figure it out. The makeup looks amazing and so does my hair. A very simple bun just as requested.

In the middle of the day, it rains and cools down the evening from a sweltering summer Suffolk, Virginia heat to a comfortable Norfolk night just for me.

As I arrive with Daddy, we talk about how we are going to get down the aisle.

"All right now, when we get out there, you make sure you stay on beat."

"I know you aren't telling me to stay on beat. I'm a dancer!"

"Yeah, and this time when I walk you down, I'm not taking you back."

The driver and daddy laughs.

"What is that supposed to mean?"

"The last time I walked you down the aisle in white, they gave you right back at the end!"

"Daddy, that was for my cotillion as a debutante when I was seventeen. This is different. This is forever."

"It better be."

Before getting out of the car, the wedding coordinator comes over to check on us.

"Hey Ashanti, you look beautiful. Um, the programs and place cards are still in the van, but everyone is already seated. Do you want to wait and get the fans or just go ahead and start at exactly 7 o'clock?"

For this entire time, I would like to think that I have not had one bridezilla moment, but this is it.

"I probably inhaled an unhealthy amount of that spray glue and also cut my finger off trying to make those things. We need fans!"

"Okay, no problem."

As I am proudly walking down the aisle with my daddy, I get a panoramic view of the entire wedding party from the tallest groomsmen to my groom who stood by the most adorable ringbearer and Bible bearer, Q and Jay. My mother-in-law is standing in the middle behind a waterfall in the Japanese flower garden. Then I see my three flower girls because Gig couldn't pick just one niece, and I couldn't make him. I see my maid and matron, best friends, and then Gig's sister. Lord, please let me get married without making a big deal out of this, but I know I said no hair in the face! What is so difficult about that? She has bangs down to her eyebrows and is wearing the wrong shoes. I knew it! This is what Gig tried to warn me about earlier today but didn't want to tell me. It's all good though. I focus my attention back on my husband-to-be because it's vows time. Even standing here, I'm not to-

tally sure about what I will say when it's my turn, but I think well on my feet. I'm so glad he goes first.

"Ashanti, my queen, I will always cherish you as long as you let me keep my fan on." Everything else comes out like the sound of Charlie Brown's teacher. Did he say something about his fan in our sacred vows? Is this the comedy hour? Okay, I can't believe he said that.

"Gig, I promise to cherish you as my king as you honor me as your queen. Forever."

After mixing some sand, lighting candles, and a saxophone solo, we were down the aisle. Walking down the aisle, I got real clear about my support with five people seated on my side in support of me and standing room only for Gig. Where is my family for this reception that I paid for? Hurt? Hell yes, but I never took the smile from my face. In the garden, we take photos and finally get to the reception with the best musician ever. Being in the band has its perks way after the field shows.

Angel said to remember to eat because you will be hungry late at night, and there will be nothing open. She said I should have the caterer make me a plate because I will be so busy greeting guests that I won't remember to taste the thousands of dollars of calories.

We did none of that.

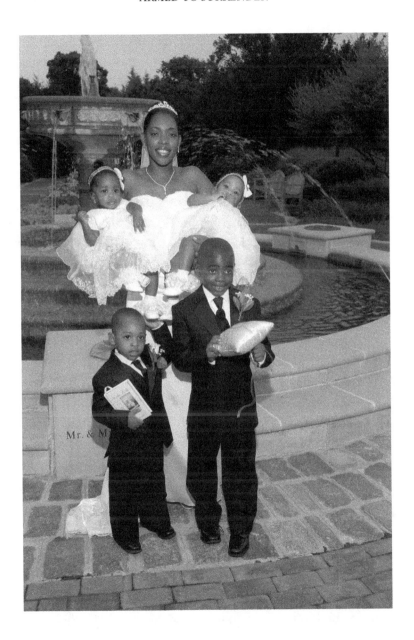

Instead we rode back to the hotel in the back of the luxury rental car that should have been the funds for the rehearsal dinner. We did it, and this is amazing. The rings are back on my finger and blinging all over the place.

"Baby, go on and head up and relax while I get the boys their rentals. They have to take this stuff back, or we will get charged another day for these tuxes."

"Okay, well, I don't have that extra day's money so hurry up. We only have an hour left of 777, and I need my husband-wife time. You know the husband-wife time we've been waiting for since August 2006?"

He gives me the key, and I head up to the most beautiful honeymoon suite ever. Gig and I were supposed to see this together. He was supposed to carry me over the threshold. But hey, let me enjoy this music, candles, and rose petals all over the bed. Is that a steaming hot drawn bath in the jacuzzi tub? I have never even been in a jacuzzi tub. Our bridal party is off the chain. No, my bridesmaids are off the chain. They made sure this night was special for us. I wonder how long these candles have been burning. Wild girls, I tell you.

Only I could pose so beautifully on the side of the bed in my wedding dress. I didn't bring any of the bridal shower lace, and without having a real bachelorette party, I didn't acquire anything too nasty. So, he can take it off for me, every darn button, zipper, and bow. He will work for this. After thirty minutes of posing, my arms give way to a full collapse onto the bed into a quick nap. Awakened by the jingle of his

keys at the door and clicks of the access pad, I rise to see that the minute hand is standing at attention on the four, and the hour hand on my watch is at one. It's Sunday morning, and my wedding night has officially passed. We get three hours of sleep before heading to the airport.

Jamaica was an unforgettable three nights of rum, scuba diving, passport stamps, passion fruits, and sanctioned unprotected sex. Thank God I booked an all-inclusive venture because my account is overdrawn, and my credit card is over the limit. We're broke and in love.

Once we're home, Gig starts his new job. As a new wife, my goal is to get us out of debt and into prosperity. If he couldn't afford to get me a ring on his credit, then we are in trouble. He's showing me that handling finances isn't his thing, so we agree that I will make sure everything gets paid. I also pull both credit reports, call each creditor that is past due, and request a statement in the mail. I am so proud of the chart I made to lead us to debt freedom in five years. When Gig gets home, I am eager to show him the hard work.

"What is this?"

"Look baby, I called all the creditors and asked them to send us the account info to your correct address."

"What have you done? I was waiting for those bills to fall off and now you restarted everything!"

"But I just thought that if you owed it, you should want to pay it. My bad."

"I will handle my bills and get myself out of the debt I brought to the marriage. That's on me not you."

"I apologize, Gig, I was just trying to plan how we can pay the bills like we talked about."

He could tell that he had hurt my feelings.

"Babe, I want to do this. You shouldn't have to pay my debt. That's all I'm saying."

"Okay. Well, look at what mom sent over, the cake!" I try to change the subject altogether.

If there is one thing we have in common that can make everything all right, it's food.

"Let's eat it right now! We didn't even get any at the wedding. Come on, I'm getting the forks!"

I know, I know, you are supposed to wait until the first anniversary to eat the cake, but what else has been traditional about this union? Why break the new tradition of not following the traditions now?

The next month, our baby girls finally turn one year old, and we celebrate their baby dedication too. Mommy has to help us pay for the cakes, and Q's birthday, just a week later, was thankfully funded by his paternal grandmother. Now, his party included a frozen ice machine, pinata, moon bounce with a slide and all. It's safe to say he was celebrated. By August 15th, we are ready to begin our new lives as a couple—Gig with a university media marketing job and me with a brand-new principal and a brand-new program called

AVID. Twenty-six students and their families accepted the challenge over the summer, and I'm looking forward to a change in everything.

Back at home, I visit Gig in the basement while he is on that computer again.

"When are you going to edit our wedding video?"

"I have two more in front of ours that I already got paid for, so I have to do theirs first."

"So, when are you leaving?"

"Huh?"

"Oh, never mind."

Traveling back up the three flights of steps to the bedroom, it hits me. He lives here. He is actually never leaving. He's not just here for the weekend. Every morning I wake up and every night I go to sleep, he's here. This is what I wanted, right?

Is this what being a wife feels like? I'm sleepy, tired, achy, and irritable. Maybe it's the constant sex that's making me sleepy and achy, but why do I feel irritated that he's not going back to Norfolk. It doesn't make sense. I have to shake off this single Ashanti and embrace the married Ashanti. I want him here with me. And he's here, so what's the problem? We've been married only six weeks, and we have celebrated Gig's birthday, the twins' first birthday, dedication ceremony, Q's birthday, Granddad's birthday, and now my mom's birthday. Something is up, again, but I'm not saying anything until I

know for certain. All of those emotions coming together like that could only mean one thing. But we just got married! God wouldn't allow that, would He?

BABY MAKIN' HIPS

He did.

On September 15th while everyone else in the family is at the groundbreaking ceremony for our new church edifice, I sneak to a Saturday appointment with Dr. G. to confirm what I already know. This time I need confirmation of how many little people I am now baking.

She already warned me about having more babies right now, but who knew I would conceive on my honeymoon? I know we want one more baby, and I know I am not getting any younger, and thirty is my maternity cut off. I'm twenty-nine. Then I have to factor in my teacher schedule. If I am going to plan for a baby, it will be with a summer conception and spring birth, so I can finish my eight weeks of maternity leave just in time for the last day of school. That way, when I return to school in August, my baby will already be four or five months old. That beats taking an eight-week-old to a strange babysitter any day.

"Ms. Bryant, good to see you."

"I'm actually a Foster now."

"Well, congratulations to you and Mr. Foster. I see you wasted no time."

She leans me back into the lady position to check me out. She feels my tummy and listens with her stethoscope. I learned to watch their faces and not the screen because I don't know what I am looking at anyway. But faces, I know faces. Her head cocks to the right a little, and her eyes move to the left. I know something is up.

"Let's go to the ultrasound machine. You aren't going to trick me again."

I smile, but inside, I have knots in my stomach. My husband isn't here to get this news.

I just had twins a year and a month ago, and now I am pregnant again.

I lie back again, and the gooey, cold cream goes on the ultrasound wand while her hand touches my newly pregnant tummy. The face. I'm watching her face. She sees two. I'm having twins again, but something is different. Baby B doesn't have a heartbeat, but it's early. I will return in a week and check things out. For now, though, I have a cute picture of my fifth and sixth babies. This makes a six-year-old, two-year-old, and twelve-month-old twins. Boy, will I be busy, but what a blessing this is! I can't wait for Mom and hubby to get home from the new church groundbreaking ceremony to hear all about it.

My husband seems excited, but we vow to tell our parents together. This is the first pregnancy that I feel like I can really celebrate from conception. I'm married now and justified in having as many babies as I want. But I can't stop thinking about little Baby B being behind. Sure enough, seven days later, there is a heartbeat. Not as fast as Baby A's but a heartbeat nonetheless. At ten weeks, I breathe a huge sigh of relief because I know everything will be okay. We decide to give my mother and caregiver the news in a creative way. We decide to decorate a plain white shirt to say, "I'm going to be a big sister in April 2008." I drop the girls and toddler off on the way to work and allow one of the twins to walk in by herself. Mom sees nothing. I call her five times that day to check on the babies, and she says nothing. I start to think that she's upset and that I'd done something wrong. I call one last time and just come right out with it.

"Did you see Savannah's shirt?"

"Oh, yes, it's so cute!"

"Mommy, did you read it?"

"Read it? No, I didn't read it."

"Mommy, read the shirt."

"I'm going to be a big sister in April 2008. That's cute."

"Mom! Who is the baby of the family?"

She screams, and even though I am on the phone, I know she is dancing around too. That feeling of making my mommy proud will always be one of the most important feelings

in my life. For once, I have not embarrassed her. I can shout from the rooftops that I am expecting with my husband. And I did. Today, I smile from ear to ear knowing I did the right thing by getting married.

Only a month later, it's October, and I'm fifteen weeks pregnant. My clothes are tight, and maternity clothes are an evitable wardrobe. But this time, I'm off season and need more clothes. All of the other babies were conceived during the winter holidays, but these babies were conceived during the time the previous crew were born. The maternity clothes for winter just aren't as cute as summer dresses and spring crop leggings, but I yielded and picked up a few sets, courtesy of Grandma Helen.

Chapter 34

JOHANNAH

Having babies leaves you with no personal and sick leave to take at work because there is always an appointment, so I only took a half day this time. I may be able to see the sex of the babies today, but I know that isn't the focus. Dr. G sends me to the sonographer to check on the babies' growth since I am a mommy of recent twins, and Baby B has been taking his or her time trying to catch up. I hope she can tell me the sexes though. I drink a lot of water as prescribed, and I really need to let some out. Just as I am walking up to the receptionist to let her know that my bladder is about to overflow something serious, they call me back.

I hurry back past the dressing rooms and ask if I can let just a little out. She obliges.

Grateful for the opportunity, I only let out a little.

"Thank you so much. I didn't think I would make it."

"No problem. Go ahead and get undressed waist down, or you can just pull everything down to here."

As I am getting undressed, I notice a collage of pictures, and the children look like twins.

"Oh, I have been in this room before. The lady in this office has twins too. I remember us talking about them when my girls were baking. She's so sweet."

"Yeah, she's off today, so I'm just using her room. I'm going to put the gel on now. So how many weeks are you?"

"Fifteen. This makes pregnancy four for me, and my girls are fifteen months old."

"Girl, you're busy."

I smile.

"Yes, I guess you can say I will officially have my basketball team with this pregnancy."

The monitor that is mounted and facing me is off, and I can't see the screen on my right.

The sonographer and I talk about life, going to school, and raising children.

Everything is growing as scheduled. I take a huge sigh of relief for Baby B. We've made it this far, so I know we will be victorious for the long haul. I start to cry tears of joy.

She finally turns the screen towards me. "Here's your baby."

"Which baby is that? Baby B is always smaller."

With a perplexed look, she says, "It's only one baby, Mrs. Foster. You see the shadow around the baby. That is the fetal tissue from the deceased fetus. I assumed you knew already."

Her words feel like individual letters typed into my heart with a needle. I close my eyes for a moment to build up enough courage to look to the right at the fate of my womb. I take a deep breath and slowly turn my head.

It doesn't even look like a baby. It was a blob of slime and tissue surrounding my healthy baby like a shadow or a blanket hugging the other baby and letting him or her know everything is okay.

I wish someone was hugging me right now. I'm alone in this room.

She thought I knew my baby was dead. She apologizes and gives her condolences, and then prints out eleven pictures for me of my babies and leaves me alone to get dressed as she goes to meet another client. This is a business for her and a devastating blow for me. We did it the right way this time, and now, I lose.

The lights are on in the room now, and I am sitting on the side of the bed, struggling to dial my husband's phone number and wipe off this gel which is all over my pants at this point. There's no cellular service in here, of course. I'm angry with him. I should not be here doing this alone, but he's getting ready for his first major production at the university, and he can't be everywhere, so I understand. I could have just rescheduled, but now, I need some time to process this thing. There is no longer a Baby A and Baby B. There is one baby being cradled by his brother or sister's remains. I finally get hubby on the phone.

"Baby, I just came from the sonogram, and they said the little baby died."

"Oh, baby. I'm so sorry. Was Mrs. Helen there?"

"No, I thought you were going to try to come."

"I'm sorry you had to do that on your own. God knows what He's doing even though it doesn't make sense to you right now. You need me to come home now?"

"No, go ahead and get ready for your event."

"Well, could they tell the sex of the other baby?"

I breathe in really deeply, exhale, and try to be as calm as I possibly can be in this moment.

"I just told you I have a dead baby's remains inside of me, and you're asking me about the sex. No, I don't know the sex."

"All right, baby. I love you. You hear?"

"Yes. I love you too."

I wish it was a regular phone, so he could hear me hang up in his ear. That gets on my nerves about these cellphones. What about hanging up on people?

The only comfort I know at this point is to go home to my mother. Everyone is home, and the daycare children, including my three, are fast asleep. She meets me at the door, and by this time, I am starting to feel what the radiologist said.

"Can I hug you?"

Knowing me she needed to ask permission bcause I would just push her away from me.

"Not right now. I just need to lie down. Everyone asleep?"

"Yes, they just laid down."

Upstairs, I go to my quiet place. I put the sonogram pictures beside me and fall into the bed fully clothed. This is the same bed that I labored in for every other baby. When it was close to delivery, I found comfort in her bed with my thumb in my mouth. I need to be in my mommy's bed right now. She comes in and sits on the corner of my bed, rubbing my back.

"I don't really know what to say that will make you feel better. I have never lost a child, but I love you very much. God knows what He is doing. Can I bring you anything?"

I can't respond to her. I'm thirsty, but I can't talk much less make a decision about whether or not I want my husband to come home and mourn the loss of our child with me.

Shortly after, she brings me some homemade, Mrs. Helen's fried chicken legs, steamed broccoli, a cup of apple sauce, two pieces of sliced bread, and some slushy lemonade juice that she put in the freezer to taste like a slurpee. She knows how to present it just right to help me feel better.

Mom will keep the children for me tonight since hubby will be working late. Thinking about this is too much for me. I need to work. Work helps me figure things out or ignore it altogether, whatever works at the time, so I will work. When

at work, I am in control and have the ability to create and inspire. I'm just going to work myself better. We have some field trips coming up that need plans, so I will work on that. I work until I fall asleep at the laptop. My husband awakens me with a kiss, and I immediately begin to cry again. I don't think I ever stopped.

Our baby is gone but still with me. He says it's okay, and I know it's okay, but what I don't know is why us, why me, and why now. What did I do that was so wrong? Everything seems so right.

Work is how I manage to mask the pain and interrupt the thoughts of my dead baby decomposing in my womb that wasn't good enough for her. So, I go to work the next morning.

There are guest speakers to book, field trips to get approved, and papers to grade. Sitting at home and looking at twelve-week-old baby pictures will not help me heal. Work will help. That is until I walk past the nurses' station.

"Hey, Mrs. Foster."

"Hey, Nurse Winbush. How are you?"

"I'm good. And how are you and those babies?"

She hugs me, but it's two seconds too long, and I immediately get enveloped in the cradle of her military broad shoulders and big arms. She was there to catch the tears. I explain but not too long. I'm here to work so that I don't have to think about what's happening in my body.

Usually, my classroom is quiet, but my teacher neighbor always seems to keep it live in her room, and today is no different. They are banging on desks, opening and closing a door we share, and she's screaming at the top of her lungs. I don't have enough energy to go in to address them because they respect me. As I begin teaching, it gets oddly silent over there. Did she take them on a full bathroom break again? What happens next changes the whole trajectory of the day.

"Mrs. Foster, can you come here please?" She enters our shared door. I approach her classroom to find that the students are in there, and they look really sad, so I'm concerned.

"Is everything okay?"

"What do you have to say to Mrs. Foster?" One student raises his hand and is acknowledged.

"Mrs. Foster, I am so sorry for having bad behavior that made you lose your baby."

I froze. Did he just say what I thought I heard?

"You didn't make me lo… Thank you, sweetheart. I accept your apology."

With that, I let the principal know that I couldn't stay; I needed to be with my family. What I really wanted to do is curse that teacher out and explain to her why the kids misbehave with her.

Chapter 35

IT'S A BOY

Well, I lost one baby girl, so now I only have two baby girl toddlers. When I arrive to pick them up early from work, they are asleep. Usually that is my sign to tiptoe away, so I can get some free time as well, but not today. I have plans for us. They cry as I get them dressed.

"It's okay, baby girls. We're going to get pictures taken."

"You're doing that now?"

"Yes, Mommy, I'm taking my girls to get their pictures taken."

"All right then. You have a snack for them?"

After they are both dressed identically in their pink and green, as only twins should be, I load them up in the navy-blue Nissan Quest and head to Picture People in the mall. This mommy and daughters day comes to a wonderful end as I have the difficult task of choosing whether or not I want to purchase the pictures of cute little bald-headed Layne with her thumb in her mouth and Belle taking snacks from her sister while she's distracted performing for the photographer

in the red shirt and funny hat. By now, we are good and tired and bring home every single picture in various frames and sizes. Celebrating my baby girls was expensive, but I feel a little better. We just need one more frame, so we stop by the neighborhood craft store before heading home. As we roll into the store with the double stroller, the clearance section catches my eye. Down the aisle is a delicate, purple butterfly windchime for only two dollars. The regular price is nineteen ninety-nine, so I have to have it. The butterfly reminds me of Johannah Grace, my angel baby I am saying goodbye to too soon. By now, Layne and Belle are letting me know what they want to purchase by knocking things off the racks—one on the left and the other on the right. Needless to say, after getting my frame, we head out before I have to pay for anything extra. At home, we hang our photos and prepare the rest for the grandmas and other family members.

Two weeks later, I have to go back to get another sonogram. This time I tell no one. I just felt the baby move this morning, so I am confident that all is well. I want to surprise my husband with this announcement. I know it's a boy; I can just feel it. I'm wearing flats, and I'm huge and this chin hair situation has me convinced I am making a man. As soon as she puts the scanner on my tummy, he starts showing off. I think the cup of orange juice helped. I have to remember to shout out my fellow twin mom message board where I got the idea. The acid from the OJ had my man dancing and moving. Now, I have to create a cool way to present my husband's first son to him. He won't be home until after midnight because of

the show on campus, so I have plenty of time. Mommy has the twins and my boys for me. I always thought about how I wanted to surprise him, and I work hard to design the perfect plan.

I am trying so hard to stay awake until he comes home, and I am failing miserably, so I decide to lay at the top of the steps. That way I can't miss him. The door opens, and he laughs.

"What are you doing asleep on the steps?"

"I have a surprise for you."

"What is it?"

"Well, first you have to put your bag down and come with me."

I walk him over to a card on the table and ask him to read it.

Children are a heritage of the servants of the Lord.
(Now, go to the place where you brush your teeth.)

Another verse meets him on the sink. He reads it, and off he goes. Five more times he engages in this exercise which leads him to the family room. There he sees a wicker basket with pink and white balloons hanging from it. The tissue paper is pink as well. There are gifts inside the tissue paper with a card. He sits down in the chair with a cheerful yet disappointed face. I know my husband. He is smiling, but he wants a boy, and he's not hiding it very well.

I turn on the video camera to begin rolling his last session. He reads the scripture.

Psalm 127:3-5 "Sons are a heritage from the LORD, children a reward from him. Like arrows in the hands of a warrior are sons born in one's youth. Blessed is the man whose quiver is full of them. They will not be put to shame when they contend with their enemies in the gate."

I can tell he is no longer listening to what he is reading because he is blinded by the abundance of pink.

"Go ahead and open the gifts in the basket."

"Why? I already know what it is now."

"Just open the gifts."

He starts to unravel the baby pink and fuchsia party paper and sees the first gift. He puts his head into his hands and starts to sob. It is a bib that says, "Daddy's Little Slugger." In this moment, his dream comes true. He sits in silence probably thinking about the wonderful relationship his father ensured they had. He never did open the rest of the gifts. That was enough for him. Five months into marriage, and he is getting his baby boy.

I don't even feel as pregnant anymore. I know there is a baby in there, but something is missing. Part of my maternal feeling has disappeared. I am trying to focus on loving this baby, but it's so hard to think of this as a wonderful blessing.

By now, being the financier of the home is stressful. I know Gig is working, but I can't see the household benefits. He says he needs his whole check for his car note, cell phone

bill, insurance, gas, personal expenses, and food. That is no longer working for me, and I need to see the money.

What I didn't know is that the truck payment had been inconsistent long before our union, and the sound of a tow truck around two in the morning was the way I found out. I see lights, and my husband sits up in the bed.

"Baby, I think they are here to get my truck."

"Get your what? You didn't look outside. Why would you think that?"

He gets up and peeks to confirm that it is so.

"Gig, what is going on?"

"I haven't been paying it because you said you needed the money for the family."

"What are you talking about? What money do you give me?"

"You sat me down and told me we weren't making it. So, I stopped paying it. Let me go out and get the stuff out and get my license plate at least."

What is he spending money on and where is the money for all these photography shoots and videography stuff? I'm confused as hell, but right now, I need to be ready to support him when he comes back upstairs. I put my pain away and focus on my husband's loss. He comes in with his bottle of Jergen's lotion, Norfolk State tag, and a pack of gum.

He gets back in bed, and I'm sitting up with my body firmly placed on the headboard.

"Don't worry, baby. We are going to get another truck, and it's going to be bigger and better than that one. Okay?"

Gig has no words and lays his head on my thigh and props up on my huge belly.

I feel his tears on my legs, and I can't speak any other words, but the word of God.

"His word says that He would never put more on us than we can bear, so we can handle this. We just have to work together as a family. Plenty of families operate with one car."

Where the hell is his money though?

By my eighth month, I am extremely uncomfortable and sleeping sitting up. Nothing helps including that loud fan he likes to blow all night long. But I can't have the TV on?

Chapter 36

MIDNIGHT TRAIN TO GEORGIA

My husband left the bedroom for permanent basement dwelling. You'd really rather sleep on the couch than sleep beside me? Really? There's more to that, but I don't have the time or energy to figure out grown people when there are four little ones under age six who need rearing and constant supervision. I can't help but feel that part of his manhood left in the tow truck pulling away the last thing he had left from his singlehood except that cell phone number.

At the very same time, the National Board for Professional Teaching Standards memo caught my eye in the district's weekly bulletin. I recently finished my master's and have been thinking about a doctoral degree, but this opportunity comes with a thirty-credit graduate certificate with the George Washington University for a nominal fee and several thousand dollars for ten years! This is my plan to pay for my doctoral degree. I will use tuition reimbursement and the National Board Certification. That's it! Gig likes my plan, but then again, he usually goes along with whatever I say anyway. I immediately apply and try to coach a few to join me. My

invitation is met with instant resistance wrapped in fear and ignorance.

Oh, that's too much work!

I heard that process is harder than getting a master's.

No thank you. I don't need all of that.

Well, I do. I see the opportunity that exists for educators with those four letters behind their name, and I want my teaching to be known nationally as high-quality and engaging for students. This is not the traditional way I thought this would go. I am not in the general-core classroom anymore, so I grapple with the idea of pursuing the certification. I land on English Language Arts for Adolescents and Young Adults. I know I don't plan on going back to elementary school, but I may want to do high school, and I absolutely will be someone's professor. AYA-ELA it is. The interest meeting is packed, standing room only, but only sixty survive and become the GWU Cohort for Teacher Leadership. No teacher in the history of my school has achieved certification, so being first feels great. I can't think of a better class to achieve this with. My AVID babies continue to amaze me with their creativity and desire to learn. I am honored to be their educator. Only my class could create lyrics and a dance routine to Soul For Real's "Candy Rain" and complete their own rendition of the "Twelve days of AVID," including five Cornell noooooooooo-tes, instead of five golden rings! I know I am not supposed to

have favorites, but secretly we teachers do, and this class is it. I think these children will be my AVID babies forever.

The actual classes start in March, and I'm still pretty busy with the baby. Our c-section isn't scheduled until April 15th, so I will be able to get in at least three good classes. The first class is crucial even though we are meeting at the local high school. I haven't been in the seated position for this long in about a year, and my bladder has a mind of its own. Signing our lives away is another dagger as we have to commit to staying in the district for three years in exchange for them paying for our coursework and national board expenses. I have no desire to go anywhere else, so I sign and head to the notary table without hesitation. The first assignment is the Community Walk, which is due on April 14th.

Chapter 37

SIR DUKE

Sid was born with a small infection, so he can't come and hang with me in my room. I have to go to him, which is not bad because I need to be up and walking anyway. The problem is that my meds schedule is not vibing with his feeding schedule, and I have given strict rules not to artificially pacify or provide any other nutrients but my milk. So, this time they call after I had just taken 1600 milligrams of Motrin and a Percocet, and I pass out on the way there. Needless to say, I wasn't allowed to walk to him without another person or using my walker like an old lady.

My coworkers really understand me. They know how important it is for the AVID showcase to be great, and they will do whatever it takes to make me feel comfortable. Len answers my call.

"Can you make sure you bring my laptop when you come?"

"What's so important that you need your laptop? You just had a baby."

"I have to get the certificate done for a showcase that is this week, and then I need to sign them."

"Look, I'll print them, but I'm not coming back up to this hospital to get your signature."

"Okay, I will find a way. Just make sure they are printed on cardstock please and thank you."

I had Sidney on Saturday, and they put me out on Thursday with two more days left in his weeklong course of antibiotics. Dealing with only birthing one of them is one thing but having to leave the only one I have left is quite another. I'm not strong enough emotionally to keep leaving him, so on Thursday, I say my goodbyes and do not return until Saturday morning when it is time for him to go home. God saw fit for our neighbor to work not only at the same hospital but directly with my baby, and she picked up freshly pumped milk every morning while bringing me new sterile tubes to pump in. All I did all day was eat, sleep, cry, and pump. The girls were getting out of their cribs, and Joshua had just started school, so I was comfortable but missing my babies. What kind of mom doesn't jump at the opportunity to see and bond with the baby she carried for almost thirty-nine weeks? She's the one who couldn't decide whether she was supposed to be in mourning or celebrating, the one who didn't want the birthed son to feel the energy of her guilt and sadness from not being able to carry his twin sister, the one who feels guilty about being upset when God has already

given her more children than some women will ever have. That one. Me.

When he finally comes home, he cries all day and night nonstop. If he isn't nursing, he is crying. It is like he can never get enough, and nothing helps, not swaddling, rocking, riding in the car, singing—nothing. So, I do the unthinkable. I teach him how to self-soothe by putting his fingers in his mouth for him. It works immediately. No more tears. He even tries to put his fingers in his mouth while nursing. He now knows how to be quiet, and I can finally take a shower and finish this paper for class on Tuesday.

Missing class is not an option, even when I just had a baby.

"Mommy, I need to go to class. I can't get a B."

"Ashanti, you just had a baby ten days ago."

"I know that. Do you think I don't know that? I need to go. At least for the first half."

"So, what is it that you want me to do?"

"You really want to know?"

Then she gives me the look.

"I really want you to sit in the car with the children and the baby while I am in class. At the break, I will come out and nurse the baby to sleep and pump the rest of the milk in a bottle for you. Then I want to go back to class."

"You are serious, aren't you?"

"Yup."

"Well, let's do it."

I walk in class on April 22nd, Earth Day, and everyone is in shock that my little belly has disappeared. Yup, it's gone folks, and the baby is in the truck, so I may have to go out to nurse him every two hours.

I pass that class with an above average percentage and enroll in the summer classes. During this same time period, my grandfather falls ill. His heart is weak, and he is unable to help my grandmother out who is still recovering slowly from knee surgery. Soon they become residents with my parents, and they become caretakers for the both of them. Day and night, my mother supports my family, her family, and her parents while taking care of a very full daycare daily. I know she's tired, and I wish I could help more, but I need to finish these GW classes and this National Board certification.

Months later, after nursing Sid and putting him down for a nap one gorgeous Wednesday during my maternity leave, I hear a jingle at the door, which is familiar, but the time of day is not. What is Gig doing home so early? Maybe he came for a quick lunch treat, but he knows it hasn't been six weeks since the delivery. I met him on the steps, and he had a small box and carbon piece of paper in hand.

"Hey babe, what are you doing here so early? You wanted to hang out with your favorite wife?"

"Not quite, Ashanti. They let me go."

Gig took another job much closer to home, which helped out a lot with one car.

"What? They can't do that. You just got . . ."

"I'm still within my six months, Ashanti. They can do that."

"Well, what was the reason?"

"I was coming in a few minutes late when I had to come in from the airport a few times."

That month the part time job that Gig picked up at the airport conflicted too much with the full- time job he acquired less than a year ago. I did the only thing I knew to do. I called Doc. Even though Gig never taught before, on Monday he would start as an English teacher until the end of the school year.

Chapter 38

SUGAR, SUGAR

The other major event on our calendar is Gig getting a vasectomy. Having five children is definitely a handful, a basketball team, and any other analogy that goes along with the number five. I also don't want to go through another loss like we did with Johannah, so Gig makes an appointment for a consultation for the big snip in early January 2009. Sid is about eight months now and starting to enjoy some solid foods which means my menstrual cycle should be coming back in the next few weeks. With a cycle comes the potential of having another baby or set of babies, and I'm thirty, so we aren't doing that. I have my girls, and he has his boy. The Foster name will be carried on, and we can officially close shop as long as he does it. I've been poked, prodded, and sliced open enough in the last three years. I'm tagging him in. No more for me.

Both of us attend the appointment because I am a believer that men listen differently than women. Women hear everything while men hear what they want to hear. After a series of questions about hereditary illnesses, exercise, diet, surgeries, and the like, his vitals are collected. The doctor asks

questions about how often he gets up to go to the restroom at night, which although I couldn't see three flights of stairs away, I could answer based on the amount of times I heard the toilet seat go up. He says two, and I say five. More questions than I have ever been asked follow, like how long it takes a cut to heal, and do you get thirsty more during the day or at night, then the doctor pricks his finger. She asks him if he was seeing double to which he just laughs and says no, not as long as he has on his glasses. As the number rolls up, the look on her face is not settling. I couldn't tell if it was amazement because it was so good or disgust because it was so horrible. But whatever it is requires her to bring in a nurse. Gig and I are looking at each other, wondering what the problem is as she begins speaking.

"Sir, your blood sugar level should be between sixty and one hundred. Really no more than that."

"So, what's his number?"

"Six hundred and seventy-five. You should be in a coma right now. I don't even know how you are still standing and talking to me right now. You can either take him directly to the emergency room for this crisis, or I am prepared to transport him immediately. What will it be? I need to know now."

"I will take him. I need to call my job and let them know I can't come in today."

"Me too."

"Here are his vitals and his sugar level. Go now and we'll set up another meeting once we get this under control."

"Come on, Gig, let's go."

"So, doctor, what about the vasectomy?"

"Let me help you save your life first, sir. This is serious. You could have died if you had one more day like this. Until your sugar levels are under control, there is no talk of surgery."

The early morning vasectomy consultation turns into an all-day affair as he receives bag after bag of saline solution and insulin shots to bring his sugar down. That evening, he was released with the most terrifying of doctor's orders; insulin shots for the next three months on a schedule.

The first two weeks I have to give him the needle twice a day, and then it decreases over time as pills are introduced to this new way of living with diabetes. Three weeks later, a few days after Valentine's Day 2009, my milk decides to dry up. I try everything to get it started back up, fenugreek, steel oats, and Mother's Milk tea, but my milk wouldn't budge beyond a few drops. I have never had an issue with milk supply, and as a matter of fact, Sid always had an oversupply. I still think that has something to do with carrying him and Johannah. I try to supplement with the store brands, but Baby Sid is very particular and only wants mama milk, so I make an appointment to see what the doctor can prescribe to get my party started once again. Since I haven't started my cycle yet, I bypass the urine sample and go straight to the room. Why would I waste their resources checking something I already

know? The "preggo" people pee in the cup; I just need some goodness to get my baby fed.

"How are things going?"

"They are okay just busy, you know?"

"Yes, I know."

"And you are having issues with your milk supply, right?"

"Let's try this," she says while writing the prescription. "Did you leave a sample for me?"

"Oh no, I haven't started my cycle back yet, so I didn't leave one."

"I need you to do that and bring it back to me."

I obey and bring the cup back to her to calm her little nerves, so she can check the box.

While I wait for her to go through the motions with my pee, I check a few emails and Facebook.

She turns to me, rips up the previous prescription and says, "Here is the one you need. This is for prenatal vitamins; you are pregnant. See you in about four to six weeks."

She chuckles and leaves the room, but I'm not amused. I'm still sitting on the patient's table trying to process what just happened. As stressed out as the marriage has been lately, I think we only made love on Valentine's Day and that was probably a "just because" effort from the both of us. The insulin is no joke, and it is not as easy as before to keep the fire burning. That night, and a few prayers later, I visit Gig in

his basement dwelling, stood over him on the red couch, and alerted him of news I knew he didn't want to hear. Baby six is coming and there is nothing we can do about it but rejoice. God chose us once again. He cries, but I am unclear about the tears of joy part. I just know that after the announcement, I left him sitting up with his head in his hands.

Now, we have to break the news to mom. She's so consumed with Grandma and Grandpa, and I already have five. I'm not quite sure how she's going to respond, so I take the passive route. I send an edible arrangement with a message that gives a clue about what else is happening with us.

Date: March 19, 2009

Subject: Edible Arrangement

Mrs. Helen,

Thank you for the tender, loving care that you give to our family!

Enjoy your sweet treat!

Love,

Gig, Ashanti, Quincy, Jay, Layne, Boom, Sid, and Baby Foster

Why hasn't she responded? I know she is busy with Grandma and Granddad, but she still has the daycare kids.

Later that day she responds via email.

My Blackberry pings with her special ring tone alert, and finally I get to read the email congrats.

SUBJECT: Fruit Basket

Thanks so very much for the fruit basket!

If the deliverer read the card correctly, you're pregnant.

If you are, I am extremely upset. I already have too much on my plate, plus my mom and dad and now another grandchild for me to take care of!!

I am upset. We will talk Saturday or Sunday.

Well, that is the last thing I expected to read. Today is Thursday, and I am carrying another baby that you don't want to talk about until Saturday or Sunday? It's not like it was planned. Hell, we tried to stop the process altogether but couldn't. And how about this? I can have as many babies as I want! You have the right to say you can't take care of anymore of them, and we can find another provider. But I'm your daughter. I'm finally doing right, and this is what I get in return?

I don't have the balls to say that to her, so I get through pick up and departure on Friday and await Saturday.

Chapter 39

HAPPY BIRTHDAY TO YOU

First birthdays are always huge in our family. They draw many adults and children, ready to celebrate the brand new one-year-old. Some relatives are coming from as far as Norfolk since they haven't seen him since the baby blessing in November at Thanksgiving 2008. I have yet to meet a one-year-old with more than three to five real friends to invite. The rest are the older children and adults, and this party is turning out no different.

I never thought I would be planning a first birthday and carrying a baby at the same time. Baby six sure did sneak up on us, but I am extremely happy about him or her growing in my little tummy. To heighten the experience, the twins are only two years old and about to turn three in four more months. I am exhausted, but thanks to Mel, Sidney's godmom, Angel, who is Joshua and Quincy's godmom, and my mother, I was able to get the house cleaned. Mommy even cooked the meats for me. Uncooked meat still makes me uncomfortable.

The cupcakes were my mom's idea. I wasn't sold at first, but mommies know best. When ordering the baby boy's cake,

I let the pregnant brain take over, and I came home with a three layer, ten-inch, round cake in my favorite flavor—carrot! Little kids can't eat that, and quite frankly, I am not planning on sharing it. During my anxiety, Mommy suggests the cupcakes as we head to the grocery store.

"You don't need to spend your money on a cake that they're just going to mess over anyway. Get some popsicles and cupcakes."

"But what about him smashing the cake? That's a tradition."

"A tradition for who? And what is the worst thing that can happen if you don't have a cake?"

I'm frantically trying to search my brain for something terrible, but nothing surfaces.

"Believe me, Ashanti, it will be fine."

"Let's get these then. They're gorgeous. I've never seen a platter like this in the cooler before."

"That is because the Lord placed them there just for you."

"You love to give God credit for everything."

"All the glory!"

I turn to toddler twins Boom and Layne in matching grocery carts and ask them if they like the cupcakes. Layne shakes her head yes as her mouth is preoccupied with the thumb she's been sucking since she was in utero. Boom's eyes grew from big, beautiful, brown dimes to huge caramel nickels. I put the cupcakes in the back of her cart, and her eyes never left those cupcakes. I should have known she was up to something.

We are home, and everything is in place. We have about one hour left before our guests arrive, and we all retreat to the living room for some good ol' Judge Judy to pass the time. I believe Judge Judy is the only person who can calm my mother and make her sit down and relax. There is a standing rule of no talking when Judge Judy is on the screen. I'm just crazy enough to go along with it in my own house.

Boom has already asked for a "coucake," as she calls it, three times getting the exact same response of no.

Her response is just as exact, "Wait?"

I tell you she is a textbook Leo. She refuses to give in when it is something she wants.

Soon we hear a faint melody coming from the kitchen. It's Boom, and she's singing again. Boom is always singing, and we always sing with her when we know the song. This time, however, is a bit different. Her song is a little muffled but melodic nonetheless. We can't see her from around the corner, but we join in anyway.

As we join Boom in singing the Happy Birthday song, she starts to get a little louder, an indication that she is walking towards us. She sings another round of the chorus, and I just happen to look up and over to see that the entire platter of thirty-six cupcakes with whipped, white icing and rainbow sprinkles is now slanted parallel to match the contour of her little toddler body, almost hitting the floor. And she continues to sing as she walks slowly towards the baby who

is sitting in the middle of the living room floor. The cupcakes are slipping out of her hand, yet she is still singing!

No one moves for three or four seconds, possibly in awe of what we are seeing and wondering if we are dreaming. When reality hits us all at the same time, it is Q's "Awww Boom Boom" that helps us realize that this is really happening.

All at once, I gasp and begin to cry. My mom laughs, and Angel goes into action mode to try to save the cupcakes. I excuse myself immediately because I want to scream, but I don't want to scare the children. Mom, in true mom mode, tries to readjust the whipped cream massacre that has occurred to my baby's first birthday cupcakes, which would have been fine, except she tries to convince me that they are just fine.

"Just fine? These cupcakes are far from just fine."

"Well, all they're going to do is make a mess out of them anyway. So, what? You're not going to serve them now?"

"You can't serve food like that Mommy. You know that! I can't believe she did that!"

"Well, you did sing the Happy Birthday song with her. That's like giving her permission."

The room erupts in laughter, and I retreat for a few more minutes. I'm pissed.

After emptying my bladder, I have time to think a little more. It is kind of funny. I just wanted everything to be perfect. I soon realize that everything is as it should be.

The party begins and ends, and Sidney Joseph has a house full of people and presents to celebrate his birthday. Mission accomplished, even with the upside-down whipped cream all over cupcakes. One guest noted that the cupcakes had "personality" or that "those cupcakes have Boom written all over them." I am stressing for nothing. I officially announce my fifth pregnancy and my sixth baby, and to my surprise, everyone already knows. I guess it is my glow. With celebrating Sidney comes celebrating Johannah and the little time she spent with me. Today, we should have celebrated both of their birthdays, but God said no. And when God says no, it means her circumstances would have been more than I could handle. His word says He will never give us more than we can bear. He gave me her and took her away, and that is what I can handle.

But why do I need to handle this pain? And with baby six, the day has come. Majesty, our Nissan Quest SE with leather captain seats and full technology package is too small for our ever-growing family. Gig and I search all types of vehicles, trying to find the perfect one for our family, one that seats eight with at least four attachments for car seats. We will have four in car seats, one in a booster, and Quincy, my superhero.

By June of 2009, I am finished with the National Board process and earn the graduate certificate while six months pregnant. Certifying is going to happen, so now it's time to start my journey to Dr. Foster.

Chapter 40

ANOTHER STAR

The rest of the pregnancy is perfect. I can't think of a better one. I'm built to do this, but not anymore. Dr. G made it clear that my uterus is way to flimsy, and I've been through five pregnancies one being a high risk and three ending as caesareans. Weeks after baby six is born, I learn that I didn't achieve National Board certification the first time as I had hoped, but I have two more years to get it together. I only missed it by a few points too. By December 2010, Gig finally gets snipped. No more babies for us. And with that snip, something left our marriage. I'm just not sure what. But something is different.

Being officially back in school is an amazing experience. Dr. Foster here I come. The huge blizzard gives me time to figure out which doctoral class to start first.

I need to finish this doctoral degree before Q gets to high school, so I need to be done with this degree in four years. It's going be a challenge, but I can do it. So, instead of taking two classes per semester, I'm actually going to take four. That's going to take some major organization on my part especially with a newborn baby. I have a goal, and I'm going to

see it through. And wouldn't you know, my very first class is something that I love, research. Something someone told me very early in the doctoral program is that when you are given the opportunity to do research about anything, make sure it has something to do with the topic that you want to study for your dissertation. That way it helps you get chapter two of your literature review done faster. I thought that was an excellent idea, so the very first thing that I write about is the thing that I love the most, college and career readiness.

Online learning is also new to me until this program begins. I took a class for recertification but never an entire program. I do what I know best; I used the Google calendar and a syllabus to guide what I needed to do. For me, the Google calendar is the end all and be all. And if it's not on the Google calendar, chances are it is not going to get done. So, every time the syllabus becomes available, I print it out and actually type assignments in the calendar three days prior to the actual due dates. That way, if I'm behind or miss a day, I'm still in the okay zone. Another thing I have to consider is the actual time to read the documents. I didn't anticipate the books being online, and I learned that I need a real book. So, it's been a lot of ink and a lot of paper used actually printing out chapters, so I can mark on my text.

In the online world, you have to send in a classroom experience which means when one of my colleagues types something or responds to a question in the discussion box, I have to comment on at least two of them no matter how ridiculous their responses are. One thing I do is make sure

that I post early, and then have an opportunity to go back midweek to comment. If you wait until the last minute, everything that you thought about saying may have been said already, and then you will be forced to make up pleasantries. Whoever said online learning is easy is crazy, but it's the only way I can get through a program of this caliber with a life like mine.

My laptop becomes a permanent fixture on my lap or on the side of my bed. Once everyone is asleep, the work is completed. Gig is still working the part time job in the evening for the airline, so he doesn't get home until after eleven anyway. Anytime one of the children come in and see me on my computer they will automatically say, "Mommy when you finish doing your work can you…" Well, sometimes I wasn't doing my work; sometimes I was just on Facebook, but their understanding is that whenever the laptop is open Mommy is doing work, and that doesn't make me feel too good. I know I have to change some things as soon as the startup program is done. We're instituting some boundaries, so I can have more face time with my children.

Chapter 41

BREATHE AGAIN

I appreciate being able to nurse all six of my babies. I really do. I don't have to get up and warm a bottle, look for formula, wash bottles, prop bottles, hold bottles, and it helps me shed these baby pounds. But there is just one issue that I wouldn't wish on anyone. When babies don't complete a full serving of milk in a session, sometimes milk stays in the nipple, and if I don't clear out my nipples soon enough, those ducts get clogged. No one wants clogged ducts! Men have no idea what women go through, but sometimes I wish they could just once. The milk doesn't stop producing just because it's clogged. The baby has to eat, and the mind tells the body to keep doing what it's doing. But that duct rules everything.

What's worse is that if I can't get the clog out, it can get infected and turn into another bad word in the nursing community, mastitis. They should have just called it "nipple influenza" because that's what it feels like to me. I've tangoed with it a few times before, and now I know better.

After feeding the three-month-old his midnight liquid gold, I feel the beginning stages of a clogged duct under my

arm. This one is a doozie! What helped in the past is to use the hot water from the shower as I physically move the clog from underneath my arm to the breast, so the milk can begin to flow freely again. The average breast has fifteen ducts, yet it only takes one to ruin your life for a few days or a few weeks. And this is my one.

I get the shower as hot as I can possibly stand it and get to work kneading the side of my breast, awaiting some relief from the pain. It is so hot that the steam overtakes the entire shower in my master bedroom, and I am sweating like crazy. Then I feel something I haven't felt in years since my wedding night: fast-paced breathing, heart beating really fast, and tingling lips. Oh God, no, this can't happen in here. I get out while the shower is still running and sit on the toilet in my towel to catch my breath.

What I can't do is pass out in this bathroom. The children are sleeping, and there is no way that Gig can hear me all the way down in the basement. I have to get this together for the sake of my children. I start to breathe as normally as possible when I suddenly start to feel coldness at the tips of my fingers and feet. The shower is still going, and I'm still hot and sweaty but having chills at the same time. I reach for the doorknob only to hear cries from the baby.

That's the plan. Feeding the baby will calm me and help get the clog out. I get the baby and sit on the side of the bed to nurse him. He's quietly nursing, and I'm starting to shake.

This is not going to end well.

I reach for the phone to call someone, anyone at this point. With shallow breaths and eyes that won't even stay open propped with toothpicks, I only have enough strength left over from holding the baby tight to press redial.

"Hello."

"Hello. Ashanti, are you okay?"

"I can't breathe. It's too hot."

"Where's Gig? Ashanti! Where's your mom?"

I want to answer her, and in my mind, I am. But she can't hear my mind. She can't see my thoughts, but she knows me. She knows my history. She will know what to do. She's my Angel.

"Hello. My name is Angel, and I'm on my phone with my friend. She needs help. She's in PG County."

I hear Angel talking to the Baltimore Emergency Unit on the phone with Prince George's unit. Thank you, God. Someone is coming to save me. Honestly, I don't know what happened for the next few minutes, but I opened my eyes to a knock on the door and seeing the reflection of lights on my blinds.

They are here to help me finally!

I am still unable to move from the seated position holding onto this now content and sleeping baby for dear life. I can't get up to get him in the crib, and I still have on this towel. To hell with it at this point! I just need some help.

Gig rushes up from the basement, and I can hear the emergency workers say, "Is there anyone here who needs help?" My door stays wide open, so I can hear the children with their asthma issues. Plus, I have supersonic hearing.

He answers, "No sir," and I start to panic even more. With the last effort in my body, I call out to him and push the dresser to the wall. "Gig!"

He opens the door back and says, "Wait. I think it's my wife! Follow me upstairs."

The next morning, I wake up in my bed. I am told that I refused to go to the hospital and asked the emergency workers to be quiet, so they didn't wake my babies up. That sounds about right. I'm surprised I didn't ask them to wash their hands.

Life caught up with me.

"Baby, I'm going to stay home with you today."

"I'm fine; I just need some rest. That took a lot out of me."

He takes my laptop and says, "Well, you can't rest with this thing in your lap."

"Go over there and get my baby, please. I can't believe you let her take my baby. He's probably over there eating chicken legs and drinking Pepsi right now." We laugh.

"Okay, I will get him, but you need to put the laptop down."

"Okay, I will when you get back."

Oh, now you want to stay and be with me? If you were with me last night, you would have been able to help me.

He returns with my newborn and his worrisome fan.

"Can you PLEASE turn that fan the other way? I'm really fine. You can go back downstairs if you want to."

I'm so annoyed. The one thing you say you left the bedroom for and here you go with it in my face yet again. Are you here for me or you?

Chapter 42

SIXTEEN CANDLES

And in the midst of everything else going on in life with graduate school, AVID, and just being a mommy of six, something very exciting is happening. My sister is turning sweet sixteen in April. I didn't have a sweet sixteen party, and that's okay, but we are going to do it up for her. Now, the only thing she needs is a dress. I didn't realize that getting a dress would take us through so much turmoil, but it did. We go from store to store looking for the perfect dress for my sweet, little Maria. Eventually, our search moves to the Internet, and things took a huge turn. Baby sister found many beautiful dresses, and I mean gorgeous dresses with beads and sequins with the right cut for her beautiful, growing body, but I want to talk to her about it, so I sent her an email.

Maria,

Of the two dresses you selected, the first dress is more appropriate for your age and Christian lifestyle. The description on the second dress gives you an indication that it is revealing before even looking at the dress.

It states: *"This stunning dress for prom or cocktail parties features a one shoulder design that is chic and elegant. All eyes will be on you as you arrive in this amazing purple dress. Made of 100% spandex, this dress has a form fitting silhouette and a **sexy open back that is seductive**."* I'm sure that is not how you want to portray yourself at 16 years old. I will order it if Mom gives you permission, but I am also letting you know that it is not appropriate. I want to make your 16th birthday a great time for you, but I will not neglect to share with you as your big sister.

Love,

Sis

There is no way that I am buying her that dress as a sixteen-year-old.

Her response was:

Thanks for the information. I have something to say to you as well. As you know, this is my special day; therefore, I would not like you showing your breasts or dressing dirty at my party. My friends and family will be there. I don't want my name to look bad. We are sisters, and we do look out for each other.

Her response to me blew me out of the water. Is this my little sister talking to me right now? No problem.

So, I say:

You don't have to worry about my fat ass being able to fit into a dress that fits your body type or me being a hypocrite about my Christian lifestyle. And feel free to go off all you want but know this, if it weren't for me encouraging Mom, you wouldn't be having a $3,000 party. And if it weren't for me, you wouldn't have the invitations you do. But don't worry because I won't be at your party that I have worked so hard to make wonderful for you. I won't do any other things to embarrass you. It's unfortunate, but I'm not stressing you. You are 15 and have lots of growing up to do.

I see how to govern myself from now on. I will never have anything else to say to her about her dress, her behavior, or her anything. I know where I stand.

I cry myself to sleep again that night, and this time, Gig was there to console me.

"Baby, you know she's just a child. She didn't mean it. She didn't mean to say those things."

"Yes, she did, Gig."

She meant to say those things, and I'm her sister. And no matter what my past has been, I've always been her sister, and I feel like I've lived enough life to know that the dress is inappropriate for a sixteen-year-old. Whether I have five baby fathers and eighteen children by the age of twenty-two, today I can still tell her that the dress is inappropriate!

I'm not going to buy it, but my question is why didn't my mommy tell her that she couldn't have it? Why do I feel like I have to be the bad guy?

You know what I'm washing my hands of the whole ordeal! I won't even go to her party.

Later that night, the inevitable happens. BK needs to be fed, so I pull up the computer while he's nursing and see a letter in my inbox.

Ashanti,

I know that I have deeply hurt you, and to tell the truth, I really didn't mean it. I wrote terrible things because I was SO MAD that I couldn't get a dress that I wanted. I defamed you so badly. I never wanted things to escalate like this. You have worked very hard for my party, putting all of your priorities aside. I have made a huge mistake. I can't bear having my sister being mad at me over a dress. I do realize that I am an idiot for thinking that way and saying such things. I would really like for you to come to my party. I can't stand feeling this way and hurting you by my wayward actions. I am only 15 years old, and I can do and say some outrageous things. I really cannot afford to be mad over a dress because most children only dream about what I tangibly have. If you can find it in your heart to forgive me and come to my party, it would mean so much.

Love,

Maria

The party was awesome.

IF YOU LOVE ME

Our third anniversary is supposed to be spent giving leather gifts, but I have a different plan. I am tired of driving Gig everywhere since his truck was repossessed for nonpayment when we first got married. He's been driving my first car, but he can't help me transport the crew in the little Mazda. He's working at the airport and is working his way up the educational ladder, so we can afford another car note if he stays disciplined. He is so surprised by the big, red bow on the truck I purchased just for him on our anniversary date of July 7th.

Months later, we're still not following the plan set forth in the beginning, so I write him a letter. That's the way I communicate best with him these days since I never see him anymore, even if he's in the house.

October 2010

Good morning husband,

As I stated last evening, I am willing to do whatever it takes to make things work. I propose the following:

In order to keep the truck:

- *Gas up at Costco's (discount gas with membership)*

- *Join Verizon Wireless so that you don't have to pay your cellphone bill. I will pay it if you stay within the minutes. When you go over the minutes, you have to pay the difference.*

- *I will make your accessory lunch each night when you go to Delta. Accessory means you will have everything except your warm sandwich which you can buy at the airport.*

- *I will prepare a cooked meal each night (Monday-Thursday) so that you will not purchase other meals from outside of the home for your dinner. You can eat at home.*

- *All full-time and church monies are not touched. After your car note, we still have a car insurance of $100 a month approximately. When you work an evening or extra church job, that is BILL money.*

- *You will budget Delta money on your own, giving me access to view the progress and help when needed.*

If you no longer want the truck:

Visit Carmax and choose at least 5 vehicles under $10,000. They have plenty. I will trade in the truck, and I will calculate the residual payments that we will pay together until the debt is released.

I hope you can see that my desire is for you to have the best but not to live two separate lives. It doesn't make sense for a couple to have separate bills. We have nothing to hide. We must work together to make these finances gel. There is way too much money coming through our home for us not to be able to make it and save. People raise their families on $700 a month. If we work together, we can maximize all that we have. It's being done on my part. In order for me to help you, you can't shield things from me. That defeats the purpose of my role as the financial planner. How can I plan without a full scope of the finances?

I love you, and I know that we can make things work. You have to be willing to give your ALL. Right now, that is not what is happening. Right now, you are giving me a view of what you want me to see. That's not marriage. Let's get married.

It makes no sense that a family with several streams of income can't get it together. We have to fix this and fast!

I feel like a broken record just saying the same thing over and over again. Such is life.

TURNING AROUND FOR ME

Today is the day, November 20, 2010. The National Board scores are being announced today, and I have been trying to log on all morning. I already purchased my NBCT shirt and frame, so if I don't make it, life will not be fun tonight. It's already noon, and teachers all over the nation are posting on Twitter about passing. But I just can't get into the system! After lunch, my most challenging AVID class comes in. I certainly can't sit and watch this laptop all day, so I put my busy child on assignment.

"Aniyah, since you're finished with your warmup, I need you to watch this laptop, okay?"

"What am I supposed to be looking for?"

"Look for the hourglass to go away and a blue screen to come up. Let me know when it does."

"Okay, I can do that."

I continue to take attendance, and the counselor comes in to ask me about a student. I get the students started on their

vocabulary activity while I speak to Ms. Falls in private. The next thing I hear is Aniyah's big voice from across the room.

"Hey, Mrs. Foster, you said a blue screen, right?"

My heart is pounding, and I jump up out of my seat to see the screen.

"Do you see words?"

"Yes."

"Okay, read them to me."

Ms. Falls grabs my hand because I'm shaking it as if I just slammed it in the desk drawer.

"What part do I read?"

"Just start at the top, Aniyah!"

"You mean the part where it says congratulations in all caps?"

I ran to her and screamed, picking her up from the floor and swinging her around.

In that one moment, my toughest student gives me the best news of my educational life.

I am a National Board certified teacher.

Ms. Falls takes a moment to explain to the students exactly why I am excited, and they applaud and give me hugs. On the same day, I receive word that my application for educational consultant for a national organization was accepted, and in April, I need to travel to San Diego for training to

prepare for my first summer institute experience in Atlanta and Orlando. Things are moving in another direction in my career, and I love it!

It goes without saying that I love teaching. Not only do I love teaching students but now their teachers too. Being an AVID staff developer lets me share my gift of service and passion for ensuring all students have equal access to academic success and social growth. I quickly realize that in order to truly impact students, I need to continue the work with the souls of their educators. So, when the school community decides to nominate me as teacher of the year, I am very honored. I am not used to people making a big fuss about me, and I'd rather not be singled out for any work that I do. Let the work speak for me is what I always say, but this time I need to shine bright like a diamond and let the world know about the amazing things that happen in my classroom. The letters are pouring in from everywhere. These are the letters that I will keep with me forever whether I ultimately become the official teacher of the year or not. I am already in their book.

One particular letter from my principal moved me to tears:

I am pleased to nominate my AVID Coordinator, Mrs. Ashanti Foster, to receive the distinction she deserves—Prince George's County Public School's 2011 Teacher of the Year Award. Please allow me to explain how Mrs. Foster is worthy of this honor.

Ashanti has been under my direct supervision for four years. She has taught in this building since its opening in 2002. In my judgment, her intelligence is well above average, and she understands both students and the learning process to a degree that is exceptional even among our best teachers. I continue to marvel at how Mrs. Foster can manage several school responsibilities flawlessly and her personal life as a wife and mother of six, all while pursuing her doctoral degree in Educational Leadership.

During Ashanti's tenure here, her moral qualities have been above reproach. Her personal characteristics such as patience, consideration, emotional stability, and good judgment are great assets to the school. Moreover, she shows improvement every year. Her colleagues respect and admire her as a professional and friend. They readily welcome her into their classrooms to observe and support, while appreciating her warm smile and helpful mannerism.

In closing, I recommend Ashanti Foster without reservation and should you think it necessary or desirable, I would be happy to discuss Mrs. Foster's qualifications with you personally.

Lord, I thank you for orchestrating my life this way.

Within a week, the following email hits my inbox.

Good afternoon,

*You have been selected as a finalist for the honor of **Teacher of the Year**! The Educator Awards Committee would like to invite you to participate in a 10-minute interview on **Monday, April 11, at 5:15 p.m.**. Additionally, a staff person will be calling to schedule a time to videotape you in action with your class! On behalf of the Educator Awards Committee, congratulations on your nomination for this honor, and we look forward to seeing you on Monday!*

My extreme excitement quickly turns into panic because I'm going to be out of town for the last half of the week prior to the camera crew coming. It's okay. The class is pretty much on autopilot, and they facilitate their own learning, so I know I don't have to do a dog and pony show. That's not my thing anyway. I just need to allow them to be seen as they are, bright and brilliant AVID students! Yes, that's what I'll do. A finalist? I can't believe it! You mean of all the applications they received they chose mine as the top of the list?

The entire time I'm in San Diego I'm thinking about my students and how my room better not be torn up and how they better have all of their work done. So, I decide to do what only I would do. I Skype them during my lunch break, so they are just starting their day back home in Maryland.

I can tell that they miss me so much, and I miss them too.

"Hey, AVID babies."

"Good morning, Mrs. Foster!"

In unison they recite, "Today is a great day because I am learning the AVID way. Writing, inquiry, collaboration, and reading. I will do my best in all that I'm achieving."

"That's wonderful. I am so proud of you already. We will have special guests on Monday, so if you want to wear your AVID shirts, you can. Please, please, please make sure your interactive notebooks are ready to be graded. We will engage in Socratic seminar using Friday's text, so make sure you mark the text and use the questioning strategy for the margin. Any questions for me?"

"Yeah, why we always got to have the same sub?"

"Because I would like your experiences to be seamless, and she understands the routine.

Be respectful. I love you."

My three nights and four days with AVID are nothing but amazing, and I feel prepared to teach the Atlanta and Orlando summer institute in a few months. My plane ride back is spent writing thank you notes to all of the people who endorsed me for this award. They had a very quick turnaround, and I appreciate their support. Their words will stick with me forever. Within just a few more hours, it is time for me to get off the plane and back into reality. I grab my things and make it to my car. Now, I'm officially back in mommy mode

in the mommy vehicle. When I arrive at my mother's house, the children are so excited to see me, and I'm so excited to see them too. I give them huge hugs as they run one by one down the driveway. Next is the big questions: What did you bring us? As I give them their trinkets from San Diego, they are spending more time looking at each other's trinkets than being thankful for their own, but I'm too tired to address being grateful right now. When we get home, my husband comes up from the basement to the kitchen to greet me. Yes, he was home while all six children are at my parents' house less than a mile away the entire time I was in San Diego. Kids can't live off of ravioli, applesauce, and one serving of juice. There's too much complaining when I am away, so off to Grandpa and Grandma's they go.

"Welcome home, baby."

"Thank you."

"Are you ready for tomorrow?"

"I think so. I really don't know what they are going to ask me, but what God has for me is for me."

"You got it, superstar!"

As he retreats back to the basement, I go upstairs and begin to ensure all permission slips are signed and check out agenda books for behavior concerns and homework completion for the week. Thank God Mommy already gave everyone their bath and even styled the girls' hair for me, which is one less thing I have to do before bedtime in a few hours.

The next morning, we all hit the ground running even though my body is three hours behind, still hooked on the west coast and very present on the east coast. Today my class and I will be getting the visit from the TV studio, and I have my teacher of the year interview this evening. What a day it is going to be!

As the TV crew files in with lights, microphones, and stationary cameras, it all becomes real to me, and I start to run the day like a normal day. We engage in a Socratic seminar, so all of the chairs are in one big circle. We start today just like we do any other day with their AVID pledge, and by this time, I'm more than nervous because my principal and assistant principals have come into the room to observe. I'm never nervous when they come in the room, but again, they are never in my room. Then I look up and see a familiar face that makes everything right. One of the crew members is actually my middle school media arts teacher. I was excited to see him, and he actually comes over and says he knew I would do something great. That makes me feel good because he remembers me from middle school, and I am now teaching middle school students. It could not have been orchestrated any better. The students do an outstanding job as they always do. I wasn't ever really concerned about that. I just wanted to make sure that the room was clean.

Later that afternoon, I change into something more appropriate for an interview and head to the Board of Education building. It wasn't until I sat in the waiting room that I remember that I haven't really been interviewed for anything

in years. I start to worry just a little, but I remember to just answer the question. The letter said there are no right answers or wrong answers, so just answer the question the best you can. The other candidate sitting beside me is equally as nervous. We comfort each other and talk to each other about all the things that we do. I share that I have six children, and she shares about her experiences with her family and her children also. If nothing else, this is a great networking experience for the both of us. We wish each other good luck, and I wait. During my interview session, I feel myself clamming up. I hear the questions, but I'm nervous, so I try to answer as quickly as possible. I leave the room unsure of my fate but knowing I have given them my all.

Chapter 45

WORKING DAY AND NIGHT

The night of the reception starts off as a rainy night. Each of my six children are dressed in red, black, and white to match me in my red dress. After taking an official photo for publications and receiving the official flower, I am ushered into a room where the other finalists and I are briefed on what to do when your name is called. As I sit with my two tables of supporters, I look around and take in the moment. I am surrounded by my mother and father, my siblings and husband, and many former educators, students, and colleagues. I only wish each great educator had this opportunity. I vow that I will promote and celebrate my teachers all the time for their hard work with children, but tonight is my night. When they call my name, my video plays, and it looks amazing! When the voice over the video speaks of me having six children, the entire room gasps, but I am used to that by now. As I walk up to the front and receive my plaque, I start to think that my moment has arrived.

The time has come to announce the teacher of the year. My interview mate and I stand beside one another and wish

each other good luck. She whispers in my ear, "I think you got it." I lean over and say, "We will see in a minute." At this point, it's just formality. I lock eyes with my mother, and then the lady in the royal blue dress directly in front of her. I'm thinking go ahead and call my name, so I can read my thank you speech, please.

The name is called. My colleague looks at me and smiles with excitement. Then I say to her, they called your name. She looks shocked and goes up to get her award. I, too, am pretty shocked, but I am grateful for the opportunity. As I head back to my seat with my family, two audience members, including a previous TOTY, come to hug me expressing that they just knew I had won. That is nice and all, but I didn't win. I lost. A few photos and hugs later, the family and I pack up to go home. On the way home, I cry inside. I feel like I have disappointed my school, but I don't know why I didn't receive the honor.

At home, I start to feel the impact of having six children and managing the household with little spousal support. Mounds and mounds of clothes are piling up, and everyone is growing fast! It's time to bless someone else and give some things away. The blessing of baby showers is that you get so many things that the baby, or at least my baby, can't wear them all. There are brand-new clothes with tags, shoes still in boxes, and plush baby boy blankets. I know just who to bless with them. Jay's stepmom is due any day now. This is actually the first time that she and I aren't pregnant together. We had our first girls in August of 2006, and we synced up again in

the spring of 2008 for her daughter in March and my "twin-less" son in April. I email her to see how the new shoes I sent for the baby girl fit and to see if she would like all of these new baby boy clothes. I was not prepared for her response.

Hey Ashanti, thank you so much for the shoes. We love them, and they fit wonderfully. Monday I was discharged from the hospital. We had an emergency, and our baby didn't make it.

What does she mean he didn't make it? He couldn't come home with them right now and is still in the hospital? She's due and has a full-grown baby inside of her. All I know to do is pray and wrap my virtual arms around her. Immediately, the pain of losing Johannah hits me and hits me hard. I just had a hard time at SJ's birthday party as I usually do. One day it won't be like this. He deserves all of me, and he deserves a mommy that can stand to sit through the entire happy birth-day song without excusing herself. What he gets is the over-board party that costs thousands of dollars and leaves the other children wondering what makes him so special. I don't think I would have ever sat and had lunch with my son's step-mom, but in the name of hurt and loss, we did. We prayed, we reminisced, and it was at that table that I knew Johannah's life would be a testimony to others of how to embrace their loved ones and live through it.

The very next month, I am called to do another assign-ment right before school ends. I know my students are tired

of me leaving, but this time it won't be for long. As I prepare the lessons, I get interrogated by one of my AVID babies.

"Are you leaving us again, Mommy AVID?"

"Yes, but for just two days this time. I have a conference."

"Well, we need you here. Can't someone else do it?"

"They probably could but not like me. I need you to be responsible for your behavior today."

"Okay, but do you always have to get the same substitute? She's mean."

"No, she's not mean. She's an extension of me, and she's serious about expectations. You'll do fine, and I will see you guys next week!"

As I leave out blowing kisses, one yells, "Bring us something!"

They don't even ask me where I am going anymore or what exciting place I'm going to this time. Now, they just want to know when they can have me back. We are family, and I belong to them.

Chapter 46

A LONG WALK

Just as I thought, the summer institutes were nothing short of amazing! We fly on standby for free, so getting to the ATL is no problem. This is one of the perks of working part-time for an airline which Gig's entire family and friend circle use often. Gig plans a special dinner at the Sundial restaurant at the Westin after visiting one of our first date spots, the Georgia Aquarium. Sitting in the gorgeous rotating restaurant situated on the rooftop, I really want to be positive with my husband, but I am about to explode.

"Ashanti, what are you thinking about?"

"About how we got here and when it will ever get better. I can't live another year like this. Four years in, and it's painful."

"Ashanti, I know you're hurting, but what else do you want me to do? Every time I touch you, you get upset or just lay there."

"Do you realize that you only come to the bedroom to have sex with me then leave immediately? Do you realize how that makes me feel? Like a prostitute, that's how."

"That makes no sense."

"Those are my feelings, so how can you say that? I always respect the way you see it even if I don't agree."

"So, you are mad because it's too hot upstairs, and I can't sleep, so I go downstairs."

"You always minimize and flip. That's why I just keep it to myself."

"I'm sorry, baby. I'll fix it."

"We need counseling."

"We're two educated people with master's degrees; there is nothing that anyone can tell us that we don't already know."

"But the church has counselors on staff."

"I don't need the church people to know my business, and your mom is working there."

"Well, can we at least go back to Couple's Ministry on the dates you aren't working or go hang out with Keisha and Colby? They're our age."

"I don't know them. We'll just be talking about weather and politics."

"We can only get better by having accountability partners and getting into ministry and not just working the camera, Gig."

The flight and ride home were silent. Months later, he finds his own counselor outside of the church after a last resort protest from me. It ends with me walking home from the neighborhood church. I can't compete with pornography, but

God can. The entire way I sing: *Lord, do it again, make a way out of no way, Lord I know you can, manifest your presence, manifest your love, you've done it before, please do it again.*

Every time we try to have a civil conversation, it ends up with one accusing the other of something and him leaving, so the safest communication at this point is the written word. The day after meeting with the pastoral counselor, October 11, he sends me an email.

Hello my wife,

I want to thank you for coming to counseling with me to see what we can do to repair our marriage. I'm taking full responsibility for the state of our marriage and your frustration level. It kills me to see you so distraught and uninterested in me. That is not how you were when we met, so I understand that my actions have gotten us here. I know that you are tired of me saying "I will do better" or "I will change" and "I'm sorry," etc. I honestly don't know what to do or say to make things better. You have made it clear that there is nothing that can be said or done, so all I can do is pray for guidance and understanding.

I'm embarrassed that I've caused this rift between us. It's obvious the way I've chosen to deal with things that we disagree on has been counterproductive. I'm trying to be the man of a household that I have no clue how to run. I need your help. When I ask for your opinion on something, it makes me nervous when you say, "you decide." I'm just being honest. I have poor decision-making skills, and at times, I'm afraid that I

won't make the right decisions. You always make the right decisions, so I value your input and advice. When I don't get it, I feel lost.

I'm making the decision to take the pastor's advice and move back upstairs starting tonight. I know that you said you are not comfortable with me being there and that you will feel like I will be invading your privacy if I come up there. However, I felt the pain in your voice when you said that you feel alone and not supported. I know I need to reverse that if you are to ever be in love with me again.

So, what I will do is what you advised and do what I think is best to be a good husband. I will start by creating the list of what I need as the pastor advised. I will also take the responsibility that I have been ducking for so long and make payment arrangements with the people who I still owe money. Even though I'm scared to death about it, I'm clear that if I want stuff in my name and to be an effective head of the household, I have no option but to correct the horrible fiscal behavior that I have engaged in since becoming an adult. It's shameful that I will be 40 years old next year and am in such shape. I have to work on this.

I will stop the futile efforts of edible arrangements and other things as I know it's an irritant to you. I will just do my best to honor my word, and hopefully, we can turn the corner.

My biggest fear is that I've done irreparable damage to our marriage and that you no longer want me in your life. I have never seen you so disconnected, physically uncomfortable, de-

tached, and uninterested as you were Tuesday night. Again, I know that you were only in that posture because of my actions, so again, I feel that weight. I can't remember the last time you called me baby, smiled at me, had a happy tone in your voice when I called you, kissed me out of the blue, or just had a friendly conversation. I long for those days again, and I'm hopeful that we can get back there.

For a while I have been struggling with the fact that I wasn't doing anything to glorify God, including not leading my family down a spiritual path. I know that I'm supposed to be doing something, so I have to take a class or continue to pray to find out what it is. This was confirmed to me when the pastor berated me for not tithing. So, I will start doing that as well. I will need your help in deciphering what needs to be given.

I ask that you read this email with an open heart and mind. I know that this is more of the same stuff over the years. I don't know how else to approach this. This is a very confusing and difficult part of my life. You have to understand the tension on all of my jobs compiled with my known shortcomings at home and my flight from God. I'm hoping that He will lead me in the right direction to fix all of this.

I love you and want you in my life forever.

Your husband.

Chapter 47

SEASONS

When asked about teamwork, my AVID site team is at the forefront of our AVID success. Having the right members on the team is the key to moving any organization forward. Because I know that, I took my time looking for members who love children. If you don't love children, you can't be on my team. I will coach you and train you, but I need the core of your soul to be the work of growing and loving children. Second, I look at what I bring to the group and what else is needed. We need someone tech savvy, someone non-classroom based, someone who speaks another language, and definitely a parent and a student. It has taken me a few years to build this team, but I have to say that it is amazing. Our program now serves thirty-three percent of our building, and parents are calling a year in advance to make sure they get an opportunity to apply. I never thought we would have to turn people away. I never thought that the program would thrive so much that parents of talented and gifted children who at first looked down on the AVID program wanted to be in on the perks like college tutors, guest speakers, and college tours.

The college and career ready culture is truly alive on this campus, and we are well-positioned to go to the next level in preparation for National Demonstration status, or at least I think so. Lately, I feel like I have hit my professional ceiling, but I'm too comfortable here and afraid to try anything else. If I leave, what about my own children? I'm used to having them close. Their elementary school is in walking distance to me when I am here. Give me another year and this will be the first Demo school in the state. We have what it takes! Just one more year.

After the summer of 2012, the energy in my school community changed. Instead of feeling like a family, it feels like the survival of the fittest with by any means necessary approaches to win. Because my focus is always teaching and learning, I am blindsided by some allegations that misrepresent the core values that I stand for. I will never compromise my integrity with my husband, my children, or my career and being used as a pawn to win is not going to work. No weapon formed against me shall prosper. God didn't say the weapons wouldn't form, but He said they won't take me out. And they didn't.

That one more year turned into a time in my life that I had to lean totally on God and my family to endure. I believe God is tired of me ignoring His subtle hints to prepare to move forward. He warns that I have outgrown my pot, and my roots are crowded. I am busting out of the pot, roots exposed. I need to be replanted in a larger pot with more fertile soil. It is a strong wake up call, and after months of

thinking and praying about next steps, I make up in my mind that I will take one step and trust God to lead me the rest of the way.

During this time of immediate transition, I acknowledge a few things that will guide my every moment from this day forward.

- Everyone is not your friend, so keep your circle tight.

- Therapy and counseling are necessary when going through traumatic experiences.

- Depression is real and to ignore it can be death to any relationship, including the one with yourself.

I realize that in order for me to be whole for my family and teach to the whole child at school, I need to rest, feel secure and safe, and have a sense of belonging. I have none. My cup is empty, and the only way to get it is to realize that no man can fill my cup, not my husband, my parents, or my kids, no one. I'm really low. I've been on autopilot since 1999 when I took twenty-one credits a semester while pregnant to now enduring the school and doctoral work heartache all at the same time. It seems I'm raising kids and running a home alone while my husband retreats to the basement. I'm waving the white flag. This school drama is the last straw. Autopilot is cool on an airplane until something in the dash does something out of the ordinary. It is then a catastrophe. Every morning after getting all six children dressed by myself, I secure them in their seatbelts and unload them at my parents' house. My father takes the youngest two to school, and my mother keeps the young-

est four in the daycare center. Every morning she meets me at the door and collects all the children. There are no diaper bags because she has everything they need. Once everyone is out, I back out of the driveway and head off to work.

March 22nd, however, was different. Mom comes to the door, and I put the kids out and put the truck in reverse. Seeing no cars, I release my foot from the brake, but at the same time, my mother screams my name like Celie from The Color Purple when she and Nettie reunited. Of course, I put on the brake, and she runs to the truck.

"You need to slow down. That baby was not in the house yet. Come here Bryant Keith. If you don't get it together, somebody is going to get hurt."

He was still standing on the side of the car, undetected by the backup sensor that I rely so heavily upon. I almost killed my own baby.

This is it. I can't sacrifice my children for someone else's. That day, the paper that I reluctantly accepted from my doctor and have been carrying around in my laptop bag was presented to the interim principal. He asked me if I was sure that this is what I wanted to do and asked me why I hadn't come to let him know all that was going on with me. I didn't want to participate in the gossip and rumor mill that got him there in the first place. I chose to exercise my right as a human being, a wife, and a mother. My reports have fallen on deaf ears, and I'm no longer interested in the fight. I yield to the Holy Spirit.

On March 26, 2012 in the middle of the year, I packed my bags and left the school and the classroom. I also left my students without saying goodbye, no warning or see you soon, just an empty classroom. At that moment I vowed never to depart this way again.

Weekly appointments to the doctor and bi-weekly sessions with a therapist mean a lot of copays that I can't afford while I wait for the thirty days of unpaid leave to pass me by, but Mommy and Daddy help me out big time.

Chapter 48

SAFE IN HIS ARMS

Just a week after my departure for health reasons, I got a call from a colleague about her school and a potential opening that I may be interested in. I'm really open to anything at this point, but I really want to stick with AVID or be at an AVID school. I already interviewed with a high school for their AVID coordinator position and was interested, especially because the principal knew my work as I served as his daughter and son's AVID teacher. The principal at the other school heard I was looking for a change and wanted me to consider that school as well. Word sure does travel fast.

Two days later, I'm at home when she calls and says it's an academic dean position. I say okay but had no idea what that is. It sounds like it is outside of the classroom, but I don't think I'm quite ready for that. I love teaching. Then she calls back the same evening and says it's an administrative position and asks if I have my credentials. I am almost finished with my internship but need to count my hours since my early exit in March. I tell her that I'd just visit, hoping that would be enough for her to stop calling me about it. Six songs play

on the commute to this school. Is this in Virginia? Is this still in the same district? I'm used to a three-mile commute, not thirty minutes! Upon arrival, I notice nice homes before making the right turn into the parking lot.

I still can't put my finger on it, but I felt a sense of peace and safety as soon as I walked in the door. I ask several questions about the school, the goals, and my potential role. After the visit, I feel at home here. I see a few familiar faces from past educational journeys, and I know they are about business. If they are here, then this must be legit. I'm still not totally sold on the move itself. I know I have to go somewhere else, but I haven't gone to another school in ten years. I won't know the building, the people, the lunch restaurants, or the teachers, yet I am supposed to lead them. It's a lot to take in, but I can't shake the fact that I feel at peace here. When I'm leaving for the day, the principal asks what I think about the school. I say I think the school is beautiful and has a homey feeling, and I would be in touch.

I get home and find out that the two principals were actually brothers. Only my luck.

I chose peace. It was a matter of time before I could officially interview, knock the panels socks off, get board approved and be official. It was a pure exercise of faith because I chose not to interview anywhere else, and I had to compete with other candidates. Many people warned me that it may fall through, but I didn't care. I believed this is what God had

in store for my family and me. I was searching for peace and what was the school's mantra—PEACE—Positive Energy Activates Constant Elevation. I know this is my new home.

HEARTBREAK HOTEL

Every birthday is a birthday worth celebrating to the fullest. I believe God gives everyone twenty-four hours a year to focus solely on themselves, and on my birthday, I do just that. This year is no different, and I absolutely need to celebrate after the crazy school year I just endured. This year I am celebrating being thirty-four and fierce with a weeklong list of activities to include bowling night, karaoke night, a night at the Orioles game, paint night, and culminating with an all-white dinner party with forty friends at my favorite restaurant, Public House at the National Harbor. The night was amazing. This room has just enough room for a birthday cake, table, and forty amazing people. Both my daddy and husband light my birthday cake—the climax of the night in my eyes. As a young child, my daddy got me a birthday cake. He continued the tradition all the way up to the year I got married. I guess he passed the torch to my husband at that point. Well, that night I purchased my own cake, but my daddy and hubby lit all thirty-four candles together. This is peace. Finally, my husband and I have a night away from the

six children. Thank God for Kayla who is taking care of the crew while we adult for a while. Mommy and Daddy's gift to me was to go and get the kids for the night, so hubby can stay at the National Harbor overnight with me. I booked a room at the Gaylord with my Marriott points, so it didn't cost us a thing. But Gig declines.

"Stay here and enjoy your friends."

"But everyone is leaving, Gig. You're just going to leave me by myself?"

"Someone has to get the kids."

"I just told you Mommy and Daddy said they were going to get them and take my truck, so you can stay here with me!"

"Ashanti, stay here with your friends."

"Why are you acting like this?"

"Your friends are waiting. I'm leaving."

When I turn around, I see a few of my sandbox shorties hanging around and making sure I'm good like we always do. Morgan Bear and a few others help me gather the remaining favors.

My friends see the look of disappointment on my face. They know what I've been going through.

"Well at least you tried," one girlfriend said.

"I'll walk her back to her spot. She shouldn't be walking by herself even if the hotel is next door," says Morgan Bear.

"Thank you!" He extends his arm to begin the short walk to the lavish resort.

"What's up with your man?"

"I really don't know. He doesn't really celebrate birthdays, so maybe he just needed to be alone."

"Do you think it was me?"

"He doesn't even know you, and he's the husband so why would he be threatened by you? Don't you have a girlfriend anyway? That's crazy."

"Some men don't want any remembrance of old times, Ashanti."

"Whatever. That's so dumb. Again, I'm wearing his rings, raising his children, and trying to be loving to him not you!"

"Oh, so you don't love me anymore?" He's now holding my hand and walking into the elevator with me.

"You know what I meant. I'm serious about my marriage and everyone else's. It's forever, and you know I don't lose well."

We stand and talk at my hotel room door on the tenth floor. "So, are you coming in or what?"

"Do you want me to come in?"

"I do."

The opportunity to step out on my marriage is always there, but I want my husband tonight. I want him here with me, but instead, I'm alone at this beautiful resort in a hotel room with a view of the nearby city. I have no investment in

staying, so I pack up and head home to my family. An evening for us just wasted. Morgan Bear helps me get all of the remaining items and favors to my truck in the garage before heading to his next destination. When I get home, admittedly excited about seeing my love, I see that the light in the basement is off. That means he's in the bedroom! Yes, I got him this time. Yet as soon as I turn to lock the front door, a brush of wind blows across my back, and I see him hurrying down four sets of steps with his fan and blanket, retreating back to the basement. So, the bedroom is fine to sleep in after all. And it's not too hot after all? It's me. Now, it is clear. He is retreating from me on my birthday that I came home early from to spend with him and give him my lovin'. Instead, I'm in the bedroom sitting on the side of the bed again. This time looking at the huge pile of clothes in the hallway that needs to be washed and the handwriting practice that the baby has done in red permanent marker on my bedroom door. I'm home. Back to life, back to reality. Happy 34th birthday to me.

Chapter 50

TRANSITION

I spend the rest of the summer trying to organize my life and participating in professional developments that will prepare me to leave the classroom forever and move into my first administrative role. I also spend time defending my dissertation proposal, which is a success, and now it's time for IRB approval and the meat of the work. Usually I'd be studying unit plans, helping with scheduling students, talking to parents about AVID placement, and thinking about what bulletin boards I want to create. Instead, I get an office, a real office all alone! As the principal escorts me across the courtyard, I tell the story of how I have never had windows in my entire teaching career, and the principal just gives a quick nod and grin.

"Wow! They were really trying to keep you a secret, huh?"

"I guess so, but you seemed to find me anyway!"

"Well, we're glad to have you." He unlocks the first closet door on the right which conveniently shares a wall with the boy's community bathroom for the floor.

"Wait a minute! Wait one minute! This can't be my office!" He takes a seat and laughs at my disbelief. My mouth is wide open, and I just stand in the door looking around. A room with baby blue walls lined in hickory shelves that I don't even have enough books to fill up. No windows. Again.

This must be a thing.

Next week school starts, and the kings and queens are coming. The common language here is that of royalty. We are all kings and queens and conduct ourselves as such. Crowns and peace signs are on everything, including the T-shirts that students and staff get every year. Positive energy activates constant elevation. That's what attracted me to this position. I need positivity in my life right about now.

We're in the principal's office on the first day back, and we hear yelling coming from outside.

"Uh, somebody needs to move their car! We aren't going to start it off like this. Naw."

The voice comes into the front office repeating the same demand. "Whose truck is that in my spot?"

Is he talking about my truck? The space said assistant principal, and there's three of them. There's three of us, right? So, what's the problem? That was my introduction to the assistant principal. I'm actually an academic dean although my job description is the same as an assistant principal. I see this guy has some issues with territory.

"I can move; it's not a big deal to me."

"Yeah. Okay, good. We aren't starting out like this."

Then the principal says, "No, you park in my spot, and I can move. You're a woman, and that's not important. Give me your key."

"Okay, I have to go and get it."

"Well, don't go all the way back over to your office right now. We're working, and he can wait."

Once the principal clarifies the expectation of the work, I never have a parking issue again.

I'm going to love it here.

Presenting nationally is absolutely part of my repertoire, and my principal supports it. From Learning Forward, Association of Middle Level Educators, National Council of Teachers of English, ASCD, AVID, and National Association of Black School Educators, I am booked. It doesn't hurt that we are a Title 1 school and send participants to conferences anyway. After a few months there, I am finding my groove. I'm assigned to seventh grade and the English Language Arts department. I'm the only lady in administration, which I know is confusing for some, but I'm clear on the fact that I have a husband and these men are my brothers, even Randy, the aggressive assistant principal. I call myself the enhancer. They ideate, and I just sit back and listen until they are finished and bring the reality back to the table. So, how will teachers eat lunch? Where are you going to get four extra classrooms? Which teacher will have one hundred students at

that time? Yup, they need me, and I need them just as much. I always have great, innovative ideas, but no one to say yes. I quickly learn that as long as it is for the kids and keeps us out of the news, I get the yes. My first big yes is to coordinate a schoolwide college tour where we'd take all six hundred and sixty kings and queens to state universities at the same time on the same day. We call it the "College Takeover," and it is such a huge success that it makes the Washington Post! Positive press increases the students' love for doing whatever it takes to get back to those campuses for good. I learn to love my commute and use it as quiet time to be with my Father. The mornings getting six people dressed and ready to go are insane, but I do it. Thank God for my daddy who takes the babies to school and picks them up every day.

SEVEN

At home Gig and I continue therapy and attempt to put band-aids on the broken pieces of unresolved conversations, lack of trust, and the financial instability of our marriage. By January of 2013, a proposition is made.

"Hey, baby. Bryant Keith is growing up so fast, isn't he?"

"Yup, even though he and I made a pact that he would slow down. He's doing the exact opposite."

"You ever think about having another one?"

"Another one? Honey, you got a vasectomy."

"I know, but can't they reverse it?"

"I mean I guess so, but is that something you want to do? BK is already three and potty trained."

"I just feel like we made that decision too early, and God isn't finished blessing us yet."

"Really? You think that?"

"Yes, and I want to do it. Will you research it?"

"I will."

After months of consultations and discussion board searches, in May 2013, we travel to Austin, Texas to get the vasectomy reversed. We vow not to tell a soul but to work on getting well and then getting pregnant. The same nausea that I had on my wedding day is what I have at the Courtyard Marriott the morning of the procedure. So what we already paid them a thousand dollars for a down payment? I feel like this whole thing is a mistake, and they can just keep the deposit. What if something happens to Gig in surgery? Should we just pay the extra twenty-five hundred dollars to get him put under anesthesia? In silence, I reflect and accompany him anyway.

I know the pain is excruciating because he holds my wrists and tears up while I pray for his strength and comfort. Our husband-wife getaway is over, and now, we are back home to work on a baby. Does he think that this is going to fix our marriage? Does he believe that the sex or focus on motherhood will take me away from the reality of the mess we have put ourselves in? We will name him or her Seven. Seven Solomon or Seven Simonne. It makes sense—he or she will be baby seven, and we need an S name like the rest of his siblings have. We shall see.

At school, I volunteer to take over the duties of master scheduling to give our kings and queens an individualized opportunity to excel in whatever they'd like to discover. It's hard to do that with a cookie cutter schedule, and the cur-

rent builder doesn't want to help me, so I am teaching myself along with district support. No one I know ever signs up for this major task, but when I become a principal of my own school, I want to understand each role and provide support where it is needed to ensure all of my team members are given a fair opportunity to be successful.

Even though we are having more sex, it is a job more than a pleasurable experience between husband and wife. Gig even moves back upstairs which has me over the moon. But the intimacy is missing. One morning at 5 a.m., I scream in the bathroom and summon him as if something is wrong. Upon arrival, it is clear that everything is all right. His response to me is, "So you did that to work off energy you had built up for someone else?" I just took a shower and got ready for work. I can't with him. When I don't initiate, I'm boring, and when I do, I'm a hoe. Well, I'd rather be boring and not accused of thinking about other men. Back downstairs he goes after a week. I'm also behind in doctoral work, and after a year of stalling, I'm withdrawn by the university. After petitioning for more time, I was reinstated with a plan that I must execute in order to remain in good standing. I'm going to get it together between scheduling and motherhood. Matrimony has me confused. All I can do is pray at this point.

THE MASTER SCHEDULE

The family reunion is not like it used to be, but the crew and I will attend later this evening. Right now, I'm trying to get these clothes washed, so the kids can have something to wear next week. Being the master scheduler is extra tough. I never realized it would be this hard, but I'm up for the challenge. I just need to be able to lock in and get it done.

Baby Sidney always has something going on up there in his little head.

"Mommy, can we go over Mrs. Helen's house?"

"For what, Sid? We'll see her when we pick her up for the family reunion."

"I need to go check on her because she's tired."

"I'm pretty sure Mrs. Helen is fine. I just talked to her this morning."

"But Mommy, I need to go check on Mrs. Helen. She's tired."

"Okay, go put your sandals on and let's go."

Ten minutes later, I drive up to my mom's house, and we let ourselves in.

It's Saturday morning, but there is no aroma coming from the kitchen. The absence of the fabric softener smell and tumble tumbling sound of the washing machine is unusual, but maybe this is just a relaxing Saturday.

She has her blinds closed, the tv off, and her covers over her head. All I can see is her three remote controls in line near her pillows. She is sleeping.

"See. I told you she's fine."

Sid climbs on the bed. "Mrs. Helen, are you okay?"

"Yes, baby, I'm just resting. Mrs. Helen is tired."

"I told you, Mommy. I told you she's tired."

"Okay, Sid. Let's just leave and let Grandma get some rest. Mom, we're leaving. I'm picking you up at four, right?"

"Yes, that's fine."

"And dad is going too?"

"Yes, but stop by his room and remind him. You know how he likes to say nobody ever told him nothing."

"Hey, hey, don't talk about my daddy. See you later."

About forty people are in this little room for the family reunion, and it's just about over. After the scholarship game show is the family meeting. Now, I know I have a lot of children, but Mom seems to be going back and forth to the bathroom quite a lot tonight.

Here we go with the family meeting. Daddy says that they're going to meet me in the car, so I said no problem. The event is over, but now we need to know who will be the next family reunion chair. After about fifteen seconds of silence, I finally volunteer.

But now my entire family is in my truck waiting for me. My sister comes in.

"Mom's not feeling well, and she's ready to go home."

"No problem because I'm ready to go home too."

Outside I approach Mom at the passenger side window in the front seat. "Mommy, what's wrong? Maria said you aren't feeling well."

"I can't find my schedule. My schedule is gone." Standing there, I have no idea what schedule she's talking about.

Dad's hands firmly grip my steering wheel. The entire truck is silent.

I should go back inside and call 911. I should let the family know what's happening to her, so they can pray. I should call my husband, so he can be on the first flight home to help me navigate whatever is happening to my mom. I should pray.

"Mom, are you okay?"

"I'm just tired. I need to get my schedule."

All of the google searches have pointed to stroke, and they also say to get the person to the emergency room immediately.

This is my battle.

What is taking so long to get home, and how can I have the ambulance ready at the house when we get there without her knowing? There is no way that my mother is going to allow me to take her to the hospital, but I have to find a way to get her the help she needs.

"Dad, what's the game plan? You want me to stay here with the kids and you take her?"

"No, she's gone up there and gone to bed."

"I cannot go home, and I will not go home and worry about her all night wondering how far this thing is going to go. I can't do it. Either she's going with me to the hospital tonight or with you." "We'll bring the kids in and put them in their room, and you can go in there and talk to her. But you already know what she's going to say. Deal?"

"Okay, if you can get the babies in, I'll go straight up to her bedroom and start the conversation."

I walk in her room and see the TV is off, and she's rattling around in her closet.

"Mommy, you need to go to the doctor. They need to see you now to help you. Why are you in the closet? Mommy, no not pajamas. You need a doctor now." She continues to select a set of pajamas and is not responding to what I am saying.

Now, she's attempting to get in the sheets with the pajamas on.

God, You know she's headstrong. *Please give me the words to say to get her in my truck now.*

"Look, you're my mom, and you're all that I have. So, please, please get dressed and get in my truck, so I can take you to the emergency room. If everything is fine, I will bring you back tonight. I promise."

"I'm just tired."

"Fine then. I will stand here and watch you sleep because I cannot go home worried about whether or not I'll have you in my life tomorrow. Better yet, you can either go in my truck or go in an ambulance that is going to wake all of the neighbors, and then everyone will know. You know how much you would enjoy that, right? So, what's it gonna be? My truck or the loud, blaring ambulance?"

Thank God, she's in my truck. She's pissed, but she's in the truck, and that's all that I can ask for.

"Mommy, you know you're having a stroke, right?"

"I'm just tired."

"Okie dokie." I turn the radio up, and we finally arrive at the hospital.

"Okay, Mommy, we're here. Let's go in."

"Yes. Hi. How are you? I believe my mother is having a stroke."

"No, I'm not. I'm just tired."

This whole "I'm just tired" routine is getting on my nerves already because she knows good and well that she is having a stroke right now. But, okay. "Miss I'm not having a stroke," let's see you speak for yourself.

"And what's your mother's name?"

"Ma'am, her name is Helen Bryant."

"Date of birth?"

"Go ahead, Mommy, tell him your birthday." She gets the point.

"June 27, 1940."

"Okay, and your contact number?" She motions to me to give the information.

"Oh, now you want me to speak for you, huh." I make eye contact with the attendant that matches her birthday she gave with the one on her license.

"We'll be with you shortly."

"Thank you so much for your help."

They whisk Mommy away to the back and give her a gown to put on. After she is undressed and puts the gown on, she lies in the bed. There is more silence.

I have a great idea! I can just give her paper, and we can communicate that way!

"Here, Mommy, you want to write in my notebook? Tell me how you are feeling on this paper."

Why is she drawing waves? I asked her to write to me how she is feeling not draw waves. My knees no longer work and thank God there is a seat right behind me. This is not happening to me, to her, to us right now.

Voicemail. Voicemail. Voicemail. I don't have time to keep calling him, but that post on Facebook is a clear indication that he sees me calling. How are you posting on Facebook but don't see my messages and calls coming in? I can't even focus on him right now. My mom is all I have. I mean Daddy's always going to be there, but there's nothing like a mom. I'm a mom, and I can't imagine my children without me. I don't even want to think about it.

"Mommy, you want some water?" My breaths are shorter now, my heart is jumping into my eardrums, and that tingling in my lips from college days is back.

No, please not right now. I need to be strong for Mommy. She can't see me this way.

I have to get out of here. The receptionist's desk held my body as I draped over it in despair.

"Ma'am, are you okay?"

"My mom is having a stroke, and I'm so scared. Is my mom going to be okay?"

"The doctors are with her now. Let me help you."

"I'm okay. I just need to breathe. I need some air before this panic attack goes any further." I return to the room where Mommy has been evaluated.

"Hello, Mrs. Bryant, we're going to transport you to Holy Cross Hospital, okay?"

"So, where do we go when I get her there?"

"Oh, no. She's going in the ambulance. You can follow along, but you may want to wait until she's been admitted. It will be some time, and it's already 1 a.m."

"Mommy, you got enough covers on you? Daddy is going to leave the house now and meet you there. I'm going back home to care for the children, okay?" She doesn't really acknowledge what I'm saying.

"But wait, we have to pray first."

The lump in my throat is too big to allow words to pass, and what do I pray for while my mom is being wheeled away from me? What if God's will for her life is to leave us tonight or never be the same? What if she never recovers her speech? How long will it take for it to come back? What in the hell is going on? Where is my husband, and why isn't he answering his phone?

I follow behind the ambulance, and that Redskins hat is peeking out from among all of the cords and helpers in the back.

The lyrics of an old song goes through my head. *I feel like going on, though trials come, on every hand I feel like going on.*

I have to sleep, but I can't sleep. Back at my parent's house, I check on the children and find comfort in my mother's bed. This is the same bed I labored in with my first and second baby.

I did this to her. This is all my fault. I have stressed her out to no end. Baby after baby after baby out of wedlock, and now, I'm married and still have drama and two more babies. Between watching the children and hearing me complain about my failing marriage I have created this stress. If she gets through this, I promise I will only ask her to do things for me in an emergency. I need my mom. I need her in my life. I need to hear her voice again. I need her to not be tired anymore. Caring for her own parents was enough, but I had to pile it on.

This master schedule for school is far from completion and school opens in a few weeks. I have to tell my principal what is going on just in case someone else needs to step in. I know it's too early in the morning, but I haven't slept anyway so hopefully he's up.

"Hello . . . hello?"

"My mom . . . she's sick . . . and the schedule . . ." Tears overwhelm me as I become vulnerable with him.

"Ashanti, the last thing you need to worry about is the schedule. Do you need anything for the kids? Where is your husband?"

"Not answering the phone. I think we are okay."

"Look, whatever you need, you know I got you."

Gig finally calls after nine that morning.

"Hey, I missed my early morning flight, so I'm going to get the next one this afternoon."

"Well, I need to get to the hospital to see my mom, and visiting hours are over at 6 p.m., so you need to come home now."

"The hospital?"

"Yes, the hospital! I have been calling you all night."

"Oh, I'm sorry. My phone died, but had I known, you know I would've come straight home, right?"

"Yeah right. Goodbye."

I get dressed and get ready to go by 2 p.m., so I don't have to talk too much.

I hear his keys at the door and rush down to leave out. He's late, and I have an hour drive, the same one we took for Baby Q's birth. He doesn't get any hellos and welcome homes from me.

"The kids have eaten and should be ready for a nap. See you later."

"Uh, okay. So Ashanti, what happened?"

"That's what I am going to find out, Gig."

I haven't seen Mommy since yesterday. Well actually, that was this morning, and I'm tired.

Alcohol swabs, disinfectant, band-aids, and the scent of Bengay overcome me as soon as I walk into the door. Nausea quickly sets in just in time for someone in a wheelchair to roll past me. People don't come to the hospital because they feel good. Mommy, on the other hand, except for forgetting a few words and still mixing them up, is recovering from her mini stroke and can go home in a few days with therapy and more appointments to follow.

I feel like my last straw has been pulled, and my guitar has been strummed so hard that it is now broken.

"Mommy, I can't do it anymore. This pressure is too much, and we have six children who are watching us. I can't keep sharing space. We're either going to be married or we're not."

I will never forget what my mother said to me the last time I felt done with Gig a year ago.

"Listen to me clearly. Don't ever say what you don't mean because when he is gone, you need to be prepared for what he will do while he is gone and that he may never return."

In my heart he is already gone. Speaking of hearts, my chest is feeling a bit uncomfortable lately. I messed up by mentioning it to my mom.

"You know what I just went through, and I exercise every day. You have to slow down and take care of yourself. When is the last time you had a physical, Ashanti?"

"In October. You mean with Dr. G, right?"

"No, I mean a regular doctor and regular bloodwork."

"Uh, I don't know. I just usually go to Dr. Gillian, so I will make an appointment." I called the office to make an appointment while still at my mom's house.

"Next appointment available isn't until December 31st."

"Great Ashanti. I will be right there."

"For what?"

"Because the last time I had a chance to go with you and didn't."

"Okay, okay, I get it!"

The next few weeks it's all hands on deck getting Mommy better and getting the school ready to open with my first time as master scheduler. My principal brings over dinner for the entire family a few times so that I can concentrate on my tasks. I guess he really means "whatever you need, you know I got you."

Chapter 53

HE HEALS ME

I don't think I have been to an internal medicine doctor for a physical since before I gave birth to Jay in 2004. Every year since then, I have either been pregnant, nursing, or both. I realize now what Mommy is saying.

The internist says I need to lose weight. Losing twenty-five pounds, though?

In my mother's quest to live, she decides to accompany me to the appointment about my thyroid. It is only x-rays, and the tech can't give me a prognosis, but she wants to come anyway. Who am I to spoil a party? We arrive, and they call me back rather quickly. In the room, the tech asks me to remove the clothing around my neck where the examination will take place. Mom and I walk in the room and have a seat. This feels familiar, but I'm not quite sure why. We continue to talk about my weight loss and how going green has been going.

"I made a new smoothie this morning."

"Really, what do you call this one?"

"Behold. It has pineapples, green apples, spinach, kale, lemon, and kiwi. Really sweet."

"Oh, like Norfolk State green and gold."

"Exactly! Look at you knowing all about the college scene!"

"You guys talk about it enough, so I should know." We laugh.

The tech arrives, and I lie back.

While she is talking to us about what the examination entails, I look to the right.

Immediately my heart starts to race, and I sit up slowly as if I was summoned like Lazarus.

"So, basically, what will happen is you'll lie back down, and I'll put . . ."

"Excuse me. I just need a moment, please."

I'm now breathing heavy and grabbing my chest. Mom jumps up and helps me outside.

"What's wrong?"

"Do you need a chair or some water?" the technician asks.

"No, I just need a minute." I try to catch my breath. "Mommy, that's the room."

"What room?"

"That's the room I was in when I found out about Johannah. It's the same pictures, and I can't go back in there. I'm sorry, not today."

My lips are now tingling, and I am failing at controlling this anxiety attack.

I make a decision to get it together and focus only on breathing.

Mom goes to talk to the technician, and within ninety seconds, I am in another room and calm enough to resume the examination.

She puts a pillow under the back of my neck, apologizing along the way.

With tears still in my eyes, we complete the exam.

Even though we are in a different room, my head is in a different space.

Why in the world would God allow people to conceive only to take the child away?

My thyroid is fine. My bloodwork is good, and I've lost fifteen pounds. I don't plan on losing any more. This scale, wristband, and app, which are all synced, and portioned lunch containers keep me going, and I feel good in my clothes again. I wish I could lose my tummy first though. Every time I lose weight, my butt is the first thing to go, and that is not okay. I don't even know why I give my money away for this gym membership. I don't use the membership that much. I do, however, stay faithful to these Facebook ab challenges

with planking and lunges. Zumba on XBox One is always a fun activity and a simple dance class, so I really don't need a membership at all. But I still have it. That part of my procrastination burns me up. Just cancel it already!

Mom sends me a prayer. She knows the fight I'm in, at least the parts I choose to share.

Lord, please bless Ashanti from the top of her head to the bottom of her feet.

Build a hedge of protection around her and keep her safe from all hurt, harm, and danger.

Please give her the desires of her heart.

Heal her marriage to Gig.

Bless Gig in whatever he endeavors to do, Lord.

Please turn Gig's heart to the family that you united him with.

Build them together in Christian love and unity.

Let them love the children more than they hate each other.

Bless the six little angels that You blessed them with.

In your name I pray and give thanks. AMEN

Around September 2013, someone added my name and several email addresses I own to divorce sign ups, so I'm getting messages everyday about tips for divorce. Why would someone feel it is appropriate to do that to me? Of course, Gig says

he knows nothing about it, and we go on passing one another like roommates in a dorm room. No affection, no respect, no communication, no desire, and no fight.

Chapter 54

LISTEN

Being the youngest must be the coolest thing ever. I'll never know what it feels like to have that role, but I know what it's like to raise one. After having five other children, you get tired and can depend on the older ones to assist in child-rearing activities like dishwashing and making cereal.

But this child is different; he's absorbing every experience from this family of eight and responding to every opportunity to act anything other than his age. There is nothing I can be told about him that I wouldn't believe. By the age of three, he had potty trained himself, including straddling the toilet in a front-facing, half-seated method without prompting. He taught himself how to write his name and served as the chef when I took too long to cook dinner by mixing an entire stick of butter, one carrot, the celery stalk, and a pack of pepperoni covered with toilet water for his daddy's soup. Unstoppable.

One day he asked me for something to eat while I was folding clothes in my bedroom. I entered the bathroom to put away washcloths and told him no while he sat on the side of the bed. His response is always, "In a minute?" And

then he looks for my yes or no. If I say no, he says, "Gotta wait?" Why can't he take no for an answer? On this day, he figured out how to use the dishwasher door in an opened position as a stool to climb up on the bar to reach the cabinet of cereal boxes located above the stove. Once on the stove, he knocks the cereal box open and cereal pours into the open dishwasher door. This is when I run down the stairs to see that some of the pieces of cereal that were strategically captured for his dining pleasure had been politely concealed by the clean bowl and spoon that he got from the dishwasher. He was eating his cereal out of the bowl with a spoon. No milk, just cereal. Note to self: move the cereal. It was located there purposely, so we could regulate the cereal pouring and wasting going on.

We quickly learned that BKs schedule is our schedule, and there is no sleeping when BK is awake. Period. Those big, brown eyes staring me in my face when I'm speaking to him are hypnotizing. Now, if I could just get him to stop writing alphabets all over my bedroom wall, and better yet, if I could remember to stop smiling when I see it, we'd both be better off. The days are good, but the nights are rough. Sleeping is more like napping for me since I feel like I need to stay awake to make sure he's still breathing. It's not the asthma, although that is a concern as well, and it's not the fact that he has so many allergies that he should be in a bubble. He "mouth breathes" all day, and during the night, in between breaths and a series of loud gurgling, he stops breathing. I've experienced it night after night alone since I'm still sleeping alone

every night. It ends with him taking a huge deep breath after about four seconds of an interruption of natural blood flow. After about a month of paying attention and sleep deprivation, we visit Dr. Mazique who orders a sleep study, and I learn that my baby has tonsils that are the size of a grown man. Since he has a November birthday, we can't go to the kindergarten when he is four, so he's going to attend a private transitional kindergarten program for the 2014-2015 school year. Part of the application process is a health inventory, so we take BK with us to Sid's wellness visit in April for an August start date. After learning that his tonsils are preventing him from resting at night, we also learn that he is old enough to take the vision and hearing test.

"BK, when you hear the sound, raise your hand. Okay, let's practice."

I see the dots lighting up to indicate the machine is working, but BK isn't responding.

The next test checks his ear to make sure it's working properly.

"Are you ready?"

BK shakes his head saying yes, and the technician places the tool back on him.

After a series of unresponsive beeps that, at this point, I'm hearing myself, she stops.

"All done, BK. Dr. Mazique will be right in."

"Ashanti, BK only heard one tone, and that was the highest tone. We will send him to ENT, but it looks like he has significant hearing loss. Do you see any signs of hearing loss at home?"

"Well, he does always ask me 'in a minute' after he asks me can he do something or have something. I just thought he was being BK."

"Does he lean in when he speaks to you?"

"Yes, he always does that, and he holds my face in his hands and won't let me move it while I talk to him. Oh God! He's been telling me all along, and I've been so busy, so angry, so distant, and so unavailable that I missed his cries for help."

"Ashanti, it's going to be okay. That's why we can get him into ENT. You caught it, and you did see the signs, but you just didn't know what it all meant. You are a good mom."

"My baby can't hear, and I had no idea. His mom, who carried him. No clue, yet every clue, every day at the same time."

"BK will probably need surgery to correct the issues with breathing and need tubes inserted to release the pressure, so he can hear. Let's work on getting into the ENT. I'll call them to expedite now. Let me see what I can do."

"Wait, before you leave, I have one question. What is ENT?"

"Ear, Nose, and Throat. They are specialists who have expert training in these areas."

"Whew, all this time I thought you were going to call an ambulance."

"For you or for him?"

"Haha, Dr. Mazique. Thank you for everything." Her reassuring back rub lets me know that even though I'm alone at another doctor's appointment getting devastating news, God is still in control.

A week later, he failed the ENT tests as well, and the surgery date was set for Wednesday, May 21, 2014. Days leading up to the surgery, I secured time off with my ever so patient school team, moved his bed down to the living room, and attempted to mentally prepare myself for my first pediatric surgery. People think just because I have six children, I have all the answers. I don't. I'm scared.

ALL OF ME

BK has no idea what's about to happen, but this little hospital robe, compression socks, and hospital cap is making him feel like a hospital superhero. Rabbit Foster, his new friend, and I hang out in the prep room that morning after saying goodbye to Grandma, Granddad, Daddy, and Auntie Maria. On the way to the back, the attendant tells me we will count down, and then I will leave. Okay, countdown and leave. Got it.

They probably should have dismissed me at ten because watching my baby boy collapse into the doctor's arms from a simple gas waved in front of his face was more than I could bear at that time. I fainted briefly, and it was a little too late to practice my breathing. A wheelchair ride later and I was back in the waiting room with my family. I spoke no words, and my family complied with my unspoken request to provide uninterrupted silence. The only sound I hear an eternity later was "Bryant family, all done. Who is going back to recovery with BK?"

Back in the recovery room, he's in and out of consciousness and fighting me. Resorting back to what worked when

he fought his sleep, I start to sing. His current song is John Legend's *All of Me*. I'm convinced that music is the medicine of the soul. His soul begins to rejoice, and his body and mind settle down as he sways with me. This is good. He's alive. Thank you, God, for saving my baby. And now we recover.

The next few days are rough, just he and I at home all day, popsicles, failed attempts at medication disbursement, and jealous siblings in the afternoon. God certainly knows what I need and when I need it. Sometimes blessings come packaged in garbage bags, yet I am open and available to receive whatever He has planned for me. I prefer a directed path because He clearly has a plan.

After I finish cleaning the breakfast dishes, I sit down on the couch to enjoy quiet time with the patient. Being home during the day with full sunlight shining into our home put the spotlight on how dirty the walls and baseboards are from the thousands of handprints, spills, and dirt. While I am discovering areas for improvement, BK is making his own discoveries.

First, his breakfast, lunch, and dinner slurpee from what he calls 7-Eight must be delivered on time as we are not eating solid foods yet a week into his healing. I have already told him that the store is called 7-Eleven, but he rebuts, "Eight comes after seven, Mommy. That's not right." Choosing my battles, I just call it 7-Eight. Kiah, a family friend and tutor, gifted him an Iron Man costume mask and putting it on is a

requirement before taking any medications. BK is doing just fine. And this quiet time feels just fine too.

BK, however, is not acknowledging the serenity and keeps sitting up to look around which is quite painful for him.

"Mommy, what's that sound?"

I only hear the air conditioning, but that's so faint that he couldn't be talking about that.

"You mean the TV?"

"No, Mommy. It says, Mmmmmmmmmmm."

"Hmmmmmmmmm. The dishwasher?"

I carry him to the kitchen, and he asserts with eyes wide and amazed, "Yes!"

It's the very same dishwasher that he's used as a step stool and breakfast seat, yet he's never heard it in operation. There's nothing else I can do all day but hold him and try to figure out what else I have withheld from my son through my refusal to decide that being present is more important than the perfect life. The rest of the week has many more "Mommy, what's that sound" opportunities and having to turn the TV and music down due to his sensitivity.

Saturday evening is the prom at my husband's school, and I know that I need to go because I'm always complaining that he never invites me to stuff, and now that he is the acting principal, it is good luck to have his wife on his arm. But he didn't even stay home with us this week like he said he would, and I'm dog tired. Plus, I can't leave the baby this soon. I'm

not ready. That morning, BK's wondering led us to our first outing since surgery.

"Mommy, what's that sound?"

"What does it sound like?"

"Beek, beek, beek!"

"That's the birds, BK."

"Are they singing a song or just talking to each other?"

"Well, I don't know, but let's go and find out!"

The only place I went that evening was to sleep after finally eating one of Jay's amazing grill cheese sandwiches.

BKs world will never be the same. And neither will our marriage.

I didn't go to the prom, but I'm definitely going to be at graduation. This is probably his only time addressing a senior class as their principal, and I can't miss it.

THE NEW GIG

Graduation came and went.

"Hey, what time do I need to be at the school today?"

"For what?"

"For graduation!"

"That was yesterday, Ashanti, and I'm hurt that you didn't come, but I saw you posting on Facebook. You had me up there looking like a fool because I built you into my speech, and you weren't even there. Plus, it wasn't at the school."

"Gig, you gave me the wrong date, and you're blaming me? Wait, so let me get this straight. When you left yesterday morning and you knew graduation was that day, you didn't feel the need to tell me the location or how to get access to tickets? That's almost like you didn't even want me to go in the first place."

"I did want you to come, but in my mind, I knew you wouldn't."

"You're reaching right now, Gig. So, you withhold information from me so that I could prove to you that I wanted to go? I don't have time to play games with you, but I did take off the morning so I could go. I can show you my leave slip if that matters. And will you please look at the date you put in the calendar? I can't be held to an expectation that I can't even fulfill because you gave me the wrong date."

"You just want me for here for a paycheck anyway."

"Excuse me? Is that what you really believe?"

"Yes."

"A paycheck doesn't make you a provider. Remember that."

Saturdays at the house are spent running back and forth from campsites to scouts to dance studios to the pool for swimming and not really settling down until around 4 p.m. I don't even ask for help anymore; I just do it and receive spousal support when it is sparingly offered. This Saturday, however, the babies are over my mom's, and Q and Jay are away with their fathers' families. That leaves a quiet house with only me and Gig home. Since I only want him for a paycheck, let me show him what wanting him just for a paycheck looks like. After a few calculations, I print out a child support agreement and post it on the basement door where he resides.

"What is this paper all about?"

"You said I only wanted you for a paycheck, so that's what it looks like to only be financially invested."

"Where am I supposed to go, and what is this three thousand all about?"

"Based on your salary, that will be your child support for your children. You obviously don't want to be here, and you have made new friends who are more important, so let's stop the games and you can go and be truly single. It's too hard being the only one fighting for the marriage and family all the time."

"I moved up here to be with you, and I don't know anybody, and now you want me to leave."

"You've been gone; this is just a ceremony at this point."

"I just don't know how you could send me a note like this!"

"I just don't know how you could treat me like this over and over, counselor after counselor."

"You don't want to change; you don't want me, and you want to be single. Fine, if you have nowhere to go, then when I feel myself breaking again, I will go to my parents' house. I can't sit in this house and ignore your foolishness anymore."

My birthday is a June girl's night out, and no, I didn't tell him. The summer is strange and estranged. No talking. No loving. No nothing. He comes and goes when he pleases but is always on the phone. His new job has new friends and new people to fool to make them think he has it all together. For what? Be home with the kids? At least do that. It's only one

night for goodness' sake. I have friends too. We hang out too. I come home late too. I still sleep alone.

Our seventh anniversary is this year, and it's rough, but I must keep trying. That evening, I ventured down to my husband's basement hopefully not to argue, not be misunderstood, but to maybe be embraced. During our intimate encounter, I begin to cry. Here's the same red couch where he first touched me. There is no way that I can go through it again, knowing what I know and being on the receiving end of complications that indicate infidelity months before. I just get up and leave. This is officially the most unhealthy and toxic relationship that I've ever been in. No one wants to understand. Everyone longs to be right. I'm not coming back. If he wants to be a team, he knows where to find me, and when he's ready to tell me the truth, I will listen and forgive. I spend the rest of the night writing another appeal letter to be reinstated in the university's doctoral program. This anxiety is keeping me from being productive in any way. The fear of not being perfect, of not knowing exactly how to analyze my statistics and just finding the bloody time to do it all well is too much. I need to get back in. Last time, I used mom's stroke, but here we are a year later and two dissertation chairperson changes, and I'm still at data collection. I'm over the hump. I just need them to let me back in, so I can follow the IRB and finally live up to the title that people are calling me without my request. I'm too embarrassed to stop them though. Who works on the actual dissertation for two years? Me, I guess. Back to the grind.

One recommendation from the current therapist is to have couple's and individual therapy. I'm learning to lighten my load by articulating what my heart feels, so I write and deliver an email letter to my biggest fan, my mom.

This weekend has been particularly difficult for me as I reflect upon our journey on this weekend last year at the end of July. Through therapy, I'm learning to get the pressures off of my heart by writing, so bear with me as a lighten this load. I can't help but make note of how strong you were on Saturday, July 27th and still are. You knew things weren't okay. I found notes that you wrote at dinner and of course, things you wrote to me in the hospital. I still have them as a testimony to what God can do. You weren't able to say much, but one phrase continued to come out as clear as a bell. It was "Thank you, Jesus." I couldn't figure out why you were thanking Him for this horrible thing that was happening to you, but all I could do was pray and know that His will was best for us. As we parted ways in the emergency room, I followed the ambulance as far as I could before heading the other way to home. As I rode home, I honestly didn't know if I would ever have my mom back. I thought about the times I didn't want to get you a Pepsi on the way home. I blamed myself for putting you through too much stress with the kids and my marital problems. I thought about how much Daddy loves you even though he has a different way of showing it. I thought about what I am supposed to say to my children and siblings. I thought about losing my best

friend. I thought about how you kept your composure and why I couldn't do the same. I thought about so much.

But God. You were determined to speak and write again. And you did. You are an example to others to never give up, and I won't. You are an example of what sacrificing yourself for others all the time with no rest is, and I am working on that. How fitting is it that you were introduced as a leader in church today amongst the elders and all those other important titles on the exact day that God sat you down to rest for a bit? I get why you were thanking Him now. You were thanking Him for the healing. You were thanking Him for the opportunity to be used as a testimony of what He can do. You were thanking Him for ordering your steps. Congratulations, I love you and you deserve it all! As I get my baby ready for his first day of school, I am officially nervous because no one has provided care for my children but you. Thank you for taking care of them at minimum to no cost when I needed you.

Love,

ME

His birthday is coming up next week, though, and the kids and I are going to surprise him with a homemade dinner. I'm not giving up on him, but sometimes I need a break. The dinner is ready, but he didn't come home that night. I sent the kids to bed and texted him several times. I guess he is on his tit for tat agenda, but this time, instead of trying to get back at me, he really hurt his children. I'm at the point where

I could care less if he comes home, but I won't stop trying to close the gap with the children.

I'm learning more and more in therapy to express my feelings. I have to admit that the more I'm hurt, the more I become guarded. I heard a preacher say once that the more bricks you add to build a wall up the more you guard yourself from the pain. But by doing that, you also shield yourself from any love that may be trying to come your way. I get that analogy, and it makes perfect sense, but this heart can't take any more pain, so I am willing to jeopardize the love for soul survival.

At the same time, my children are preparing for a new school year, especially Quincy, as he starts high school in a rigorous science and technology program with honors classes. This is the moment I have been waiting for. Finally, the child who was born into the marching band family will continue the family legacy I started by marching in his high school band playing trumpet. I'm so excited for him and make sure he has black shorts and several plain white t-shirts for practice. After his first day of band camp, I can't wait to hear all about how things went.

"Hey, Mom."

"Hey, honey, how was your day?"

"It was okay. I just have to practice my trumpet a little more since I didn't play last year."

"Well, you know what they say, practice makes perfect."

"Yup. And how did you guys play the music, march, and do dance routines without messing up?"

"You'll see! We have pride in what we do, and the crowd is counting on us to deliver, so we do."

"Okay. They said practice is going to be every day for the next two weeks, and then on Mondays, Wednesdays, and Fridays. But I also have to figure out when baseball starts because I am going to be on the team."

"I thought baseball was a spring sport. When you talked about it, you said marching band in the fall and concert band in the spring with baseball."

"Mom, that's what you said, but they have baseball workouts that start in the fall too, and I heard if you want to be on the team then you need to attend those as well."

"That's cool with me as long as it doesn't interfere with band."

"Well, what if it does?"

"Then I guess you would need to pick one because it's not cool to do either only half way. You already have Intermediate Band on your schedule so you might as well stick with that."

"Yes ma'am."

This boy must be crazy if he thinks he is going to drop marching band. He lives because of the band and quitting is not an option. I already put it on Facebook, so we can't renege now. Quincy attempts to juggle both for an entire

month, while getting complaints from his trumpet section for not knowing his music and from his band director for missing practice.

In early October of that year, I pick him up from practice and he looked defeated. He got in and put his head down, face into the palms of his hands. There weren't words I could utter fast enough before he blurts out, "I can't do both. It's too much, and I keep messing up in band. The band director said I can't miss anymore practices because they are getting ready for homecoming and writing the drill for the show."

I was just finishing reading a book called *Conscious Parenting*, which helped me to understand that I shouldn't force my life's desires on my children but teach them to explore while I provide opportunities for them to love their own life. I had prepared myself for this moment.

After Quincy took a shower, he came down to talk to me. He sat on the side of the bed, facing in the opposite direction of me and broke into a deep cry.

"What's wrong my son. What is upsetting you?"

"You told me I have to make a decision about baseball and band, but I already know what you want me to do, and I don't want to disappoint you."

"Son, I know that I have been forceful about band and for that I apologize. I learned recently that as a parent I am cheating you out of opportunities if I only say you can continue the legacy and that you are a marching band baby and

don't let you have your own mind. I apologize for making you feel like what you really want to do isn't important."

I kneel in front of him and grab his hands.

"I'm serious, Quincy. I have lived my life, and it was fun for me. You have my full support in doing what you want to do because this is your life, and I have no business taking it over. Please accept my apology, son."

"I hear you saying that, but I just don't want you to be mad at me. I want you to come to my games."

"Absolutely, I'm there. You need to make sure you tell the band director that you are making another choice. He will respect you for that, and you are still in the class for a grade, right?

"Yes ma'am."

"There are five more that I can get in the marching band! Just kidding, just kidding."

I reach to embrace him, and it feels like the weight of the world shifts from his shoulders to mine as he lets out more tears and sobs. This cry isn't for me, but I'm here to hold my fatherless son tight anyway. I don't need to ask him what's wrong, I already know. Sure, Virgo still lives up the street, but you'd never know it.

Chapter 57

LOW BATTERY

The first few months of the school year have been amazing. I truly enjoy working with a great staff and fearless leadership team. On the other hand, my husband has apparently finished being in the summer honeymoon phase of his new job with new colleagues and new hours. You really can't be too productive these days without some type of technology. Well, in the hustle and bustle of getting the half dozen up, dressed, fed, and spiritually sound, I left my laptop charger, and no one at work has one like mine. I have a few options. I can get in my vehicle and spend another hour roundtrip to get it myself, or I can call my superman who always answers the phone and saves the day. I choose the latter option, and within twenty minutes, Daddy is there in the front office with my cord. As we leave the front office, he calls me into the hallway.

"Look, those kids can't live like that. It's a mess in that house! And what is that mountain of clothes in the hallway for? No wonder you can't find anything in there. You and that boy are going to have to do better for those kids."

I listen to his concerned, albeit angry, tone and start to cry.

"Daddy, I'm the only one doing anything. I can't make grown people do stuff, and I'm trying to train the kids, but it's just too much for one person."

He sees the unspoken brokenness and pain on my face.

"Look, your mama and I will come over and help you. Don't cry. We'll get it done, okay?"

He wants to wipe my tears and give me a hug just as much as I want him to, but that's not who we are, so I walk away grateful for the kind of love he wants to give me.

Finally, the weekend is here, and the kids don't have dance this weekend, which means I can chill and try to clean up some. Well, Daddy's early morning visit changed all of that. Within thirty minutes, Daddy, armed with a brand-new box of heavy-duty trash bags, loads up ten gigantic bags of our laundry on his pickup truck. Giving instructions to get my children dressed, my mother met me outside to drive them to the laundromat to get everything clean. I thought he was going to come over and help me, but seeing his truck pull away with ten huge loads of dirty clothes, I realize the deep hole that I am in. We have so many clothes that each family member has his or her own table at the laundromat.

Then one of the children asks where her daddy's table is. The fact is that his clothes are not present because he chooses to wash his own clothes, so he's all good. Heaven forbid one of those precious socks gets mixed up with our socks.

Mommy and Daddy help me wash, dry, and fold each and every unmentionable. I am relieved, embarrassed, disappointed, and grateful all at the same time. I burst into tears on the way home. How could I allow my home and my housekeeping to get this far behind? I have to do better whether I have help or not. I cannot allow my children to believe that piles and piles of clothes are the norm. These are six future families that I have a direct influence on, and I pledge to do right by them. I can't control anyone's behavior but my own, so I will push forward and tighten up with the children.

Chapter 58

ALMOST DOESN'T COUNT

It was at the National Council of Teachers of English conference, which was hosted in Maryland this year, that I was inspired again to tell my story even if it's only a sentence a day. The speaker says that thoughts that aren't captured in writing are lost forever. I don't even know what story to tell, but I know I have to tell something. So, my decision is to capture memories for each child in their own book. Like I really need another thing to commit to, right? It's the least I can do. My mommy used to write to me in college all the time. I miss her letters, her words, that I could just read over and over again. It is important for them to know how I think and strategize. We think aloud in the classroom, but what about at home? Are we so busy trying to make it happen that our children don't learn from us?

We are heading out of town for Thanksgiving next week to celebrate Gig's brother getting married, and the children are in the wedding. Gig needs to get some work done on the truck, so I am waiting to get the call with the price tag. Serving on any committee offers perks like being able to meet

authors, introduce panelists, and have my name in the program—a resume builder.

During the early part of the conference, I keep getting calls from my husband. I send them to voicemail and send a text asking if he's okay. He doesn't text back but continues to call. I'm moderating a panel, so I can't just get up and leave, so I call him after the first session at 9:55 a.m.

"What's wrong, babe?"

"I can't take this anymore. It's gone too far, and I'm leaving."

"What? Where are you?"

"I'm in a parking lot in the middle of somewhere. I don't even know."

At the same time, I am reading an email saying my husband got in a heated conversation with one of his supervisors and quit.

"Stay there, and I will come to you. Just tell me where to come."

"No, don't come here. I just want to be alone."

"Gig, did you quit?"

"Yes, I can't take it, and I'm never going back to that place to work for that person!"

"Okay, so what do you want me to do?"

"I don't know. Just stay where you are. I don't want you to leave your important meeting."

"Now, you know no one is more important than you, but you won't even tell me where you are!"

"I will be home when I calm down."

"Okay, well, I'm leaving here in a few minutes and will be at home when you get there."

"Okay."

He doesn't come home until after dinnertime, 6:00 p.m. Anticipating his entry is unnerving especially since he's been sitting outside on the phone for over fifteen minutes.

"So, where were you all this time?"

"Just driving around."

"Right... so, what is the problem?"

"I know she's probably already called you by now."

"No, I actually called her, but I need to know what your plan is."

"My plan is to be talked to like a human being, and that's not happening there or here, so other than that, there is no plan."

All night he is in and out of the house, going to the truck on the phone, and coming back in on the phone. I can hear him giving the play by play to someone on the phone in his basement all the way from the kitchen upstairs, yet I ask him what happened, and I get nothing. Then fine. I have six people upstairs who would love to talk me to death, so I close up

for the night and turn in for a special golden birthday for our youngest child, BK.

Today is the baby's fifth birthday party. I'm excited but highly unorganized for this event. I have so much on my mind, but I won't allow it to consume me. *My God shall supply all my needs according to His riches in glory. Jehovah Jireh cares for me.*

It's good to get to know your coworkers beyond what they do for the organization. Katrece is one of my teachers and also an avid photographer. Gig stopped bringing his camera to events over a year ago. I guess he only takes pictures for money now, or he's that checked out. Either way, I made sure Katrece would be present to capture BKs golden birthday party. He's turning five on the fifth of the month and the theme is "When I Grow Up." All of his little friends came dressed as doctors, firemen, chefs, lawyers, ballerinas, fashionistas, and my favorite, a teacher.

"Come on you two. Let me get this picture of BKs mama and daddy."

Gig's behavior is erratic at this point with the use of profanity and calling women out of their names. I'm fuming mad but more than mad. Right at that very moment, I come to the realization that this is the last picture that we will take together for a while.

The party is over.

DIDN'T WE ALMOST HAVE IT ALL?

We all come home with leftover cupcakes, gifts to open, and balloons galore. The baby is still wearing his tiger mask with face paint. I gently wipe his face, and in it, I see his father's genes. Keeping it together enough to get him in bed, I say a prayer over him and leave the room. I want so much more for my children. We are not being responsible parents, and a change must occur in this very irrational space. It is time for my shower with my amazing shower head that my husband installed just for me.

My shower time is for self-reflection. Some of my best ideas come in the shower. I replay and rehearse how I should, could, and would respond to others without judgement. I believe the water cleanses my mind, body, and soul of the clutter and dirt in my mind, so I can think clearer. It doesn't work this time. We will not have his paycheck this week, and we don't have a plan to have a paycheck next week. In the midst of all the other issues that detached men and women encoun-

ter including distrust, which leads to insecure thoughts and inappropriate behaviors that build a bigger wedge, I yield.

Blame it on me. Say it is my fault. I am done being pushed to the edge while holding the entire family down emotionally, physically, and financially with no reprieve and with no accountability but to bring home a paycheck. I have never been more broken, and though I am not physically abused, if my heart was examined, it would need sutures and stitches to mend the deep gashes in my love tank. This is not what I signed up for. For better and worse. Can we just get to the death do us part already? How in the world can a man allow his wife to suffer in this way, for this long, with no desire to ease her pain? This is not love. This is self-loathing, self-serving, and sucking the little bit of life left in me right out.

Pushing the grocery cart through the grocery store the next Sunday morning feels like bootcamp. I have to stop several times to work on my breathing. I can't pass out in this store, so I find a seat near the front and sit down to try to get myself together. After ensuring that I am able to complete my mission, I return to the produce section. I realize this may be the last time we get fresh fruits and vegetables for a while as produce is weighed and bagged. Then Gig calls.

"Hey, I'm getting ready to leave for church."

"Well, we need to talk."

"Okay."

"You have put our family in a really bad place with no care about how we would feel or survive. I'm tired of you thinking of yourself only and the self-serving behavior. I think we need some time apart, so I can figure out what my next step is. I literally can't breathe. Your presence gives me anxiety, and I have to be some good for these six kids who aren't going to stop growing, eating, and learning. They need me to be healthy, and you're making me physically ill. I don't know what else to do."

His response is swift and succinct.

"When I come home from church, I will pack my things up and leave."

Just like that.

What about the children?

What kind of man quits his job with no notice and leaves his family of eight without a fight? What kind of woman lets the daddy walk out on six children without a fight? What kind of children can recover from being fatherless, or were they already alone?

The morning after is rough. Thank God I only have two days of school this week. It's time to take the twins to therapy, but I don't have the money. On the drive there, I receive a call from the therapist stating that we have actually overpaid all year, and we don't owe anything for the next six months. God is so good! That was my reminder that God will take care of us and that we will prosper. One thing I'm grateful for is the

magnificent way the Lord orchestrates my life. If I had never met my previous supervisor, I would have never been called to work with my brothers, Vic and Wendell.

Lord, please build a hedge of protection around my family and bring us closer to You. Allow us to decrease so that You may increase. Give me the strength to endure this situation and remove the fear and doubt as I lean totally on You.

Night after night I can't help but notice this peace in my spirit. No more worry about who is where, why not me, when will it be my turn, none of that. I'm sleeping well knowing the door is locked and the children are safe, and Jay's famous grilled cheese serves as the perfect nightcap.

It is now the week of Thanksgiving, and I have lots of decisions to make. I have to figure out how I can afford to get my children to a wedding four hours away for their father's baby brother and what am I going to say to him when I see him. Forget the fact that intentional deceit is still occurring and that I probably won't be well received by the majority, but I owe it to my children and the bride and groom to show up. In this moment, the connection between my children and their extended family is paramount. I have been putting myself last all this time, so what will it hurt if I do it one more time? As long as my mom is there to have my back, we are

good. Let's get through these last two days of school, and I will make it to Wednesday with a smile.

The next two days are a blur. There is no real difference in my daily routine because I do everything anyway. The big difference is the turmoil I feel about how quickly he agreed to leave, without a fight, a second thought, a let's talk this thing through, nothing.

FALL AT YOUR FEET

God always has an amazing way of speaking to me. There is so much going on, and I hear His voice, but don't always obey. I am a child of God, so I understand what I am supposed to do, but I just get too busy, if there is such a thing. I have been praying since he's been gone. I have been praying but not seeking His face. An unfortunate incident at school left me falling forcefully on both of my knees. The pain is more than excruciating, but I know that it is temporary. I leave work early that day because the pain is too much to bear along with the pain that exists in my heart. It's been five whole days, and the children are just now asking about where their father is. I shared with them that he already left for Virginia for Thanksgiving, and we'd see him on Friday.

He is going down before us to spend the holidays with his family, and we already know the truck won't make it down there in the condition it's in, so I call him to get the truck brought home until he gets back.

"Where's the truck? I asked you to bring it home to park it before you left. You said it wouldn't make it down. How are you getting there anyway?"

"I'm riding with my sister, and I'm parking the truck at her house because she's already up the highway."

"Fine. Does she have a garage? I'm not finished paying for it yet."

"Yes, she does."

Something doesn't feel right. In my heart I know that he is lying to me.

See! Exactly! Unless the distance between Upper Marlboro and Woodbridge changed from fifty-five miles to five miles, somebody is lying! Leave it to OnStar to tell the truth when humans won't.

I text him for clarification.

I'm going to ask you again. Where did you park the truck?

It's at the person's house that I rode with.

What is the address? He sends it via text message.

Thank you.

One of my work brothers calls to check on me as soon as the address five miles away pops up.

"Do you want to go over there? I'll take you."

"I can't go over there."

"Well, if you need me, I'm always here. You know that, right?"

"Yeah."

"Call me."

After thinking about his offer, I decide I could just go and check to make sure it's okay and take anything important out. I mean if it's not behind a gate, I don't think it will be safe. If that's the neighborhood I think it is, I need to go check it out. It's Wednesday, and who knows when he's coming back. I call my work bro back and let him know I accept.

"Call me when you're outside. My address is . . ."

"I have your address already, remember?"

"Right, I forgot."

He arrives, and I leave out at almost midnight to check on my investment.

"Hey. You okay?"

"I mean I guess so. Mapquest says eleven minutes."

"I will have you there in eight."

"No rush."

We arrive at a community that is not only not gated but neither is the truck in a garage or anything. It's just backed into the driveway, if that's what you want to call it. I've never been here before, and I have no idea who lives here, but I know whose name the truck is in.

I don't even live in a gated community but seriously? He thought my truck would be safe here for five days and nights? Five miles away?

He drops me off back at home, it is oddly warm for a November night which matches perfectly with the fumes coming from my ears.

"Thanks for being there for me, I really appreciate it."

"Whatever you need, you know I got you."

Chapter 61

LEAVE ME ALONE

I decide to sell any and everything in my home that I no longer need and use. First thing to go is the black truck, and the next thing to go is the bundles of baby clothes. I can't drive two vehicles nor am I having another baby. I have lots of pots and pans, and a Pampered Chef overstock sale is scheduled. We will live our lives by any means necessary. I cringe as I think about that word. Necessary. That's the word that got me out of the spelling bee, and everyone just knew I'd win. I lost to a slacker class clown which made me feel even worse. Anyway, I am determined to be debt-free and declutter while making as much money as I can for my family. That downstairs closet should really be used as a closet, and we haven't worn those clothes for years and years. So, if my actions are seen as "cruel and unusual," then so be it. It's about my children now. Grown folks can do whatever they please.

A year ago, my children were invited to participate in the nuptials of their father's baby brother. I was greatly involved with the wedding by creating the invitations and stationery. Dresses for the girls and suits for the boys have been pur-

chased along with the rental van and hotel accommodations. We've been planning this for months. The wedding is in three days.

Another painful Thanksgiving has come and gone. The concern they have for their father is authentic and abundant on the day of the wedding. Telling them that their father left us was the hardest thing I have ever had to do. It has always been important to me that my children always hear the truth from me and be able to believe what I tell them. *It is well with my soul. Thank you, Lord, for blessing me with my mother who can be with me during this trip.* Once we are all dressed and looking amazing, we head to the church where everyone embraces my family, but no one embraces me.

"So, you stopped wearing your wedding ring already? That didn't take long."

"Don't start with me, Gig; you know I will show off in here. I'm here for Jon and his wife."

I wonder what he told them. He probably told them I did something to him. I wonder if he explained that he left to move into another woman's home. I wonder if he told them that he lied to me about where the truck was left. Who am I fooling? They know what's up. Thanking me for marrying their brother didn't make much sense, but it's all coming together right about now. As soon as the children finish eating and dance a time or two, we are back on the road.

I couldn't sleep all night once we returned home. Knowing that the truck is parked in some strange neighborhood

with no one to look after it is unsettling, so I call AAA to go and get it for me. Early Sunday morning, while waiting for the company to arrive to help me, since I don't have the key, the neighbor calls out to me from his top floor window to "leave Sara's truck alone." It's confirmation that he has surely seen the truck here before so much so that he is willing to confront me about it. I try to explain to him that the truck is in my name, and therefore, I have the right to take it. He threatens to call the police, and I told him to do it. Within ten minutes, both AAA and the police department were on site, as well as a car of women who were clearly sent to "check things out." Once I share my documents, the officer leaves, and in my peripheral view, I see a shorter man coming down the sidewalk in his robe which does its best but doesn't cover the fact that he is sporting boxers, white crew socks, and house shoes.

"Excuse me young lady. I'm so sorry for what I said."

"Sir, I tried to tell you that this is my truck and that my husband drives it. But it's all good because you confirmed a lot for me just now."

"Well, I just was trying to protect my neighbor, and I would do the same for you."

I get it.

He extends his hand to shake mine. He meant no harm like others I know. I oblige.

Daddy and I park the truck in my parents' yard, and now I can breathe a sigh of relief.

The word has gotten back to Gig, and he's calling me non-stop. After five missed calls, I answer.

"Yes."

"What did you do?"

"Why did you lie?"

"I knew you would take the truck; that's why I didn't want to bring it home."

"Uh huh."

"Well, I was calling because I want to talk to you about getting another job and using my part- time gigs to pay for the car note, so I will have something to get around in."

"Car note? You left me with six children, four who belong to you, and you're talking to me about a car note? We might be sleeping in the damn truck if these bills don't get paid."

"You didn't have to go over there, Ashanti."

"That makes two of us. Goodbye."

"Wait, so what am I supposed to do?"

"I don't know ask her neighbor; he seems to have all the answers."

"What?"

"I said goodbye."

Chapter 62

A LONG DECEMBER

December 1st

The next morning, I am optimistic and ready to say goodbye to November. I celebrate new beginnings, grace, and alignment with the Father. The blessing is the ability to praise God in the circumstance. He's so good to us and presents new mercies every morning. None of which I deserve. BK prays each day for "my daddy to feel better." He knows. I say amen. I got the keys back, and I am preparing to sell the vehicle. It's odd meeting up with my husband, but it is getting better. I believe he's becoming more aware of the situation.

December 2nd

Lots of folks want to help me out. This is a lesson I'm growing into for certain. It's always been me and Mommy and outside help was never a requirement. But it is now. I recall my principal asking me, "Why won't you let someone help you?" He's right. I just feel like mothers should handle their business, but I'm getting there. This is the second Tuesday in a row that

I've injured my knees in another school system fall. I hear the Lord saying, "Stay right here, Ashanti. I've got you covered. Just stay right there." But did He have to go through such extreme measures to get me to hear Him? Maybe.

December 3rd

I hate lengthy email responses. I believe that once an email response has reached over two hundred and fifty characters you need to handle it face-to-face. Today, Daddy and I took the truck back. It was emotional for me as I stood at the same door on July 7th just three years ago, anxiously awaiting my husband's response to me about purchasing him his own new, black pickup truck, something he always wanted. I relived that happiness in my brain while being given a subpar sale price based on how much the truck was run down into the ground in just three years. It's all good though. Good while it lasted for sure.

December 4th

Whose report will you believe? Who applies for a job less than a mile from their home at twenty-seven dollars an hour? Me. And who was given a second interview and workshop opportunity on Saturday? Me. I'm so excited! Even if it doesn't yield thousands of dollars, it will surely get me employed with them which gets my foot in the door.

December 5th

I will trust in the Lord until I die. That song has been playing in my spirit all day. I just realized that every morning I wake up with praise and worship on my heart and in my spirit. How beautiful is that? I have been enjoying wonderful sleep and have been going to bed at around 8:30 to 9 p.m. Amen for peace of mind.

Today I signed the truck away officially. I was messed up, but I knew it was the right thing to do. After a peaceful night, Gig brings the boys back home from scouts, and Sid's first question before even saying hello is, "Why did you take daddy's truck?" I just had to pray because Gig can quickly say I took it but can't say "I quit my job on you guys and left Mommy and you with no money." I see I am going to be labeled as the bad guy, but they will see when they are older I pray.

December 6th

Let the weak say I am strong. I truly thank God for music, hymnals, and psalmist like Fred Hammond who puts scripture to song. What a beautiful reminder of God's desire for us to live life in abundance and only require obedience. In this space, I need to and long to know God more, to repair my relationship with Him, and to engage in practices that my children will be proud to model.

Today is the workshop for the next part-time job at the community college. Training is all day. Lord prepare me. I am usually on the other end of this. I know I'm overqualified. I

just need to meet the right people and have fun teaching. Gig is supposed to be picking up the girls to take them to dance, but he won't answer the phone. After the noon hour, he tried to text me, but the internet doesn't lie. Someone posted a pic of him and tagged him at a bar drinking. No more social media. You, sir, are blocked. My soul can't take it.

December 7th

Because we have so many children, I thought it would be cool to honor them on their own day monthly. Actually, I got the idea from my relationship with my Morgan Bear. The fifteenth of every month, we celebrated our anniversary. He always did something special for me even when I was pledging. Well, today, I missed the girls' day. I hate that, but I will make it up to them. I'm so excited to be here presenting at the annual Learning Forward conference in Nashville with Vic. I already miss my babies and family, but during my down time, I am making provisions for us to file for child support.

December 8th

Reunited and it feels so good. Teaching is my passion. I love it. It feeds me what I hunger for and allows me to serve others. Vic and I stole the show this morning, again. The content was relevant, there was high energy, and the participants stayed fully engaged from beginning to end. I think we made great partners with various educational vendors.

I was initially very concerned about leaving the children. I mean their dad has been gone for two weeks now, and I'm gone too. They are fortunate to have great grandparents in my mom and daddy, and I know they are also supporting one another the best they can.

This is what I needed. Time to get my life together financially, emotionally, and to figure out what 2015 will bring. Tomorrow, I need to draft a will and take a look at my policies to make sure everything is cool. Mommy always said, "If you don't pay anything else, you better make sure that insurance stays current."

December 9th

That writing workshop gave me life even though I didn't want to go. Learning is learning, and anything to take my mind off of this mess I'm in is good. Today I thought about Johannah. I thought about how she'd respond to all that's going on. I thought of who and what she'd become. Johannah Grace, my angel.

December 10th

Insane in the membrane. What is the definition of insanity? Yes, that's correct. I've got to stop, and it begins today especially when I'm the one screwed on my end. My favorite plane ride to Orlando was spent trying to replace recurrent negative energy with positive, productive action. I will trust. I have flown from Nashville to Baltimore just to turn right

back around and fly to Orlando to present at another national conference. The funny thing is that nothing changed. The kids were going to my parents' house anyway. Gig doesn't watch children when I travel.

December 11th

This is how we do it. Man, that AVID interactive notebook session was awesome. I promise if I get to teach reading at PGCC, we are totaling using them. I spent alone time in reflection. It was good for my soul indeed. In other news, mental illness is real. Don't ignore it.

December 12th

I got my freak um dress on. When you look good, you feel good. When you feel good, you do good. Boy Scouts say, "Do a good turn daily." Help someone. Even though I didn't want to, I prayed. God said pray for your husband, so I did. I got on my face in prayer to God for my husband. I don't want to exchange old words with him anymore. Just ready to move on with whatever life is supposed to be. He needs help. His mental state is really messed up, and I'm concerned about what he may do with my children. In other news, I love me some post-it notes.

December 13th

Home, sweet home. Note to self: Never leave your babies for more than five days. Never expect anything from anyone be-

cause in the end, your feelings don't matter, but you are responsible for making everyone else feel all warm and fuzzy. Whatever.

December 14th

It's real. Kiah came over to craft with the half dozen. Love her. We also made pipe cleaner ornaments, wrapped some gifts for Adopt-A-Family, and had their father over for dinner. How weird is it that I'm trying to explain to my children why I'm purchasing and wrapping gifts for another family when we, in fact, are in the greatest need now?

It makes me so sad when I realize that we really don't have much savings anymore. That we, in fact, were financially abandoned. It hurts like crazy, but I'm determined to make it happen and ensure their success until child support kicks in. But who knows when that will be?

December 15th

Mama knows best. After a long day, we did homework, scouts, National Council of Negro Women drop off, Wendy's, and God. My house is a mess. I have to have a neat house to stay sane. A neat house, neat car, and neat office will keep me together. I will continue to work at it though.

December 16th

Mom asked me to move in with the kids. I realize that I'm unable to care for them with one salary right now, but I feel

like I will figure it out. I feel like we can make it. I just need to deal with these bills like consumer debt and student loans. I can do it. On the other hand, what's so wrong with saving money and moving in with Mommy and Daddy? Failure—that's what.

I guess now I am concerned with the amount of work to be done on the house to get it rental worthy. I'm still fighting and praying though. Something has got to give at some point, right?

I think I'm going to join a focus group at church also. I don't want to commit to an institute or discipleship program while I am attempting to finish this dissertation.

December 17th

Let it whip! Today, I feel like my mojo is almost at its peak. I see out of new eyes. I feel the presence of the Lord, and it has overcome my thoughts. No space or energy for negativity. No time for not being productive. I signed my W-9 for my part-time job already, and I'm excited about that.

December 29th

I didn't forget to write over the last two weeks. Every time I picked up the book, I wasn't in the right headspace. And I can't say that I am there right now, but I have something to say to my husband after being attacked on social media.

Adding frustration to an already turbulent relationship is never the answer. No virtuous woman would purposefully come into your life with the goal of causing dissention. Why would you even associate with someone like that? Is that behavior positively promoting you? You say you are so sorry about everything—whatever that means, but the bull continues. You have a history of not being honest, so I won't ask you about whether or not you knew it had occurred, but I will say that she knew enough to come for me, but why? Is she volunteering for some babysitting, tutoring, or paying these bills you left me with? I didn't think so.

A real BFF is decent, respectful, and will hold you accountable for your actions. I don't care to have personal angst and social media wars with bitches I don't even know. Tell your old bitches that if they need to share information with me to be WOMAN enough to contact me directly—not through pictures and quotes.

My friends can teach your so-called friends a few things about respect, honor, and discretion. On no day is a pic, post, hashtag about someone else's husband ever acceptable. People, you're too old for that.

What is the real goal anyway? Obviously, you have communicated that the marriage is over. Why else would someone all of a sudden feel comfortable posting and using social media to cowardly lure me into this bull? Is this the same person signing my name up for divorce lawyer tips that I have been getting every day since you got a U-haul for some chick

in your name with my address? I mean, if y'all are together, isn't that your business? Anyway. I'm clear, again. Just wanted to free you. I specifically asked you, and you never directly answered. No, I'm good now. Why even keep apologizing?

December 30th The Meeting

A year ago, he stayed out until 4 a.m., no phone call . . . no nothing.

Worried, I called my mom to come and watch the children while I drove to the school to see if you were safe. Your claim was that at Watch Night service your AV friend was hosting a party, but he needed a ride there, so you took him there and didn't find home until 4. If you recall, you stayed on the other side of the door that night. No phone call, no text, nothing.

After the altercation that ensued, I knew in my heart that I was no longer sought after by my husband. I became bitter. It doesn't feel good to assume all responsibility for everything the family does and yet still not be honored enough to be recognized as a wife year after year.

But before I go too far into the past, I must apologize for revisiting it.

I am under a pretty strict spiritual regimen which includes guarding my tongue. I allowed last evening's discourse to be more than I intended and truly feel a setback in my spiritual growth. Today, l am rebuilding. I don't choose to discourse with you regarding anything but our children at this time. I

honestly do not know who you are, and sometimes, I don't think you do either. In the absence of your leadership as the head of household over the years, I have chosen to stumble out of my role as a submissive wife and into wallowing in bitterness and disgust. For that I have to answer to God and ask Him to change me.

I believe in miracles, and I believe God can do anything. I also believe that you have some areas of mental illness that must be dealt with individually before you attempt husbandry and fatherhood. I recall you sitting on the side of the bed telling me you hear voices telling you to do stuff that you wouldn't tell me. Ultimately, when God has prepared you to reunite with your wife and family, both you and I will know clearly.

If pride, guilt, shame, other relationships, and resentment are allowed to orchestrate this marriage, then of course, other actions will be required. Be clear that it is not Godly or acceptable to share dwellings with another woman as a married man. God will never honor that, but ultimately that is your cross to bear and not mine. Don't allow other people who aren't in your situation to give you guidance; it will always be based on their experiences and a one-sided view of the big picture. It is a false sense of support. Everything that feels good isn't good for you. How can one pray to the "Good Lord" in an adulterous state and expect to be heard?

What real friends do is: question your motives, encourage your spiritual growth, hold you accountable, and cease to

judge. Real friends don't place an already and clearly unstable man in an environment that doesn't promote becoming a better Christian, husband, and father.

Real friends don't spread your business and convince you that it's coming from a noted enemy.

Even when I expressed the photo bothered me you still didn't untag yourself. Real friends sing His praises, pray for your healing, and allow you quiet time to reflect and atone. I challenge you to again govern your thought life. Real friends don't speak ill of your spouse, solely because you should never allow it. I have #rideordie friends who won't let me off the hook, won't let me fall. They hold me accountable to what God says for me to do because they know the word and speak it to me. If your people aren't doing that, I would flee without delay. It is toxic for your growth. You will never have truth moments there. You see your issues, which are now my issues stretch far beyond dollars and cents and credit scores. It's easy to lean on that, but it's so much more.

I always thought husbands would continue to date their wives and make them feel special, that I would delight in making dinner, washing clothes, and making sure the children were well adjusted. I feel like everything that I've always wanted is dismissed and denounced. You have to love yourself and God before you will ever be able to ever love me. I realize that and will endure. This is a process that must occur. The length of the process is managed by the openness, reflective time, and spiritual foundation. However long it takes is

my answer. I do not seek divorce. I will no longer be last, I will no longer accept residuals, and I will be respected as an equal partner not head of household. I will be honored as the queen and not put down for doing your job as the husband and neglecting mine as a wife. I don't know if you realize it or not, but I love you enough to allow you space to realize a change is necessary to your health, our marriage, and children. Every other thing I have ever asked of you has come with rebuttal but not the biggest decision of our lives. You just left. No conversation, no apology, no commitment—nothing. And you didn't just pack a bag, you took everything. To me, that's final, so why would you then need a key?

My advice to you is to leave that woman's house immediately, go to the doctor, and get back on your meds. It is unresolved, and your decision-making hasn't been sound for years. It has caused me not to trust you, especially when I know you will lie to me.

I will endure this and continue to make decisions for the welfare of all of my children. It hurts to hear that you have decided not to seek godly counsel, but in the end know that I love you enough to let you go if that is what is required for you to be a better you. I'm not going anywhere, and I will always hold you accountable. Even when I say nothing, I'm fully aware. Whether you choose to acknowledge it or not, I held you down when you didn't have enough strength to pick yourself up over and over financially, physically, emotionally, or mentally. It is your wife who prays for your safety and strength in the Lord every day with my children. It is true

love to hold one accountable. You will be what God has ordained you to be. So, instead of discussing your expectations of me, which is really me wanting to know you still care, I think we should discuss you visiting your children, and I will continue to pray for you. I know what God has called me to do and all of that supersedes your expectations, whatever they may be.

No salary or direct withdrawal or credit score will fix it. No amount of money will heal our marriage. It is the understanding that marriage is a classroom to teach others how Christ loves the church. Our family is down but not out. I claim the victory! Just know that you will never truly be free until your motives and intentions towards me are pure. Hurting me is hurting the children. Your actions during this season will directly affect our next steps as husband and wife. If you can't do it or say it in front of me, then you probably shouldn't do it or say it. But really God is always watching so there's that. I know you are sorry about the children not having Christmas gifts. I played the message; we get it.

Emailing me about you taking responsibility, then blaming me for asking you to leave don't match. Which path do we continue on?

Blame or forgiveness?

Guilt or confession?

What others say or what God says?

I love you.

December 31st, New Year's Eve

The plan was to go to revival tonight and bring in the new year with my church family, but instead, I'm paying for co-pays and prescriptions that I already can't afford. Three of the six are sick. I call Gig to tell him what's going on since he's their father.

"Hey, I was just calling to let you know that Boom and BK's asthma congestion turned into bronchitis."

"Okay, I'm coming," Gig yells to someone in his new dwelling. "Thanks for calling, but I need to go because we are getting ready to sit at the table for dinner."

The very thing I have begged him to do all of these years and he makes the point of saying he can't talk to me about his children because this dinner is so important. That was intentional to hurt me, and he was successful. Come on 2015! Will you just start already?

Chapter 63

I FEEL GOOD

From January to April, we don't really speak. He gets a place in March, and the children spend Friday nights over there. And who is the very first person he takes the kids to meet on his first visit with them? He's so predictable and dumb. He refuses to keep them on Saturdays claiming he has to work. Well, if you are working, can you please pay some child support? At least with this new spot that the kids say has a garage, he can keep them overnight. This arrangement actually helps me get the quiet time I need to knock out the last slides and phases of the dissertation. I only have until May 22nd, and the door is permanently closed. Nothing but God has gotten me to this point. Tomorrow morning, I defend my dissertation. Not my proposal this time, my actual dissertation. After two hours of discussion and slides and recommendations review, I am called back in and called Doctor Foster officially. *Amazing grace how sweet the sound that saved a wretch like me, I once was lost but now I'm found, was blind but now I see.* I did it. The first person I call after praising God to exhaustion is my husband, an unlikely subject, but he has

witnessed the long nights, early mornings, piles and piles of papers, and phone conferences. I owe it to him to give him the news. Then I call my mother-in-law because I would not have made it through chapter four without her. Next, I call my mom and dad and go get a smoothie. I've been locked in this house for three days determined to see it through. I had a deadline to meet, and I refused to let anything make me miss my last and final attempt to complete this program. They are no longer taking any more of my excuses. My counselor said that he doesn't know of anyone who was dismissed from the program twice and came back to finish the degree. He must not know my God like I do.

We finish the school year, and I am elated to be Dr. Foster for real. What is so bothersome is that I'm embarrassed to share it now that it's here because I've been living a white lie for a year already. The other ugh is that with the balance of my tuition looming at over three thousand dollars, I can defend my dissertation, but I can't get a transcript. Even though they dismissed me twice, I still had to pay for those semesters. Without a zero balance, I can't graduate either. I'm just ready for summer.

One organization that I am very interested in is having a committee meeting for assistant principals who want to participate in planning for the fall conference. I am a planner, so I definitely have to be there! Part of the commitment is serving as a judge of the Assistant Principal of the Year for the state. I lost last year, so I doubt someone would nominate

me again. Scott calls me about fall conference planning and mentions something about the award.

"Hey there, it's Ashanti, and I want to join the Fall Conference Planning committee since I wasn't nominated this year."

"Well, actually, you were nominated, Ashanti."

"Huh? No, my principal told me he didn't nominate me."

"Well, someone did, but you can still join the committee; you just can't be a judge obviously. I hope you consider applying again this year, Ashanti. Some candidates don't get chosen until their second time."

Whatever. That's the same song I heard at the Teacher of the Year banquet when my name wasn't called there either. I don't lose well, and I'm not use to being told no. I blame it on my daddy; his no to me is shaped more like a "not right now" or "if only you had told me sooner" or "let me know the next time it comes up" type of no. He never gives me an outright no. And I struggle with not having a good attitude when not meeting the goal. In 2015, the "no" to AP of the Year hurt my feelings, and I ended up not going to the conference. I had to stay at school but going meant meeting the person who was chosen over me. I wasn't ready for that. I don't know if I will actually submit the application because I am afraid not to get chosen again. That would be a double whammy for me, and I just can't take anymore rejection right now. Rejection at home is looking like Gig still not helping me with the children financially, and his four are in before and aftercare

costing over one thousand dollars per month. My bills are behind, and I still can't keep up.

After a productive summer of vacation, creation of six hundred or so student schedules, and travel across the nation teaching teachers how to help their children read with deeper comprehension, the time has come to begin the first week of school. This year my children officially touch every part of the educational spectrum: a high schooler, a middle schooler, two intermediates, and two primary students. With every school calendar synced nicely to my Google Calendar, uniforms purchased, and school supplies labeled, I think we are ready to begin the school year. It is Tuesday, and my fifth child's day to lead us in prayer.

"Thank you, Lord, for this beautiful day. Thank you, Lord, for our lives, health, and strength. Bless us to have a great day at school and no bullies to be mean to us. In the name of Jesus. Amen."

Our morning prayer time centers everyone and positions us for a brand-new day of excellence. It was just this year that I started to call it "circling up" because we do that with our staff at school. No matter how late we may be running, which isn't often, we pray together.

With about two weeks left to get this application done, I have some decisions to make. Let me go ahead and register for an account and see what I need to do. After scrolling through pages, I see that I must have signatures and certifications from my supervisor and CEO. Do I really want to

go through with this? I don't know if everyone will do their part in time, but it's worth a try. This would be due the very same week that I have to do observations, verify assessment goals, and handle back to school stuff with my own children. I prayed and completed my portion. I sent reminder emails and checked the status periodically. Reflecting on the work that I have completed is starting to make me excited about the possibility of earning the honor, and I am glad I persevered and completed the application. As educators, we work so hard every day that we don't normally sit down and write about the experiences, programs, and our job successes. I'm so busy engulfing myself in my areas of growth that I simply forget to celebrate. Finally, everyone's data is in, and I press submit. No matter what happens, I know that I am making a difference, so if that was my lesson to learn from this experience, mission accomplished.

I feel relieved that the application is in. There is something to be said about completing a task. It gives a huge rush of adrenaline or whatever psychological feeling that is. I love it!

Instead of preparing a typical "things to do list" with fifteen items that don't get done, I create "Today I Must" lists. As the name suggests, only the things that must happen on that day are added to the list.

The next week is extremely rough trying to finish up observations and state artifacts needed to be compliant with employee performance and testing. Plus, the principal is out of the building, and anytime he's gone, there is something

going on. I would be willing to bet that he talked to certain kings and queens about a scenario to enact, so the assistant principals can get their principalship skills tested. This time it is a teacher-teacher matter that I mediate, and at the end of that, I'm tired. Then I remember my daughter's special education meeting is today, and I forgot all about it. I have to leave Vic and the crew to run the school. Before I leave, my principal asks his secretary to ask me if I will be in the next day over the phone. Of course, I will. What kind of question is that? I dismissed it as I sped up Interstate 95 north to get to the meeting. I arrive late, but the teachers are gracious enough to meet with me anyway.

Building strong relationships with your children's teachers goes a long way.

The next day is a regular one, except for the fact that my principal asks me to fill out an emergency contact form, noting that they didn't have one on file for me. I'm pretty sure that I completed one, but he was adamant, so I quickly complied. When he gets his mind on something, he won't let it go until it's done. Towards the end of the day, an emergency staff meeting was called. What the heck is this about? He didn't even tell me there was going to be a meeting. We get down there, and this white guy comes in and starts talking about how proud he is to represent Maryland and school leaders and blah, blah, blah, and then it hits me. That sounds like Scott from MDASSP. That's the committee I've been on to help plan the conference. Why is he here? Then he calls up my principal.

Chapter 64

CELEBRATE

"I'm proud to announce that the 2015 Maryland Assistant Principal of the Year is in this room. Ashanti Foster."

Everyone claps and cheers, and I sit in awe of the moment. Around the corner comes five of my children and my mom with balloons and flowers. They got me good! Jay was still in school or they would have gotten him too. As I stand before staff, accepting their kind words and accolades, I'm smiling but thinking about how I just got paid that day and that my account will still be negative after all is said and done. I think about if the Pepco payment made it in enough time to keep my lights on and how I am going to feed my children for the next two weeks. But that is only for a moment because this recognition is moving fast. The next week I am speaking at the State Board of Education meeting and taking pictures with the higher ups in the district and state. Now, I am competing for the national award, but this honor is enough for me. In January, all Assistant Principals of the Year are flown out to Disney for three days and four nights of amazingness,

and I was able to meet with some extraordinary people who are doing out of the box things for children.

My role as 2016 Maryland Assistant Principal of the Year is starting to sink in. Just walking out of the house, there is a chance someone will notice me from the website and offer me congratulatory remarks. It feels great to be acknowledged in the community, and it is good to know that I am district raised and well-respected nationally. In the same month, I was nominated and accepted for the Aspiring Leaders Program for Student Success (ALPSS) for leadership advancement. I figure if I'm Assistant Principal of the Year for the state of Maryland, I should strike while the iron is hot. Plus, my principal said I'm ready. I respectfully disagreed with something, and he noted that I called the community "your school" instead of "our school." He said that's when he knew I was ready for my own school. I detached myself. The rest of that winter he joked with me about, "Well at your school . . ." I think that was his way of getting used to not having me there. He had me teach him everything about Google Docs and accessing documents that I created. They will be fine, and I haven't even gotten an offer yet.

To keep the celebration going, I was honored in February 2016 as one of the honorees for the Prince George's Forty Under 40 sponsored by the Social Innovation Fund with my Morgan Bear as my escort for the night. He looked great, and it felt good to be together again. I missed his dad's funeral and neglected being there for him to satisfy the jealousy of my husband who lived in the basement, yet he still managed

not to hold it against me and be there for me. That's love. What's not love is waiting for Gig to pay his child support which started back in October 2015.

Chapter 65

FAVOR

Here we are four months later and nothing. He's working, eating, and spending but not doing anything for these kids. Ridiculous. Bills get so crazy that I have to open up another bank account at a different bank, so my direct deposits don't continue to get consumed. I'm tired of getting to pay day to see that my account is still in the negative, and the mortgage is still three months behind. They are going to put us out of here, so I need to act fast.

Changing banks is a huge headache, and I should have waited until my first part-time job check came, but I didn't. This is a big mistake in planning on my part seeing that it is two days before Thanksgiving. Three hundred and sixty-five days since the marital separation, and I feel a breakthrough around the corner. Money is tight, and God has been showing off in a mighty way. Everything we need is miraculously being provided whether I have money or not.

After school, we head to the dentist's office, and that is an event in and of itself. Six children who did their best "doing school," being quiet and structured all day, are now met with

a smooth hardwood floor which gives plenty of room and an audience consisting of the sweetest business managers, receptionist, and dental hygienist you'd ever meet. When I find a good family-owned establishment in the community, I fully support it. While the children fuss about who will be seen first, the receptionist calls me over.

Lord, I hope I don't owe anything because I have just enough to get some bread, milk, and eggs this evening.

"Hey, Mrs. Foster, you have an outstanding balance of eighty-eight dollars after the insurance paid their portion. How would you like to take care of that?"

"Well, I don't have it today."

"Okay, when would you have it?"

"Uh, let's see. Probably not until the first of the year."

"You mean the first of the month."

"No ma'am, not until January 2nd at least. It's just me right now, and my priority is a place to stay."

"Okay, we can take a postdated check too."

"I just moved banks, and I don't even have access to a debit card or checks yet. I'm sorry."

"It's no problem, so we'll give you a reminder call on January 4th, okay?"

"Okay, and I really appreciate you all working with me. I know eighty-eight dollars is not a big deal for many, but right now, it is for me."

I sit for another two hours or so working on schedules and emailing parents about expectations for the Write-A-Book program at school, while telling the children to stop dancing, rolling, crawling, and sleeping on the floor. They are having the time of their lives, and I am increasingly embarrassed. The other patients are enjoying the show and smiling at the unrestrained youthfulness being displayed. The older grandmother in the glittery, red beanie paid particular attention to my dancing daughter.

"Didn't I ask you to sit down? What part of that do you not comprehend?"

"They're children, baby. They're all right."

"I have a different level of expectation for my children, and they know that."

"Oh, okay, baby. Well, go ahead and do your thing."

"Thanks."

My oldest is all done and follow-up appointments have been made. We pack up our homework, coats, and new toothbrush kits and head for the door. Before I walk out, the receptionist calls me over again. "Oh no, what do I need to pay now?" I'm thinking.

Whispering to me, "Hey, I wanted to know if you would like a Thanksgiving basket."

"Who me? Of course!"

"Okay, great! Can you come here tomorrow or Wednesday to pick it up?"

"I'll be here tomorrow and thank you so much. You are so kind."

"No problem. I felt led to ask you that, so we're going to take care of you."

Take care of me? I don't need anyone to feel sorry for me, and I'm definitely not having a pity party, but it means so much when people can see the need and be obedient to God. I really do need food for the holiday, but my account is STILL negative even though I just got paid.

The next morning, we head out to school as usual after morning circle up and prayer. We pray for healing and obedience today. The morning's commute is lovely. Many people are probably off for Thanksgiving week. I bet they are in the grocery store right now getting everything they need for the holiday. I don't know why I haven't received my debit card yet. How am I supposed to access my funds and pay for stuff? I know exactly what to do.

I leave work to volunteer at my son's middle school Math Extravaganza. Volunteering at their schools is important. It is easy to send supplies and snacks but being physically present and allowing my children to see me assist builds a greater sense of esteem and value for their educational process. Yes, my mom is Assistant Principal of the Year, yet she can find the time to spend time at our school feeding this love language of quality time.

It's time for dismissal, and the overly excited middle schoolers flood the hallways in a sea of royal blue polos in-

cluding Jay. We are officially on break, and what a break it will be. He and I head to the dentist's office where the receptionist has already called me to make sure I am still coming today. On the way there, I call home to check on the oldest son, Q, to ensure he is safe and to check the mail. His day was great, but there is no mail. This means I need to go to the bank immediately after leaving the dentist's office to get money out for groceries before they close. We arrive at the dentist's office, and the familiar smell of dental goodness hits me in the face. I have always had a fear of the dentist but try to keep it to myself for the sake of the children who are rock stars in the chair.

Jay and I are sitting in the waiting area when all of a sudden the two hygienists come out with two brown boxes full of food that are big enough to transport a cocker spaniel. Fresh potatoes, apples, carrots, and celery along with over twenty canned foods, and a host of other non-perishable items. We start to strategize where to put the boxes when we are told to wait because there's more. Here comes the owner with two sweet potato pies, a huge apple pie, and a chocolate lover's dream cake that is as tall as a top hat. But they aren't done yet: a turkey, two rotisserie chickens still warm for tonight's dinner, a ham, a slab of ribs, ten sodas, and assorted juices are all brought out for me to take. This is more than I even thought about purchasing at the grocery store. At this point, I'm in tears and immediately explain to Jay that I'm crying because I'm happy and overwhelmed. He can't take my tears. I think he had enough of it when I carried him. Many thanks,

smiles, and hugs are all that I can do. My truck is so full that only Jay and I can fit in it comfortably.

"Mommy, why did they give us all of this food?"

"Sometimes when people see that others are in need or God tells them to bless someone, then they do. Have you ever felt like you needed to help someone even if they didn't ask you to?"

"Yes ma'am, like that time I fixed you a breakfast because I saw that you never eat breakfast."

"Yes, exactly like that. And talk to me about why you felt led to feed me on that morning."

"I don't know; I just felt it."

"That's being able to hear God speaking to you and immediately being obedient."

Once I am finally home for the night, I sit on the couch. I can't move, and the kids keeping asking me what's wrong. I keep telling them I'm good, but they don't believe me, so I get up and start looking busy. A busy mommy is always an okay mommy. April calls, and she, too, asks me what's wrong.

"What's wrong, puddin'?"

"Nothing. I'm just sitting here."

I tell her about my day, and she shouts and sends praises to God over the phone.

"That's why you sound tired. Those blessings are heavy, aren't they?"

"Yes, I feel overwhelmed sometimes because I don't care what I need, it is always provided and so much more than I could ever think of! Why me, April? What makes me the one God has chosen to bring miracle upon miracle?"

"Did you watch that video I sent you yet? You have to know your why. He is using your life as a testimony of what can happen if you totally depend on Him. Someone needs to see it, and they're seeing it through your life, so keep on living and giving Him the glory."

"You're preaching, April."

"Girl, people keep telling me I'm running from my calling."

"So, stop running."

We say our goodbyes, and I realize the impact of what my life has become. As I put the Thanksgiving basket groceries away, I reach up to put the can of sweet peas in the pantry, and my arm gives out as my body yields to the emotions of the year. I begin to moan and wail as only a mother who has had two seconds of labor can relate. This life I live is heavy indeed, but heavy in faith that all things work together for good. It's filled with family and friends who truly love and support my hustle. Lord, I know there is a reason that you continue to choose me to run this race, and for that, I am honored. I think I could use a break at some point though. Have I learned the lesson You've presented in this test?

Chapter 66

MR. POSTMAN

Checking the mail over the trash can helps keep the declutter party going. I'm good at it.

Just two weeks later, on December 15th after a hard day at work, I check the mail over the trash can. What is this letter from a lawyer? That is strange. I open the letter and feel a sense of shock, confirmation, and grief all at the same time. The lawyer alerted me that there is a case for absolute divorce against me and that I need to secure them for defense.

There has been no counseling or mediation since he left, so I am in shock, but this white paper with black writing confirms what I know to be true about his will to fight. So, I am grieving for my children and the death of a union we told God we would protect and honor.

Can you just pay your child support, please? It's Christmas for God's sake! I send him a brief text to let him know that I am aware of the court document and that I don't agree with what he is trying to do.

Gig, I see that you have filed for divorce. You could have told me. We didn't even go to counseling.

Sorry. I know you are upset.

At the same time, I'm texting him, I receive another call from the dental office,

"Mrs. Foster, this is a reminder that your children have their cleanings scheduled for next week."

"I can bring them as long as I don't have to pay right now; we're really short this year."

"Oh, no, you're paid up for the year."

"Great! See you then."

The appointment, two weeks before Christmas, finishes with everyone being cavity free and carrying goody bags with new toothbrushes and floss. Let's see how long that lasts. The same day, a sheriff calls me while I am at dance rehearsal with the twin girls.

"Mrs. Bryant-Foster, I've been trying to get in touch with you, but you're never home."

"I work, and my children have activities. Are you trying to drop off divorce documents?"

"Yes, uh, we do have some documents for you. I can bring them to you wherever you'd like."

"You can bring them to my house? I should be there by 9 p.m."

"Okay, ma'am. Thank you."

I call Gig as soon as I hang up.

"So, you couldn't give me a heads up that the sheriff would be coming to my house with your children here? What were you thinking that I would give them as an answer when they asked why the policeman was at their house? Did you think about your children?"

"No, I'm sorry about that. I didn't think about it, and I'm sorry about how all this is going down."

"Whatever. We'll just be done in February if that's what you want. Tell your lawyer to email me the documents stating what you're asking for, so we can get it over with."

"I don't have a lawyer."

"Okay."

On December 16th, we had a collaboration at my elementary school, making sure five families were blessed this Christmas season. They received bicycles, food baskets, toys, stuffed animals, puzzles, and even gift cards from partnership organizations. Standing and celebrating my school families knowing that my original family has little to no food, are sleeping on the air mattresses, and having to go in the house first to make sure the lights are still on is challenging. Smiling through the pain is the worst.

The next day, December 17th, Ms. Debbie from the dental office calls and says that I need to come by again before they close. I can't pay a bill, and I'm not making myself an

appointment, so she can forget both of those. Upon arrival, the Christmas tree is lit this time and full of gifts underneath.

"Hey, Ms. Debbie. What's up? I got your text." She buzzes the doctor.

"Dr. Hayes, Mrs. Foster is here." The doctor comes around the corner.

"Hey, Mrs. Foster. Listen, every now and then we choose a family to bless for Christmas, and this year we chose your family."

"What? You just did Thanksgiving for us and now this? Thank you so much!"

"Tell Quincy that even though he has fewer boxes than the other kids, it doesn't mean he got less stuff."

"Wait. How did you know what they wanted?"

"We asked each one when they came to the back for their cleaning yesterday. We got you! Did you go shopping yet?"

"No, I'm still trying to pay the mortgage, but we have to move to my parents' house. I can't afford anything these days without support."

"So, he's still not paying support?"

"No, he isn't. He said he's waiting for the direct deposit to start."

"Well, you have a Merry Christmas and let us know if you need anything, you hear?"

I purposely didn't put the tree up until the last week before Christmas because I did not want the children to keep asking when I would put gifts under it, and now I have some. Thank you, God, for your faithfulness and favor even when I don't deserve it.

LIES

The February court date came quick. Last night I was excited about moving on with my life, but this morning, I just don't know. This is not right. I am not finished fighting for my marriage. My boss lets me talk to his mother who has been where I am, the sole provider for multiple children who makes sure their children have what they deserve no matter how many jobs they have to work. Her calm, yet confident voice gives me some peace going into it. She told me I'd have moments of wanting him back, feelings of failure, and the need to carry on sometimes all in the same day. And was she right! Trembling legs and an upset stomach fill my morning routine. I need my mommy right now, but she's on a church retreat. Daddy comes to court for support. It should be in and out as far as I am concerned. He doesn't have a lawyer, and I can't afford one without refinancing this house, so we just need to sign and say goodbye, no fault, no harm, just goodbye. The only child that knows what is happening today is the oldest. I hope I am not sharing too much with him, but I just want him to be aware of what is going on.

Constructive desertion? He's crazy if he thinks that will work! How did we go from I don't want anything, and I have no lawyer to this? As for the charges, he's asking for his lawyer's fees to be paid, shared custody, for me to pay him for back child support, and all this other stuff. Did I do all of these things? This lawyer knows good and well that she didn't send these documents to my house. I see what I'm working with now. Now, I will fight, fight for my marriage, my family, and my good name.

Outside of the courthouse, Daddy and I separate to get our vehicles. I can't believe he has allowed this woman to cut and paste a case towards his wife and the mother of his children. I gave him four beautiful children and a career—oh, he wouldn't even be in education if it weren't for me, but all I ever hear is complaints. How can he just throw away all these years? She must really be in his ear. What kind of woman puts up a father of six young children anyway?

I had no other choice but to get a lawyer, and she's fierce. She's not playing games, but she understands that I am not in favor of a divorce from my husband, and I will not compromise on the health and safety of my children. With those two main tenets in mind, I paid her a good college tuition for a year, money that could have been spent on our children. Instead we line the pockets of professionals who help families make or break their lives forever. He wants to avoid paying child support at the end of the day but doesn't want the kids on the weekends. Really?

The next month my dad says he wants to speak with both of us. I have no idea what he is going to say but sitting across from my daddy with Gig on the opposite wall, I knew it was going to be major because he took off his hat and hung it on his knee.

"You two have gone too far with this stuff. Your children are suffering, fighting, and not doing well in school. Have you even looked at them? Those are my grandbabies. I'm the one who is picking them up and dropping them off, and they just look sad. And it hurts me because you weren't raised like that." He looks at me and then begins to cry.

"Your mama and I haven't always done everything right, but we make it work.

There is nothing in your marriage that you can't fix. You have to learn to love these kids and love each other again."

He goes into his pocket and pulls out a fifty-dollar bill pushing it towards Gig.

"Here is the money. Go on a date. Find your love again. You need to fix this! Fix it now!"

"Mr. Joe, I appreciate your words, but I just can't take your money. And Ashanti and I . . ."

"See, there's always an excuse. He doesn't want the marriage Daddy, and we can't make him."

Gig stands up and starts towards the door.

"He's leaving again just like he left us before. He doesn't want this family. Go ahead, run away like you always do. That's why we can never get anything accomplished."

Disgusted with my behavior, Daddy pronounces, "I tried. I did what I could do. You all are both stubborn and need to get over yourselves. I've said my peace."

"I'm sorry, Daddy."

That is the second time I've seen him cry. The first time was when my mom told him he was going to be a daddy again at the age of forty-five. Now this. I'm not sure what else will help but prayer because every time I open my mouth, I spew venom of pain, shame, and loss. I need a new strategy.

Months pass with many court dates, parenting classes, and negotiations. On the day before spring break, the court orders him to have the children on Thursday, Friday, and Saturday nights. I'm sick to my stomach, but I do what the lawyer says and keep my log of medicines, pickups and drop-offs, grades, and attendance. Half of the time, he's either asking me to switch or late picking them up altogether. This won't last long at all. He will be begging the court to give me full custody.

It just happens to be the Thursday that he would begin his fatherly duty. Sitting on the benches just outside of the courtroom where he professed that I kept his children from him, I remind him of the day of the week it is. With a stunned look on his face, he asks if he can get them in the evening after they have a chance to pack a bag. Pack a bag? Come on,

Mr. Money Bags, you're sitting on over twenty thousand dollars of back child support. Clearly, you can go and buy some underwear. I oblige just so I can give my babies a critical talk about next steps and that they can always tell me everything. We didn't keep secrets then, and we won't start now. After the good touch, bad touch, and what to do if you get lost talk, they are ready. I release them to God not to their earthly father. Jehovah will protect them. He promised.

At the same time, I am going through a series of appointments and phases of the interviews for principalship. I'm on an emotional rollercoaster.

Chapter 68

CRUISIN'

This has to be what being bipolar feels like. Emotions are literally going up and down every moment of the day, and it's hard to keep up. I receive the call from human resources on a Tuesday night in Bible study saying that the CEO and his team have accepted the recommendations and have appointed me as the next principal of the school I interviewed for. I can't talk about it until the board approves it, but that's not going to work. I called my mentor, and he picks me up to head to the school. As we pull up, I see the most beautiful murals all over the school. And it's right up the street from the fitness place that my friend told me about. Walking the campus, I feel the heavy weight of the position. I count eleven temporary classrooms and lots of windows. Oh, boy! There's no turning back now. As we leave, I spot a drum circle and African dance class in one of the shops. This is it. This is my new school community. Thursday, June 9th, shortly before midnight, the flood of email congratulations to Principal Foster arrive. I did it. I'm a principal of my own school. It's crazy to even think about it. The next day, I choke up as we recite the Peace Pledge for the last time as a middle

school family. I will always and forever be a queen of peace. Despite the turbulence of moving to a new school, everything that I ever wanted to do happened this summer thanks to a wonderful friend and wise counsel who took the opportunity to cater to me. I rode motorcycles, went to Caribbean festivals, drive-in movies, and out for ice cream just because. Who knew there was so much to do in my gorgeous district? And he did it not because he tried to make me his next conquest but because he believed I deserved it. I hadn't been on a date since Gig was courting me almost ten years ago, but we were clear that these weren't dates at all but just two grown people with like interests enjoying summer experiences together. After getting back from riding around the city, we say goodbyes outside of my door. Friends don't come into my home, especially in the disarray that it's currently in.

"Okay, here's the helmet."

"No, that's yours. You keep it. I don't plan on riding with anyone else. I will text you when I'm in."

I'm so upset that I block myself from having this kind of life and put up with never being noticed, honored, or respected inside my home. I've gone from begging my husband for time for nine years to having to slow things down between my wise counsel and me and to put at least a day in between our excursions, so I can focus on this case. We made lists of everything we wanted to do and places we'd never been and tried our best to cross off every activity. It's the best adult time of my life until the divorce proceedings start.

Chapter 69

CHAIN OF FOOLS

Just like the twins' delivery, this divorce keeps getting pushed back further and further, finally landing on Gig's birthday. As we get closer, he keeps wanting to meet with me and ask me if this is still what I want. I continue to remind him that I am not divorcing him, but he keeps making me feel like I am. Our son, Sidney, asks me a powerful question that I don't know the answer to. He said, "If God hears and answers our prayers and I prayed to him that you would not get a divorce, why isn't He answering the prayer?" All I know to do is to go to the source, our pastor. He explains to me that God will never force Himself on us and that we, as humans, must make the steps to follow His word. He also tells me to let Sidney know that God's love for him won't ever change and neither will his daddy's or mommy's love for him. That is tough for me, but I am grateful to have a pastor who teaches. I seek further counsel about these proceedings.

My divorce proceedings have taken themselves into day three after the oddest interruptions:

- Day 1 - Fire alarm evacuation after a late start and interrupting our case for grand jury proceedings.

- Day 2 - He testified that morning, and it was uncovered at lunch that he was never sworn in, so we had to start all over. Then there were more interruptions for the same grand jury case; we went into overtime.

- Day 3 - His birthday and pending end of marriage date.

My lawyer says she's never seen anything like this before, with the drawn-out proceedings and over seven interruptions of at least fifteen to twenty minutes each. It was not an accident.

Last night, my husband came to our home and told me he took things too far with filing for divorce and that he wants his marriage. He says he wants to cease the proceedings and work on our marriage. I praise God for this breakthrough in his willingness and thinking. He has never articulated his desire to further the marriage to me, and it is definitely a step away from the divorce conversation. But he has conditions. He wants me to reduce child support, which is what he is obligated to pay for four children based on his salary. I am not as willing to change the order until we reunite in the same household. His desire is to continue to build his credit and wait to get another home together, not just in my name, and then reunite under the same roof. I don't know how long that will take. Does that make sense in the reconciliation of

a marriage? I haven't told anyone, not even Mom, because I need to make sure he follows through with dismissing the case and that we have a plan. Throughout this process, he has said one thing to me, then gone back to the lawyer and she persuades him in another direction, away from repair. He is supposed to call me back today with next steps. He doesn't, so I call him.

"Hello. I was waiting for you to call me, but you didn't. So, what's up?"

"Well, I really want us to get a fresh start without the child support."

"If you want to be married to me, then it shouldn't be predicated on money."

"Okay, well, you made yourself clear."

"Goodbye. See you in the morning."

The very same night, Wise Counsel calls and says we can't hang out anymore, abruptly and without a real reason why. Just can't. It's August, and I'm in full mommy and new principal mode anyway. It was awesome while it lasted. He still claims, however, that whatever I need, I know he's got me. I was a little disappointed, but everything happens for a reason.

The next morning in court, the lawyers go straight to the back to talk. I look over to him and tell him happy birthday. They are back there for a while. When they finally emerge, the conclusion is that Gig wants to drop all charges and keep

things as they are. His lawyer looks nice and pissed. We take a lunch break while the judge handles another case, and since I already gave my lawyer the heads up, she basically says it's up to me. In the hallway, Gig asks me to go to lunch with him at the corner spot. I oblige. He pleads that we drop everything and move on.

"Everything like what? Child support, custody, everything?"

"I'll give you sole, physical custody, and we have joint legal custody."

"I'm listening."

"And can you think about lowering child support?"

"Well, actually, you just got a new job making a lot more, so do you really want them to run the numbers again? It's up to you. I'm not alleviating your financial responsibility you have yet to fulfill. That would be irresponsible of me."

"Okay, I get it."

"So, what's the next step for us, Gig?"

"We have to figure that out."

After lunch, the case is dismissed, and we walked out—together. I give him a ride to his truck, and we decide to go and announce to my mom what we have done. It is just a double blessing that we see Pastor in the hallway. Gig tells him what happened, and he shares wisdom, gives us a love offering for dinner, and connects us with the best counselor in the house for free! We are told to come together as soon as

possible, forgive, and Gig has to be the one to arrange counseling. A month later, we have our first of two sessions.

He's not ready to move on, and I know it. His first question to me is, "Do you have a problem if I am still friends with her?" That's not the question of a man who longs after his wife. When can we have some personal time together? When can you come over to my place? When can we meet and face our truths? No. You just want to keep doing what you are doing with my permission.

Over the next six months, I tackle life as a first-year principal and mother of six with a home going into foreclosure, and no support from my husband—still. Attempting to gain the trust of a brand-new staff with a vocal community during an election season is a recipe for the perfect storm, but shouldn't I be storming? They don't know me, and I don't know them, so we are learning together. It's imperfect perfection to say the least. My personal trust issues definitely don't stay in the truck when I go in the building, but I pledge to work on it by building relationships in my new environment. When I finally walk across the stage as Dr. Foster that October of 2016, my six children watch me be a victor and not a victim. That fall, we give away Christmas gifts to families at school while my children have an empty tree at home. Again. This time I get smart and decide that we will give our hearts and choose an organization we want to bless instead of seeking gifts. We have the gift in Christ Jesus. We decide that we will be the wise men. My mom gives me the option of using the graduation party money to catch up my mortgage, and I

graciously agree. Although most of our furniture is sold or donated and we are sleeping on mattresses with one TV left as we prepare to move in with my parents during the winter break, that was Christmas even for us.

Gig, on the other hand, had a beautiful tree with gifts abounding at his penthouse apartment. Who knew that a women's discipleship group that I spoke on a panel for earlier in the fall would stop by to check on me, interview each child, and fill up the Christmas tree just two days before Christmas? God always provides.

The back and forth didn't stop my relationship with Wise Counsel. Why I punish myself this long when God has already forgiven me is a mystery, but I'm learning through his wise counseling. Our conversation brings up ideas I never even thought about.

"Can I ask you a question?"

I move my blanket and pillows from the living room couch, so he can have a place to sit. "Yes, what's up."

"Why are you still sleeping on this lumpy couch and not in a bed? I mean you aren't moving anymore."

"Why do you want to know about my bed?"

"First of all, I'm asking for you, not for me. I get that you needed the kids to have their own space, but you are a principal honey, and you are sleeping on the couch."

"Well, the girls are getting older, so I put them in the master bedroom with their own bathroom, then Q and Jay

are sharing one room, and BK and Sid are in the other. That's it unless I move."

"Well, you have the big beautiful basement that no one is doing anything with. Move there."

"He stayed down there, and I can't be that far away from the kids."

"Does this intercom system work?" Pointing to the wall.

"Yes."

"Sweetie, for whatever reason you want to punish yourself, and that's crazy, but let me know when you are ready to make that step, and I will help you out, okay? I still can't believe you've been down here since he left in 2014. Three years, with no space to call your own!"

"I know. I just want them to be as comfortable as possible. They are already dealing with so much."

"So, whose job is it to make you comfortable?"

After moments of silence pass with locked eyes, I didn't know what to say or feel.

"Look, whatever you need, you know I got you. I'm going to head out."

By February, I put my foot down. I ask Gig to come over, so we can meet. I make it extremely clear that the only reason he isn't in jail is because I haven't checked the box. I will check the box. Are you going to reconcile or keep doing you?

It is disrespectful to keep being legally married to me and living the single life. Nope, let's set a date.

"If you don't want to be married, when are you going to the courthouse, Gig? What day? Get your calendar out. Let someone else love me if you aren't. Let me go. What are you doing?"

"I'm going to pay support like I'm supposed to."

"And when are you going to make arrangements for these children to spend time with their father? You are father of the year when we were going through court, now what? Why can't you make a schedule for them? They ask about you every day. They've been in counseling for five years, and you have not been to one session. Why do you keep running? Why won't you uncover and deal with the pain? You know you are hurting. Speak it and let it go, so you can be free. But until you are ready to free your demons, I am asking you to release me."

"Okay."

Chapter 70

GRACEFULLY BROKEN

Two months later, we were divorced. In less than sixty seconds in the courtroom, the marriage was over.

And he never missed a payment after that date.

Leaving the courtroom, I text Mommy what the judge spoke.

Divorce is final.

I love you, Ashanti. How do you feel about it?

We'll get through it. It's not a celebration, but I will get through it.

Trust God; He will see you through. No, it's not easy. But God!

Yup. He has, and He will.

His greatest blessings are realized in our weakness. He knows what your needs are. Let Him fill your needs, not another person. Only God can complete you. Mom

When left to my own devices, my instinct is to prove that I'm always right, have the last word, and teach others a lesson,

but surrendering to God's will calls for the exact opposite. When allowing God's will and design for my life to prevail I'm called to: not be quick with my mouth or hasty with my heart (Ecclesiastes 5:2); be quick to listen, slow to speak and slow to become angry and not take it upon myself to repay a wrong (James 1:19); trust in God, and he will make it right (Proverbs 20:22); follow wisdom's instruction to fear the Lord, because humility comes before honor (Proverbs 15:33).

I need Him in my life every moment of the day not just when I'm in trouble. I realize that the battle was never with my husband, my job, or any of that. The battle was spiritual warfare. The enemy couldn't stand that a thriving black family with six children, six future households, loved God so much, so a tireless war came against my family to destroy our union. And we allowed it to. Where would we be today if we waited a bit longer to get married, or if I moved to him instead of insisting that he move to me? What if Johannah had survived? Where would we be if he chose to date me and appreciate me, if we had family dinners, or if we respected and comforted one another instead of looking to others, or if he had never quit his job? Where would we be if I never got tired of fighting and tore down the impenetrable wall that I built, so I could never be hurt? I don't know, but we know that all things work together for the good for those called to His service. I am the chosen one, so it's all good.

I am rebuilding my life and paying more attention to what my children need, instead of what I want for them. I realize that they were born with a purpose, and sometimes,

my views may get in the way of that purpose and talent being nurtured. Today, I am listening and watching for my cue to create opportunities for them to thrive in this world. With God all things are possible when you are armed with enough understanding to know that surrendering to Him with un-wavering faith and obedience is all you need to survive.

I love Him. Oh, how I love Him.

ABOUT THE AUTHOR

Ashanti Foster is an accomplished educator residing in Prince George's County, Maryland. She holds a BS in Elementary Education from Morgan State University, a MA in Curriculum Development from Bowie State University, and an EdD from Argosy University in Educational Leadership. She was voted Teacher of the Year and Maryland's Assistant Principal of the Year. Nationally, she presents on parental engagement, arts integration, and college career readiness.

Ashanti serves as Youth Advisor for the National Council of Negro Women, Troop Leader for Girl Scouts, and Committee Chair for Boy Scouts. She disciples other women at her church home and motivates leaders with the Praying Principals Group. Her mission is to foster the belief in readers that life doesn't have to be perfect to be amazing. Through testimonies of triumphant trials, she redefines bravery and strength.

Ashanti's personal passions are dancing, worshipping, traveling, and exploring new restaurants. She has birthed six children.

Learn more at DrAshantiSays.com

CREATING DISTINCTIVE BOOKS
WITH INTENTIONAL RESULTS

We're a collaborative group of creative masterminds
with a mission to produce high-quality books to position
you for monumental success in the marketplace.

Our professional team of writers, editors, designers,
and marketing strategists work closely together to ensure
that every detail of your book is a clear representation
of the message in your writing.

Want to know more?
Write to us at info@publishyourgift.com
or call (888) 949-6228

Discover great books, exclusive offers, and more at
www.PublishYourGift.com

Connect with us on social media

@publishyourgift